Women in the

by Frances and Joseph Gies

LIFE IN A MEDIEVAL CITY

LEONARD OF PISA AND THE NEW MATHEMATICS
OF THE MIDDLE AGES

MERCHANTS AND MONEYMEN

LIFE IN A MEDIEVAL CASTLE

THE INGENIOUS YANKEES

WOMEN
in the
MIDDLE
AGES

Frances and Joseph Gies

 HarperPerennial
A Division of HarperCollins*Publishers*

5

Grateful acknowledgment is made for permission to reprint the following. Excerpts from *The Family in Renaissance Florence: A Translation by Renee Neu Watkins of I Libri Della Famiglia* by Leon Battista Alberti are quoted by permission of the University of South Carolina Press; from *English Historical Documents*, Vol. I, translated by Dorothy Whitelock, by permission of the Oxford University Press and Eyre and Spottiswoode, Ltd.; from *The Merchant of Prato: Francesco di Mareo Datini* by Iris Origo, by permission of Alfred A. Knopf; from *Not in God's Image* edited by Julia O'Faolain and Lauro Martines, and from *Two Memoirs of Renaissance Florence* translated by Julia Martines, by permission of Harper & Row Publishers, Inc.; from *The Pastons and Their England* by H. S. Bennett, by permission of Cambridge University Press; from *Revelations of Mechtild of Magdeburg, 1210–1297* translated by Lucy Menzies, by permission of Longmans Green; from *Social Theories of the Middle Ages, 1200–1500* by Bede Jarrett, by permission of Frederick Ungar; from *Tenure and Mobility* by J. A. Raftis, by permission of the Pontifical Institute of Medieval Studies, Toronto, Ontario; from "*Land, Family, and Women in Continental Europe, 701–1200*," by permission of David Herlihy; from the Loeb Classical Library editions of Pliny the Elder's *Natural History* translated by H. Rackham and W. H. S. Jones, St. Jerome's *Select Letters* translated by F. A. Wright, and Aristotle's *Generation of Animals* translated by A. L. Peck, and from J. T. Noonan's *Contraception: A History of Its Treatment by the Catholic Theologians and Canonists*, by permission of Harvard University Press; from Joinville and Villehardouin, *Chronicles of the Crusades* translated by M. R. B. Shaw, Chaucer's *Canterbury Tales* translated by Nevill Coghill, R. W. Southern's *Western Society and the Church in the Middle Ages*, and the *Alexiad of Anna Comnena* translated by E. R. A. Sewter, by permission of Penguin Books.

A hardcover edition of this book is published by Thomas Y. Crowell Company. It is here reprinted by arrangement.

First BARNES & NOBLE edition published 1980.

ISBN: 0-06-092304-0

94 RRD(H) 10 9 8 7

To Dory with love

CONTENTS

ACKNOWLEDGMENTS

This book was researched at the McKeldin Library of the University of Maryland and at the Library of Congress.

The authors wish to express their thanks to Dr. Marjorie Wade of California State University at Sacramento, who read the manuscript and made valuable suggestions; to Hallam Ashley of Norwich, England, who supplied the Paston photographs and information about Paston houses; and to Clara Fantechi of the Ufficio Cultura e Turismo of Prato and Dr. Mario Bernocchi, Vice President of the Cassa di Risparmi of Prato, who gave assistance in connection with Margherita Datini.

PART ONE

THE BACKGROUND

1

Women in History

Traditional history, all about politics, wars, and revolutions, has devoted few pages to women because few women were prominent in those male-dominated activities. The handful who were received patronizing credit for behaving like men—a woman led an army with "a man's courage," an able queen ruled "as if she were a man."

Modern history, with its accent on the economic, social, and cultural, is beginning to give woman her due. Yet many problems need to be overcome before a picture of the past as a cooperative adventure of both sexes will emerge.

Attempts to do justice to women of the Middle Ages have encountered special difficulties owing to the character of the sources commonly used. The writings of Church Fathers, theologians, and preachers have been repeatedly cited, with little consideration of the accuracy of their description of conditions, or of their audience and influence. By a similar method of investigation one might conclude that modern Catholics never practice birth control. Law books and manuals have also been misleading. William Blackstone's eighteenth-century pro-

nouncement that women throughout ancient and medieval history were totally bereft of legal rights and even legal identities was until recently uncritically accepted. Finally, literary works—romances, poems, moral essays, tales—have been taken literally, without allowance for artistic exaggeration or satiric intent.

Apart from the problem of sources, the test of common sense has been difficult to apply to ideas about medieval women because the period is so remote to us, more remote not only than the modern era but even than the classical world. Its social institutions—feudalism, the manorial system, the guilds—seem oddly foreign and artificial. The very domicile of the ruling class, the grim and forbidding castle, seems legendary rather than historic, while armor, tournaments, chivalric codes, the ritual and trappings of knighthood, have a science-fiction outlandishness. The people, men as well as women, seem unreal, like the stiff decorative figures in the illuminated manuscripts and stained-glass windows, rather than our own flesh-and-blood forebears.

Finally, the time frame is confusing. The Middle Ages lasted a thousand years, during which large changes swept the European landscape: the people's migrations, infusing new ideas as well as new blood into the politically disintegrating Roman Empire; calamitous economic decline and vigorous revival; technological innovations with far-reaching effects; social upheavals that created new class relationships. Women's lives were changed along with men's. Few generalizations can be made about women's role that will fit the whole dynamic millennium.

For the early Middle Ages, documentation is limited because of the very nature of the epoch. The next chapter briefly summarizes what is known about woman's situation in that fascinating and, to the historian, frustrating era—the period of the migrations, the barbarian kingdoms, and the economic slow-

down known as the Dark Ages. The remaining chapters in the first section describe some of the changes which took place at the end of the Dark Ages, and the principal attitudes toward women that prevailed.

The second, and main, section of the book explores what it was like to be a woman in the high Middle Ages—the period from about 1100 to 1500—by examining the lives of individual women in those centuries. The information comes principally from real-life sources: chronicles, tax rolls, legal and manorial records, private account books, diaries, letters.

What are the elements that affect a woman's life? Recent works in women's history have tended to focus on the status of women relative to men. But the first and most important consideration in evaluating the quality of life in the Middle Ages applies equally to men and women: the technological and economic level of a low-energy but expanding society, influencing work, housing, food, clothing, health, security, comfort, and self-fulfillment.

A second basic element, affecting only women, is the state of obstetrical practice. Throughout the ages, until antisepsis and improvements in obstetrical techniques arrived in the nineteenth century, childbirth was a mortal hazard. Rich or poor, women suffered and were injured in labor; often they died. A medieval gynecological treatise, *The Diseases of Women*, from the medical school at Salerno, reflects the problems and horrors of childbirth in the whole pre-industrial era, during which doctors and midwives had few aids other than potions and poultices. Nevertheless, amid prescriptions for rubbing the woman's flanks with oil of roses, feeding her vinegar and sugar, powdered ivory, or eagle's dung, placing a magnet in her hand or suspending coral around her neck, the Salernitan text also gives sound advice, for example on breech delivery: "If the child does not come forth in the order in which it should,

that is, if the legs or arms should come out first, let the midwife with her small and gentle hand moistened with a decoction of flaxseed and chick peas, put the child back in its place in the proper position."[1]*

Although abortion, with its own dangers, was practiced from very ancient times, contraception, by various methods—mechanical, medicinal, and magical—found limited use and even less effectiveness. Women had babies, successfully or otherwise.

Several other special criteria apply to the quality of a woman's life in any historical setting.

First, *simple survival*: in many times and on different continents, women have been victims of infanticide as a technique of selective population control. The reason, although usually rationalized in terms of the female's alleged weakness of physique, character, and intellect, is transparently economic: the contribution in work of a daughter was often outweighed by the cost of raising her and giving her a marriage portion: investment in a daughter went mainly to the profit of a future husband.

Second, *conditions of marriage*: the question of consent; the relative age of consent for men and women; monogamy versus polygamy, which emphasizes woman's biological role at the expense not only of her personal, but of her social and economic roles; the seclusion of women in harems or gynaeceums, or their "privatization" at home, where they were segregated from the male spheres of business, politics, and religion; attitudes toward adultery and divorce, where a double standard nearly always prevailed.

Property rights: a woman's competence to own land in her own right; to inherit, to bequeath and sell property; to conduct a

Notes begin on page 233.

business in her own name; to dispose of her own dowry or marriage portion—the money, land, or valuables contributed by her parents when she married.

Legal rights: the restrictions upon women in taking legal action, suing, pleading in court, giving evidence, witnessing wills.

Education: the relative level of literacy or cultivation of men and women.

Work: the distinction between men's work and women's work; of "outside" and "inside" jobs, the big jobs being outside, the little ones at home. Throughout most of history, activities within the house have been considered feminine, with a strong connotation of inferior importance, although they covered the whole process of textile manufacturing and almost every stage of food cultivation and preparation. In addition, women joined men in many of the "outside" jobs, working in the fields, in the shops, even in the mines, usually at lower wages.

Political roles: women's constitutional capacity to reign as queens, or in ceremonial and social functions as queen-consorts; their opportunity to hold office, serve on political councils, and occupy judgeships and posts of local leadership.

Religious roles: women's position relative to men as members of a congregation, as ministers, as officials in a church hierarchy.

One of the enigmas of history is its pervasive misogyny, in prehistoric and ancient times, in the Middle Ages, into the modern era. Anthropologists and historians have turned to Freud and Marx for explanations: men feared women's sexual functions, or hated women because their mothers had failed to gratify their Oedipal longings; or they derogated them, in Engels's words, as the "slave of [man's] lust and mere instrument for the production of children."[2]

From ancient times, societies have attributed sinister magical powers to women, particularly to their physiology. Pliny the

Elder (first century A.D.) reported that some products of women's bodies had marvelous properties. The odor of a woman's burned hair drove away serpents; its ash cured warts, sore eyes, and diaper rash, and, mixed with honey, assuaged ulcers, wounds, and gout. Woman's milk cured fevers, nausea, and many other ailments. The saliva of a fasting woman was "powerful medicine for bloodshot eyes and fluxes." Furthermore, "I find that a woman's breast-band tied round the head relieves headaches."[3]

Most powerful of all, however, was menstrual fluid. "Contact with it turns new wine sour, crops touched by it become barren, grafts die, seeds in gardens are dried up, the fruit of trees falls off, the bright surface of mirrors in which it is merely reflected is dimmed, the edge of steel and the gleam of ivory are dulled, hives of bees die, even bronze and iron are at once seized by rust, and a horrible smell fills the air; to taste it drives dogs mad and infects their bites with incurable poison." During the moon's eclipse, sexual intercourse with a menstruating woman brought disease and death.

The dangerous properties of menstrual blood, however, had their uses as insecticides, Pliny reported: "If [menstruating] women go round the cornfield naked, caterpillars, worms, beetles, and other vermin fall to the ground." In Cappadocia, he had read, during plagues of insects, menstruating women were instructed to "walk through the middle of the fields with their clothes pulled up above the buttocks."[4]

The Hebrews took a similar attitude toward female physiology. According to Leviticus, during menstruation a woman "shall be put apart seven days; and whosoever touches her shall be unclean; everything also that she sits upon shall be unclean. And whosoever touches her bed shall wash his clothes, and bathe himself in water, and be unclean until the evening.... And if any man lie with her at all ... he shall be unclean seven

days."[5] After childbirth, a woman was similarly taboo—for seven days if the issue was male, for fourteen if female; while for thirty-three days, in the case of male issue, sixty-six if female, "she shall touch nothing that is holy, and shall not enter the sanctuary till her days of purification are completed. . . ."[6]

Adopting Leviticus from the Hebrews, the Christian church manifested the same attitudes with injunctions against intercourse during menstruation, and in the ritual of "churching," by which a woman was received back into the church after childbirth. Until this rite had taken place, the mother was considered unclean and could not make bread, prepare food, or touch holy water.

Aside from the mystery and magic of woman's physiology, a historically persistent male attitude toward sex bred misogyny. Wherever sex was regarded as a weakness on man's part and rigid codes of sexual morality were adopted, women were feared and mistrusted for their very attraction.

A final element in misogyny lies in the nature of patriarchy: where males dominated, females were "other," secondary, inferior.

Christianity was in theory egalitarian in respect to sex as to race and class: "For ye are all the children of God by faith in Christ Jesus," wrote Saint Paul. "There is neither Jew nor Greek, there is neither bond nor free, there is neither male nor female; for ye are all one in Christ Jesus."[7] Unfortunately Paul muted this ringing declaration by ambivalence in his other writings, and although it stirred echoes in later sermons and texts, equality, whether between man and man, or between man and woman, was never a medieval doctrine. Theories of equality between men belong to the eighteenth century, between man and woman to the nineteenth.

In the Middle Ages there was in fact little feminine awareness, little consciousness of women as women. In spite of their

disabilities, there was no protest—no "sobs and cries" of their "aeons of everyday sufferings," to quote a modern critic.[8] One of the few women to speak as a woman in the Middle Ages was Christine de Pisan, poet at the court of Charles VI of France, at the close of the fourteenth century. There were other women poets in the Middle Ages, but Christine is unique in speaking up for women, and in her awareness of the special role and condition of women. She was, in fact, one of the few true feminists before the modern era.

Born in Venice about 1364, Christine was taken to Paris at the age of five by her father, who was royal physician to Charles V of France. She was well educated, to the delight of her father "who . . . was not of the opinion that women grow worse by becoming educated," and to the distress of her mother, who wanted her to spend her time "spinning like other women" and so prevented her from "going deeper into science and learning."[9] Married at fifteen to a court official, at twenty-six Christine was left a widow with three children to support, which she proceeded to do with her pen, writing for a number of royal and noble patrons, including the Duke of Orléans, the Duke of Burgundy, and Charles VI's queen, Isabelle of Bavaria. Some of her poems were conventional literary productions written to order for her patrons, courtly poems on such fashionable themes as unrequited love. Others transcended convention to strike a personal note unusual at the time—poems of grief at her husband's death, and poems in which she expressed her religious or moral convictions and her feelings about the plight of her own sex. In *L'Epistre au dieu d'amour* (Epistle to the God of Love) she defended women against contemporary slanders, which she attributed to the prejudice of men who in their youth had loved women but in their ugly and impotent old age resented them. Only women had received Jesus; suffering, wounded, dead, He was abandoned by all but them. History and the Bible might provide examples of a few women who were

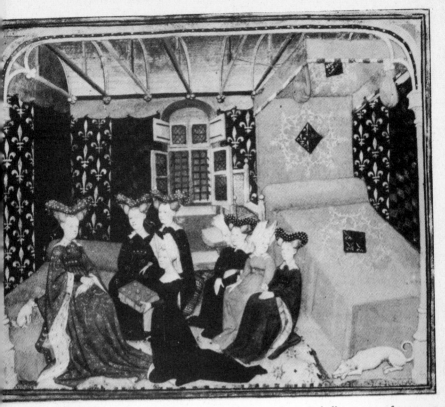

Poet Christine de Pisan presents a copy of her works to Isabelle, queen of France. *British Library, MS Harl. 4431.*

evil and were condemned to eternal damnation; yet they were very rare. She continued:

> They murder no one, nor wound, nor harm,
> Betray men, nor pursue, nor seize,
> Nor houses set on fire, nor disinherit men,
> Nor poison, nor steal gold or silver;
> They do not cheat men of their lands,
> Nor make false contracts, nor destroy
> Kingdoms, duchies, empires . . .
> Nor wage war and kill and plunder. . . . [10]

Christine concluded that "every reasonable man must prize, cherish, love woman. . . . She is his mother, his sister, his friend; he must not treat her as an enemy."[11]

Christine's was an eloquent but lonely feminist voice in the fourteenth century and for many centuries thereafter.

2

Women in the Early
Middle Ages

During the five centuries of the Roman Empire (27 B.C. to A.D.
476), women made dramatic gains in rights, freedom, and
status over their predecessors in Greece and Republican Rome.
In Athens, to quote historian Vern Bullough, "the status of
women seemed to have achieved some kind of nadir in Western
history."[1] Athenian women were married without consent,
were segregated in the gynaeceum, had few property rights, and
lived under the guardianship of male relatives. Double stand-
ards prevailed for divorce and adultery. In early Rome, wom-
an's condition was little better.

But by the end of the Empire women in most of Roman-
dominated Western Europe had achieved a degree of equality
with men in respect to marriage, property rights, and divorce,
and even enjoyed some economic independence. Their posi-
tion, in fact, had improved to such a point that some
nineteenth-century historians blamed the fall of Rome in part
on woman's "rise."

Adult Roman women were virtually free from male guard-
ianship; wives could divorce husbands; dowries were safeguarded;

with some restrictions, girls could inherit equally with their brothers. Women had an important role in religion, sharing with their husbands the responsibility for supervising the household cult, serving as vestal virgins, and in some cases as priestesses, and even conducting their own cults from which men were excluded. While they had no political rights, and could not hold office or serve on councils, they often exerted significant influence through their husbands.

Upper-class Roman women were educated. Calpurnia, the wife of Pliny the Younger (A.D. c. 61–c. 113), possessed cultivated literary tastes, with a preference for the works of her husband. "She sings my verses and sets them to her lyre with no other master but Love, the best instructor,"[2] wrote her gratified husband. Pliny's contemporary, Juvenal, complained about the typical Roman bluestocking who abandoned her embroidery and music to study law and politics, or who paraded her literary evaluations—"The grammarians make way before her; the rhetoricians give in; the whole crowd is silenced."[3]

The fourth-century Church Father Saint Jerome held classes for noble Roman women on the Aventine Hill. A letter to the daughter-in-law of one of his students offered modern-sounding advice about the education of her newborn daughter:

> Have a set of letters made for her, of boxwood or of ivory, and tell her their names. Let her play with them, making play a road to learning, and let her not only grasp the right order of the letters and remember their names in a simple song, but also frequently upset their order and mix the last letters with the middle ones, the middle with the first. Thus she will know them all by sight as well as by sound.
>
> When she begins with uncertain hand to use the pen, either let another hand be put over hers to guide her baby fingers, or else have the letters marked on the tablet so that her writing may follow their outlines and keep to their limits without straying. Offer her prizes for spelling, tempting her with such trifling gifts

as please young children. Let her have companions too in her lessons, so that she may seek to rival them and be stimulated by any praise they win. You must not scold her if she is somewhat slow; praise is the best sharpener of wits. Let her be glad when she is first and sorry when she falls behind. Above all take care not to make her lessons distasteful. . . . [4]

The Roman historian Tacitus pictured the Germans as noble savages, in contrast to the effete, corrupt, pleasure-loving Roman upper class. German women shared their husbands' Spartan existence in a kind of virtuous equality. Girls were raised in the same way as boys; "they are equals in age and strength when they are mated."[5] Wives nursed their husbands' wounds and even accompanied them in battle. Some German women hunted alongside the men. By the custom of *Morgengabe*, a male dowry was given by the groom to the bride—not jewels or trinkets, Tacitus reported admiringly, but "oxen, a horse and bridle, a shield and spear or sword. . . . Here is the gist of the bond between them. . . . The wife . . . is thus warned by the very rites with which her marriage begins that she comes to share hard work and peril; that her fate will be the same as his in peace and in battle, her risks the same."[6] Her life was "one of fenced-in chastity."[7] Flirtation and adultery, those decadent Roman vices, were scarcely known to the wholesome Germans; an unfaithful wife had her hair cropped, was stripped naked, and whipped through the village by her husband. The immoral Roman practices of contraception and abortion were considered abominations. German mothers, unlike Rome's fastidious matrons, suckled their own children.

Because women were credited with an "uncanny and prophetic sense," the Germans "neither scorn to consult them nor slight their answers."[8] Female deities, including Mother Earth, were worshiped.

But Tacitus, writing in 98 A.D., and biased by his censorious attitude toward his own society, is a suspect observer. Though

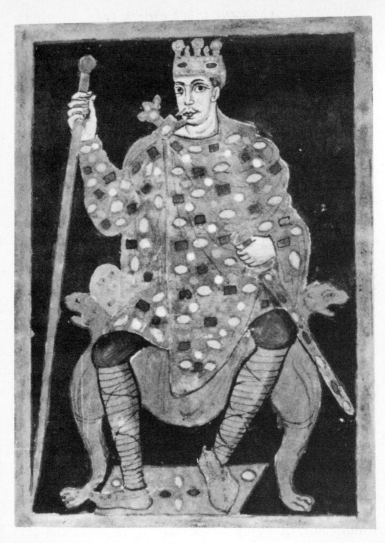

Sixth-century Frankish monarch Lothar, "most amorous by temperament," had seven wives, many concubines. *British Library, MS Add. 37768, f. 4.*

documentation is meager, Germanic sources in the form of the law codes of tribes that migrated into Italy, France, Spain, and Britain indicate a considerably less lofty status for German women. Although the codes extended special protection to women, and often provided for a higher *wergild* (compensation for murder or injury paid to the relatives of a victim) for females, they left no doubt as to which sex was in charge. As under Greek and early Roman law, Germanic women were considered incapable of looking after their own interests. The Lombard code, for example, regarded women as perpetual minors, under the guardianship of a male relative whose permission was needed for any transaction involving property. Saxon law, written down in 785, contained similar provisions: a widow became the ward of her deceased husband's nearest male relative; if she remarried, her children were placed under similar guardianship.

Polygamy was common among most of the Germanic tribes. Wives were bought and sold; rape was treated as theft; and husbands could repudiate wives with little ceremony. Long after the conversion of the Frankish king Clovis to Christianity (A.D. 506), his successors clung to the pagan comforts of polygamy and concubines, divorcing their wives at will despite the Church's injunctions. Lothar, youngest son of Clovis, had seven wives, some simultaneously, and numerous concubines. When his wife Ingund begged him to find for her sister, Aregund, "an able and rich husband that I be not humbled but exalted by her, and thus may give thee yet more faithful service," the king, "who was most amorous by temperament," began to look at Aregund in a new light. He visited her and returned to report to Ingund, "I sought a man wealthy and of good wit, whom I might give in marriage to thy sister, but I found none better than myself. Know therefore that I have taken her to wife, which I believe will not displease thee." Ingund submitted meekly: "Let my lord do that which seemeth good in

his sight; only let his handmaid [Ingund] live in the enjoyment of his favor."[9]

With the exception of the Lombards, whose law remained conservative, as time passed the legal customs of Germanic tribes were liberalized by contact with Roman civilization. The code of the Burgundians, compiled 474–516 after three centuries of contact with the Romans, stated that "if a mother should want to be guardian [over her children] no other relative shall precede her in this,"[10] and "If anyone does not leave a son, let a daughter succeed. . . ."[11] Visigoth law, drafted at approximately the same time, after equally lengthy contact with Rome, was perhaps the most liberal of all. Husband and wife could jointly administer the land either possessed before marriage; land acquired after marriage was considered community property, and the wife could claim a share. Furthermore, when the husband died, the widow retained control of the family property and the inheritance of her minor children. Girls inherited equally with their brothers, even when their parents died intestate.

Not only Roman influence, but over the course of time, that of the Christian church (even though ineffectual at first over men like King Lothar) worked to modify the Germanic codes, softening the concept of women as chattels and increasing the stability and dignity of marriage. The famous law of the Salian Franks prohibiting women from inheriting was amended in the sixth century by the Edict of Chilperic, which provided that daughters could inherit in the absence of sons. By Merovingian times (eighth century) adult Frankish women were free of male guardianship. The Germanic restrictions on women's capacity to inherit and own property were breaking down.

The Church also put an end to polygamy. In 796, bishops assembled by Charlemagne in a council at Friuli declared that marriage could not be dissolved even for adultery; a husband could separate from his adulterous wife, and she could be subjected to severe punishment, but he could not remarry while

she lived. In 802 Charlemagne extended this law to his whole empire.

He himself provided his subjects with a mediocre example, however, repudiating the first of his wives, and after the death of his fifth taking, instead of a sixth wife, four concubines. Notwithstanding, Charlemagne was a devoted family man who loved to be surrounded by his children. He never dined without them and always took them along on his journeys, the sons riding by his side, the daughters following close behind. "Although his daughters were very beautiful," wrote his biographer Einhard, "and he loved them dearly, strange to say, he would never give them in marriage, either to men of his own nation or to foreigners; but he kept them all at home and near his person until his death, for he used to say that he could not deprive himself of their society."[12] The daughters followed in their father's footsteps; though they did not marry, they took lovers and bore several illegitimate children.

In Britain, early Anglo-Saxon law codes followed the Germanic tradition in treating women as property, with wives purchased from their families. The code of King Aethelbert of Kent, written down in 597, provided a sliding scale of penalties for extramarital sex, the fines to be paid by the fornicator to the woman's protector—king, nobleman, or free farmer: fifty shillings for a serving maid belonging to the king, twelve for a nobleman's maid, six for a farmer's servant, thirty shillings to the guardian of "a free woman with long hair [the feature which distinguished free from bond women]."[13] If the woman was married, the adulterer paid a fine to the injured husband and bought him a new wife. Marriage, however, could be terminated by mutual consent: "If [a wife] wishes to go away with the children, she is to have half the goods. If the husband wishes to keep [the children], [she is to have the same share] as a child." Widows who had borne living children inherited half their husbands' goods.[14]

Anglo-Saxon wills took daughters into consideration as well

as sons. King Alfred (873–888) divided his lands among his sons and daughters, wife, nephew, and other relatives, and bequeathed five hundred pounds to his two sons, four hundred each to wife and three daughters. At the same time he stipulated that his heirs keep in mind that he wanted his land to remain in the future in the hands of his own kindred, and that he preferred "that it should pass to the child born on the male side as long as any is worthy of it. My grandfather had bequeathed his land on the spear side and not on the spindle side." His kinsmen were therefore instructed that they might buy back any lands bequeathed to women if they wanted them when the women were still alive; otherwise, the land was to revert to the male line on the women's death. These provisions were made, he explained, in order that he might give his lands "on the female as well as the male side, whichever I choose."[15]

At least by the tenth century, Anglo-Saxon women had considerable power over property. They made wills disposing of their lands as they wished. In about 950 a wealthy widow named Wynflaed, with estates in five counties, made a will leaving some properties to her daughter and some to her son. She also bequeathed to her daughter two women artisan-slaves—a weaver and a seamstress—plus livestock and bondmen, household goods, and "books and such small things."[16] Another lady named Wulfwaru left her estates "with meat and with men and all tilth" to be distributed among her sons and daughters, one property to be shared between her elder son and younger daughter, "and they are to share the principal residence between them as evenly as they can, so that each of them shall have a just portion of it."[17]

Nevertheless, it was not until the eleventh-century conquest of England by Cnut of Denmark that a law code was written which forbade the selling of women in that country: "Neither a widow nor a maiden is ever to be forced to marry a man whom she herself dislikes, nor to be given for money, unless he

chooses to give anything of his own free will."[18] Provisions about a wife's share in the guilt of a husband convicted of theft give us a glimpse of a woman's power in her own household. The thief's wife was herself free of guilt since "no wife can forbid her husband to place inside his cottage what he pleases," but if the stolen goods had been "brought under the wife's lock and key," she was implicated. "She must look after the keys of the following: namely her store-room, her chest and her coffer; if it is brought inside any of these, she is then guilty."[19]

During this period, a lady of Herefordshire willed all her property, "my land and my gold, and my clothing and my raiment, and everything that I possess," to her kinswoman, disinheriting her son. The son sued, and a party of thanes was sent to adjudicate. The lady told them: " . . . Announce well my message to the meeting before all the good men, and inform them to whom I have granted my land and all my possessions, and to my own son never a thing; and ask them to be witness of this." The thanes complied, and the will was so recorded "in a gospel-book" in Hereford Cathedral.[20]

In spite of their disabilities under Germanic law, women did play a part in public affairs in the early Middle Ages. In the violent and turbulent society of the Frankish kingdom pictured by Gregory, sixth-century bishop of Tours, in which women had few rights and many handicaps, queens figured prominently. One queen who had surprising success in asserting her personality and aspirations was Radegund, a Thuringian princess and another of King Lothar's seven wives. Captured as a child and forced into marriage at twelve, Radegund exasperated the king by passive resistance. He complained that she acted more like a nun than a queen, immersed herself in charitable work, kept him waiting at meals, quit his bed to pray, and wore haircloth under her royal robes. When Lothar murdered her younger brother—Gregory assigns no reason—Radegund fled to Noyon

and turned nun in earnest. Angry Lothar pursued, but Bishop Germanus of Paris (Saint Germain) intervened and finally persuaded the king to establish the Convent of Ste. Croix in Poitiers, where she became a member of the community. The poet Fortunatus, later bishop of Poitiers, corresponded with Radegund and her abbess for years, sending them violets in exchange for gifts of milk, prunes, and eggs. After Radegund's death in 587 Fortunatus wrote her biography, one of the innumerable saints' lives composed between the sixth and the tenth centuries.

Two other ladies, the wives of Clovis's grandsons, wrote bloodier chapters in Gregory's lugubrious annals. Fredegund, of humble birth and a maid to Queen Audovera, wife of King Chilperic, intrigued to have her mistress repudiated and dispatched to a convent, where Fredegund had her murdered. Then Fredegund married the king herself, the first step in a violent career which encompassed the murder of Chilperic's third wife, Visigoth princess Galswintha; the assassination of numerous political enemies, including Chilperic's brother Sigebert; the killing of Chilperic's sons by other wives and concubines; and assorted tortures and poisonings. Her rival Brunhild, wife of Sigebert, and sister of the murdered Galswintha, was equally formidable, if less wicked. As regent, and later queen mother, she carried on a struggle against Fredegund, the Frankish nobles, and finally her nephew Lothar II that ended with her capture, torture, and execution.

Amalasuntha, daughter of the Ostrogoth king of Italy, Theodoric the Great, ruled Italy as regent for her ten-year-old son after her father's death in 526. A well-educated woman described by the Byzantine historian Procopius as "endowed with wisdom and regard for justice in the highest degree, displaying to a great extent the masculine temper,"[21] she clashed with Ostrogoth nobles in pursuing a pro-Byzantine policy and was overthrown and banished by her cousin Theodahad, a Goth nationalist. She died strangled in her bath by Ostrogoth nobles.

Italy had its Fredegund in Marozia, who ruled Rome with her father and mother for several decades in the early tenth century. Marozia had Pope John X (reportedly her mother's ex-lover) thrown into prison, where he died, perhaps murdered, and replaced him with John XI, rumored to be her son by her lover Pope Sergius III. Twice widowed, Marozia married the king of Italy, Hugh of Provence, but Alberic, her son by her first marriage, drove his mother and stepfather from the Castel Sant'Angelo, banished Hugh, and ended Marozia's power.

In tenth-century Germany at least one capable queen played a part in politics: the Empress Adelaide, consort of Otto I. After Otto's death, Adelaide's son Otto II appointed her viceroy of Italy. When Otto II died, Adelaide successfully fought for the accession of her three-year-old grandson Otto III. For eight years she ruled in behalf of the child in collaboration with his mother, Theophano. She became sole ruler on Theophano's death in 991, governing the empire for three years until Otto came of age, when she retired to private life and charitable works, which later earned her sainthood.

Women even took on roles of military leadership in the early Middle Ages. In England, Aethelflaed, a daughter of King Alfred, led warriors against the Vikings, built fortresses along the Mercian frontier, and repaired Roman walls. Some of her fortresses, like Warwick and Stafford, became centers of local trade and government. By the time of her death in 918, she had conquered eastern England as far north as the Welland River (north of Norfolk), helping her brother Edward the Elder become the most powerful ruler in England.

A century and a half later, Matilda, countess of Tuscany, *la gran contessa*, heiress to a vast holding that extended from the northern slopes of the Apennines to the foothills of the Alps, sometimes donned helmet and coat of mail to lead her troops in support of the popes in their struggle against the German emperors. Matilda's part in the conflict between Pope Gregory VII and Emperor Henry IV made the name of her castle of Canossa

a byword for penance following the emperor's journey thither in January 1077.

Sichelgaita, a Lombard princess who married the great Norman soldier of fortune Robert Guiscard, was a true Valkyrie, tall, imposing, muscular. She customarily accompanied her husband into battle, and Byzantine historian Anna Comnena reported that "when dressed in full armor the woman was a fearsome sight."[22] When the Normans were put to flight by the Byzantines at the battle of Durazzo, according to Anna, "Directly Robert's wife (who was riding at his side and was a second Pallas, if not an Athene) saw these soldiers running away, she looked fiercely after them and in a very powerful voice called out to them in her own language an equivalent to Homer's words, 'How far will ye flee? Stand, and quit you like men!' And when she saw that they continued to run, she grasped a long spear and at full gallop rushed after the fugitives, and on seeing this they recovered themselves and returned to the fight."[23] Sichelgaita was at her husband's side when he died in 1085 and for the remaining five years of her own life played an important political role.

In the surviving eastern half of the Roman Empire (Byzantium), a more sophisticated tradition in regard to women prevailed. The Byzantine empress enjoyed wide freedom and power. She and her court lived in a gynaeceum; but the seclusion provided more protection than segregation. In her apartments the empress enjoyed complete authority, came and went as she pleased, and could even close her door to the emperor. When the Emperor Justinian entered the gynaeceum after the death of Empress Theodora in 548, he found hidden in an inner room a heretic ex-Patriarch of the Eastern Church whom Theodora had concealed for twelve years.

Empresses were traditionally chosen by a "bride-show," a lineup of well-born maidens recruited from all over the empire. But often the emperor fell in love, sometimes, as in the case of

Justinian, with a woman of base origin. Theodora had been an actress and, according to contemporary historian Procopius, a prostitute. Sometimes politics intruded, as when the Empress Irene chose a bride for her son Constantine VI (reigned 780–797). Although the matrimonial agents carefully measured her height and the size of her feet, the girl was selected for her family connections rather than her beauty.

Often the emperor's sister, daughter, or mother was crowned empress along with his wife, with whom she shared ceremonial roles. Many empresses reigned as regents—mothers and sisters of minors, wives of senile or dying emperors. As consorts they shared their husbands' rule; Theodora regularly attended Justinian's councils. They accompanied their husbands on campaign, took part in intrigues and conspiracies, and entered freely into theological controversies. Some even reigned in their own right, like Irene, who deposed and blinded her son in 797 and ruled Byzantium alone for five years; or the daughters and heirs of Constantine VIII: Zoe, who reigned (1028–1050) jointly with her three husbands; and the nun Theodora, sole sovereign for two years after her sister's death. Anna Comnena herself, daughter of emperor Alexius I Comnenus (reigned 1081–1118), although she never became empress, proved to be one of the great chroniclers of the age, and one of the few women historians before the modern era.

Most of the information about women in the early Middle Ages deals with the ruling classes. But a recent study by historian David Herlihy of records of sales, leases, and exchanges in the period from 700 to 1200 gives important insight into the role played by women of other classes. A small but significant percentage of the records, varying with century and region, identified the protagonists not by patronymics—"Peter, son of Sylvester"—but by matronymics—"Peter, son of Matilda." Evidently some women were so well known in their com-

munities that their names, rather than those of their husbands, identified the sons. The mother's family may have been long established or wealthy, or she may have had outstanding personal qualities, or have been in control of the family property. Another part of the same study showed a considerable proportion of women as owners in property transfers, again varying with place and time, reaching a high point in the eleventh century. An apparent reason was the frequent absence of men for war or other purposes. Professor Herlihy concludes, "The great, external, dramatic events of the day, the wars and crusades, are the work of active men. But their accomplishments were matched and perhaps made possible by the work of women no less active. And the achievements of both are joined together in a kind of alliance of accomplishment, fascinating in itself, and profoundly influencing the Western tradition."[24]

3

Women and Feudalism

Feudalism, born in France in the ninth century, spreading throughout Europe in subsequent centuries, and introduced to England by the Norman Conquest, brought a reactionary shift in the status of women. A system by which a lord granted land to a vassal in return for services that were primarily military, it produced a society organized for war, an essentially masculine world. Pre-feudal society was already male-biased and military, but by linking landholding to military service, feudalism meant the further disfranchisement of women. Feudal estates usually passed intact, with their military obligations, to a single male heir. Only in the absence of male heirs could a woman inherit.

Even if not an heiress, a woman under feudalism spent most of her life under the guardianship of a man—of her father until she married, of her father's lord if her father died, and of her husband until she was widowed. The lord pocketed the income of his ward's estate until she married, and she had to marry a man of his choice or lose her inheritance. The practice was universal, and continued into the later Middle Ages. A law book from the reign of Henry II of England pronounced:

> Even if a female heir is of age, she shall remain in the wardship
> of her lord until she is married according to the desire and with
> the consent of her lord. . . . And if a girl . . . marries without the
> consent of her lord, by the just law and custom of the realm she
> shall lose her inheritance. . . . [1]

Similarly, French king Philip Augustus added an important
qualification to a promise to the people of the Norman towns of
Falaise and Cáen: "We will not marry widows and daughters
against their will unless they hold of us, in whole or in part, a
fief de haubert," [2] that is, a military fief owing service with coat
of mail.

The lord could also "sell" his ward's marriage, exacting a
price from a suitor for the privilege of taking over control of the
heiress's estate, as well as to compensate for his own loss of
income. Wardships, indeed, were regarded as a normal invest-
ment, and were bought and sold like securities. In 1214, King
John of England succeeded in dealing his first wife, Isabella of
Gloucester, whose marriage to him had been annulled in 1200,
to Geoffrey de Mandeville, Earl of Essex, for the huge sum of
20,000 marks. The earl died in a tournament in 1216 before he
had time to pay, leaving the debt to be settled by his successors.
On a more modest scale, John's accounts of the year 1207
recorded payments of "100 marks and two palfreys" from one
man for marriage with a widow, "with her inheritance, her
marriage portion, and her dower," and "1200 marks and two
palfreys" from another for an heiress. [3]

Until Magna Carta curbed the king's powers to sell the remar-
riage of widows, John did a lively business in payments for the
widow's privilege of remaining single, of remarrying whom she
wished, or of keeping control of the lives and fortunes of her
minor children. The same accounts of 1207 contained the pay-
ment of 20 marks by a widow "that she may not be forced to
marry again." Single women too paid for the right to choose their
own mates: "Quenild, daughter of Richard FitzRoger, owes 60

marks and two palfreys that she may be allowed to marry
whomever she pleases, with the advice of her friends, as long as
she marries no one who is an enemy of the king."[4]

Yet despite all the disabilities implicit and explicit in
feudalism, women did not lose all their legal rights, status, and
economic power. Several factors worked against the forces of
feudalism. One was the rapid growth of commerce and city life
in the high Middle Ages. The new cities that were laid out and
built and the old fortresses and markets and crossroads on trade
routes that grew into cities created a new phenomenon, the city
working woman, who (as will be shown in a later chapter)
acquired important new rights and capabilities.

But even in the countryside the loss of women's rights was
never as complete as feudal law implied. A man who married an
heiress—the daughter of a well-to-do peasant, or a lady who had
inherited her father's lands in default of male heirs—could not
sell his wife's property without her consent. If a husband de-
faulted in administering his wife's land, she could go to court
and defend her title; he could not exclude her from the enjoy-
ment of the advantages of her land. Married or single, women
could hold land, sell it, give it away, own goods, make a will,
make a contract, sue and be sued, and plead in the law courts,
both in England and on the Continent.

Feudalism was theoretically grounded in the concept that
land actually belonged only to the lord, who granted it to his
vassals for life. A great lord granted estates to his vassals, who
subgranted land to their tenants. In theory lords, vassals, and
tenants "held" land rather than owned it, but psychology and
custom blurred the distinction. On the death of a landholder his
heir acted out the legal ceremony of homage to the lord and
re-grant of the land, but from one end of the social scale to the
other, there was a powerful sense of inheritance, and a universal
feeling that the land really belonged to the family. A corollary of
obvious significance to women was the idea that retention of the

estate in the bloodline might be more important than assigning it to a man.

Blackstone described the status of women under English "common law" as a legal nonexistence:

> By marriage, the husband and wife are one person in law; that is, the very being or legal existence of the woman is suspended during the marriage, or at least is incorporated and consolidated into that of the husband; under whose wing, protection, and *cover* she performs every thing. . . . A man cannot grant anything to his wife, or enter into covenant with her: for the grant would be to suppose her separate existence. . . .

Since the wife had no legal existence and therefore no responsibility, the husband was liable for her debts and had to answer for her misbehavior; therefore he had the right to chastise her. Blackstone regarded the arrangement as benign: "These are the chief legal effects of marriage . . . even the disabilities, which the wife lies under, are for the most part intended for her protection and benefit. So great a favorite," he concluded unctuously, "is the female sex of the laws of England."[5]

Blackstone thought "common law" was some sort of universal natural law. In reality it was simply French feudal law brought to England by William the Conqueror, and Blackstone notwithstanding, in England as on the Continent, feudal law was never the only factor determining women's legal status. Prefeudal customs stubbornly survived. Loopholes were found: parents endowed daughters by private settlements that prevailed even when contrary to common law, unless the parties became involved in litigation. Finally, new legal doctrines appeared. In England common law was supplemented by a new body of principles known as equity, based not simply on precedent but on the idea of fairness. The outgrowth of petitions to the Lord Chancellor by disappointed litigants, equity developed into a court separate from the common-law courts, presided over by

the Chancellor with wide powers to dispense justice as he saw fit. This court enforced trusts and other arrangements that insured married women rights of property denied them by common law. A husband could make a post-nuptial settlement for his wife by setting up a trust for her in equity, assuring her land or money beyond what was due her by common law.

The universally close connection of marriage and landed property was not invented by feudalism, nor did it die with feudalism, as readers of Jane Austen know. Medieval parents, like those of later centuries, normally took the initiative in choosing their children's mates and negotiating the marriage settlement. The bride's family contributed the dowry or marriage portion, which for aristocrats or merchants usually consisted of land or money, for peasants, clothing, furniture, and utensils. If the marriage was dissolved or the husband died before children were born, the dowry usually reverted to the bride. The husband contributed the dower or jointure, which was also usually land—by common law sometimes a third of his holdings, sometimes as much as half, or sometimes specific lands. Presented at the church door at the time of the wedding, this endowment was more in the nature of insurance than a gift; the land remained in the husband's hands but passed to the wife if he predeceased her. Since the bulk of his land went to the male heir, the dower lands provided a kind of social security for the widow. If she remarried, however, dower usually reverted to the husband's family. In most cases the widow's claim was only a life interest; the land remained permanently in the husband's bloodline and the widow had no power to dispose of it.

Betrothal played an important part in medieval custom. Celebrated in a ceremony very similar to the church rite of marriage, it was evidently a relic of an older secular marriage service, and was regarded as almost as binding as marriage. Not infrequently, couples lived together immediately after the betrothal, although common law regarded children born at this

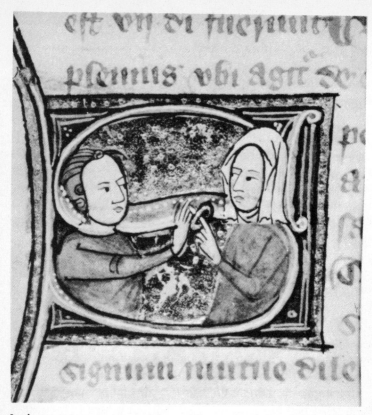

In the most important part of the wedding service, before the church door, the groom presented a ring to the bride.
British Library, MS Royal 6 E vi, f. 104.

point as illegitimate, and even the parents' subsequent marriage failed to legitimize them. Local custom often sensibly ruled otherwise.

The most important part of the marriage service took place before the church door. Here the groom named or listed the dower, and in token of it presented a ring and a gift of gold or silver coins to the bride. The couple then exchanged vows. The

ring and money represented a pledge, in Old English, a *wed*, whence the English word wedding. Following the ritual at the door, the couple moved into the church itself, where a nuptial mass was celebrated. At the end of the mass, the couple knelt and a cloth was stretched over them; sometimes the children already born were placed beneath the cloth and thereby legitimized.

Though divorce in the modern sense did not exist in the Middle Ages, a couple might separate, not to remarry; or might have their marriage declared invalid, in which case they could marry again. Annulment was costly, since it meant pleading the case in Church courts. Grounds for dissolving a marriage included consanguinity, adultery, impotence, and leprosy. Since consanguinity included distant blood relationships, relationships by marriage, and even godparents, it supplied a convenient excuse for annulment. A marriage within the forbidden degree was often contracted and allowed to continue until one or the other of the parties wanted to end it, whether for lack of male heirs, or for political or economic advantage, or simply because other fields looked greener.

King John and his first wife, Isabella of Gloucester, were related to an illegal third degree; the archbishop of Canterbury forbade them to cohabit and put an interdict on John's estates, but the interdict was tentatively lifted by the papal legate, in anticipation of John's appeal to the Vatican. John delayed appealing, and when Isabella remained childless he induced six bishops to declare the marriage void. Isabella did not protest, and remarried twice herself.

The modern system of courtship based on free choice and personal attraction could hardly develop in an age when the social institutions and customs that provide environment for such courtship did not yet exist. Parents might pay some heed to their children's feelings, but love was not an accepted motive for marriage. The Church allowed only two official reasons:

procreation and the avoidance of fornication—that is, un-sanctified sex. Twelfth-century theologian Peter Lombard listed three other "decent" motives: the political one of reconciliation of enemies; money; and—the nearest to a mention of love—beauty.

Nevertheless, medieval marriages often developed into close and loving relationships. Fifteenth-century preacher Bernardine of Siena told the male members of his congregation that "the most beautiful and most useful thing in a house" was "to have a beautiful, tall wife, who is wise, virtuous, temperate, and such as to bear children. . . . When the woman sees aught to be done, she stands in readiness. If she is with child, she suffers discomfort in her condition, she suffers in bringing forth her children, she endures toil in caring for them, in teaching and training them, and tires herself as well in looking to the comfort of her husband when he is in any need whatsoever, or in sickness."

In fact, according to Bernardine, a man without a wife was in a bad way. Who was to look after his house and goods? The mice and sparrows ate his grain, the jars in which he stored oil leaked and broke, the hoops of the wine casks burst, the wine turned to vinegar or became musty. He slept "in a ditch"—in the indentation made by his body, since the bed was never shaken up and smoothed—and the sheet was never changed until it fell apart from age. "In like manner, in the room where he eats, on the floor lie the rinds of melons, bones, refuse, leaves of lettuce, all left there without ever being swept up." The cloth remained on the table until it became moldy. "The platters he washes as little as he can, and the dog licks and cleans them; the earthen pots are all greasy, go, look in what condition they are! Do you know how he lives? Like a beast." (Here, seeing that his praise threatened the women in his audience with falling into the sin of pride, Bernardine cautioned them, "Women, bow your heads!")[6]

The greatest of medieval theologians, Thomas Aquinas, wrote that "copulation even among the animals creates a sweet

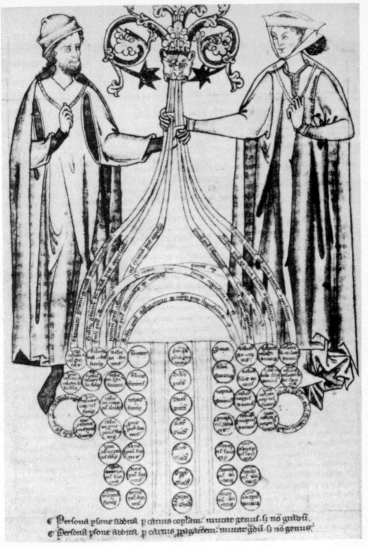

Thirteenth-century table of consanguinity, listing (in the circles) all the relatives (sisters, brothers, sisters' and brothers' children, sisters-in-law, etc.) that a man and woman could not marry.
Bodleian Library, MS Rawl. A 384, f. 91.

society,"[7] and that "a man loves his wife principally by reason of the carnal meeting."[8] Between husband and wife "maximum friendship"[9] developed, based on delight in the sexual act, in creating a household together, and in the response of one virtuous person to another.[10] His contemporary and friend Saint Bonaventure wrote, "In marriage . . . there is mutual love and therefore mutual zeal, and therefore singleness. . . . For there is something miraculous in a man finding in one woman a pleasingness which he can never find in another."[11] If people did not marry for love, nevertheless they often found love in marriage.

4

Eve and Mary

Much has been written of the medieval ambivalence that simultaneously placed woman on a pedestal and reviled her as the incarnation of evil. Preachers tirelessly repeated the tale of Eve's beguiling Adam, while elevating the Virgin Mary to the status of a cult. Correspondingly, in the lay world, woman was extolled by the troubadours, the trouvères and the Minnesingers, and debased in the bawdy *fabliaux*.

Clerical misogyny was as old as the Church. Not only orthodox Christians, but Stoics and Gnostics reacted against the materialistic and libertine life of the Roman upper class by adopting negative attitudes toward women and sex. Their asceticism fitted Christian eschatology, the conviction that Christ's second coming was at hand. "The time is short," warned Saint Paul.[1] "The world is full," wrote Tertullian a century later, adding, in language that prefigures that of modern advocates of zero population growth, "The elements scarcely suffice us. Our needs press. . . . Pestilence, famine, wars and the swallowing of cities are intended, indeed, as remedies, as prun-

ings against the growth of the human race."[2] Those who ap-
peared on the Day of Judgment with "the excess baggage of
children" would be handicapped. As for those who justified
marriage by "concern for posterity and for the bitter joy of
children," such a consideration was "hateful" to Christians.[3] To
Paul's preference for celibacy ("I would that all men were as I
myself,"[4] "It is good for a man not to touch a woman"[5]), and
demand for feminine submission ("Wives, submit yourselves
unto your husbands, as unto the Lord"[6]), Tertullian added in-
vective:

> And do you not know that you are Eve? . . . You are the gate of
> the devil, the traitor of the tree, the first deserter of Divine Law;
> you are she who enticed the one whom the devil dare not ap-
> proach; you broke so easily the image of God, man; on account
> of the death you deserved, even the Son of God had to die.[7]

Yet even this ferocious misogynist must be taken with a grain of
sugar; Tertullian, like many early churchmen, was married and
referred to his wife as "my beloved companion in the Lord's
service."[8]

Anti-feminine diatribes similar to those of the Church
Fathers can easily be gleaned from clerical writings of the Mid-
dle Ages. A modern writer quotes this from Marbode, an
eleventh-century bishop of Rennes: "Of the numberless snares
that the crafty enemy [the devil] spreads for us . . . the worst . . .
is woman, sad stem, evil root, vicious fount . . . honey and
poison."[9] The same writer quotes Salimbene, author of a
thirteenth-century chronicle: "Woman, glittering mud, stinking
rose, sweet venom . . . a weapon of the devil, expulsion from
Paradise, mother of guilt. . . ."[10]

Yet such expressions, cited to show the Church's bias, are
misleading. Marbode's lines are drawn from a section of his
Liber Decem Capitulorum (Book of Ten Chapters) specifically

titled *De Meretrice* (On the Prostitute). In the same poetic work, under the title *De Matrona* (On the Matron), he speaks in another tone entirely: "Of all the things that God has given for human use, nothing is more beautiful or better than the good woman." He cites the roles of comforter, mother, cook, housewife, spinner, and weaver, declares that the worst woman who ever lived does not compare with Judas and the best man does not equal Mary, and names an honor roll of women from the Old Testament and the early Christian saints.

Salimbene was a Franciscan friar, presumably writing for an audience of fellow monks. Like many political bodies before and since, the medieval Church tailored its ideological expressions to suit its varying constituencies. Monks who had taken the vow of chastity found themselves locked in a lifelong struggle to stick to it, and needed all the encouragement they could get. For general audiences, however, the tone might be critical but was pitched on a different plane. Affluent women were chided for their extravagance of dress, whims of fashion, cosmetics, and frivolity. Gilles d'Orléans, a Paris preacher of the thirteenth century, reminded his parishioners that the wigs they wore were likely to be made from the hair of persons now enduring hell or purgatory, and that "Jesus Christ and his blessed mother, of royal blood though they were, never thought of wearing" the belts of silk, gold, and silver fashionable among wealthy women.[11]

Still different was the note sounded when the audience was composed exclusively of women. *Ad omnes mulieres* (To All Women), a text extensively used by medieval preachers, was drafted by the thirteenth-century Dominican Master-General Humbert de Romans:

> Note that God gave women many prerogatives, not only over other living things, but even over man himself, and this (i) by nature; (ii) by grace; and (iii) by glory.

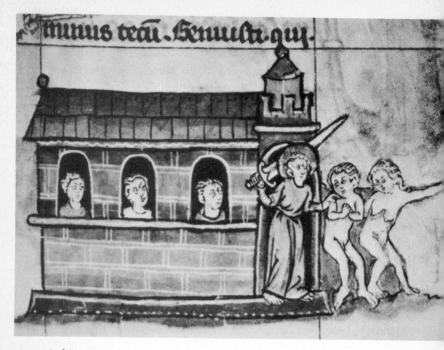

A thirteenth-century representation of the expulsion from Eden, for which Eve's frivolity was blamed. *British Library, MS Stowe 17, f. 29.*

(i) In the world of nature she excelled man by her origin, for man He made of the vile earth, but woman He made in Paradise. Man he formed of the slime, but woman of man's rib. She was not made of a lower limb of man—as for example of his foot—lest man should esteem her his servant, but from his midmost part, that he should hold her to be his fellow, as Adam himself said: "The woman whom Thou gavest as my helpmate."

(ii) In the world of grace she excelled man. . . . We do not read of any man trying to prevent the Passion of Our Lord, but we do read of a woman who tried—namely, Pilate's wife, who sought to dissuade her husband from so great a crime. . . . Again, at His Resurrection, it was to a woman He first appeared—namely, to Mary Magdalen.

(iii) In the world of glory, for the king in that country is no mere man but a mere woman is its queen. It is not a mere man who is set above the angels and all the rest of the heavenly court, but a mere woman is; nor is anyone who is merely man as powerful there as is a mere woman. Thus is woman's nature in Our Lady raised above man's in worth, and dignity, and power; and this should lead women to love God and to hate evil.[12]

Even Tertullian mended his language when addressing an audience of women, scolding them for using makeup but calling them "handmaids of the living God, my companions and my sisters."[13]

At the two extremes of its rhetorical needs the Church found two perfect symbols: shallow temptress Eve and immaculate Virgin Mary. The perception of women by medieval churchmen differed little from that of laymen: women were properly subject to men because they were physically and morally vulnerable, and lacking in judgment. Yet they were personalities, separate from their husbands (a more liberal view than Blackstone's in the eighteenth century), with their own souls, their own rights and obligations. Marriage was good, a sacrament instituted by Christ, and woman was created to be man's helpmate, "included in nature's intention as directed to the work of generation,"[14] in the words of Aquinas, although man was "the beginning and end of woman; as God is the beginning and end of every creature."[15]

In the secular world the knightly troubadour described his lady in a tone at once romantic and gently ironic, as "worth more than all the good women in the world,"[16] beautiful, accomplished, with "fair speech and gentle manner... her sweet look... sends a burning spark to my heart";[17] his love was "a greater folly than the foolish child who cries for the beautiful star he sees high and bright above him";[18] he "loves and serves and adores her with constancy."[19] Along with these elevated

notions went admonitions for courteous treatment: "Serve and honor all women," recommended the thirteenth-century *Roman de la Rose*. "Spare no pain and effort in their service."[20]

The authors of the earthy and popular fabliaux, on the other hand, depicted peasants' or burghers' wives as irrepressibly adulterous, lustful, and treacherous, tirelessly deceiving their husbands with priests, students, and apprentices, and nearly always getting away with it.

In the same satiric tradition was the anonymous *Quinze Joyes de Mariage* (Fifteen Joys of Marriage—the title taken sacrilegiously from a prayer enumerating the fifteen joys of the Virgin Mary's life). The theme was the battle of the sexes, and the protagonist was a respectable burgher whose ill-tempered wife squandered his money, withheld her sexual favors, and made his life miserable out of sheer perversity. Pregnant ("and perhaps not by her husband, which often happens"), she develops a capricious appetite and yearns for new and strange things, sending her poor husband in search of them night and day, on foot or on horseback. After the child is born, she makes him take her on an expensive pilgrimage while she complains endlessly of the pains she suffered—though they were not more than those of "a hen or goose that lays an egg as big as a fist through an opening where before a little finger could not have passed. . . . Thus you will see that, by laying every day, a hen will keep fatter than a cock; for the cock is so stupid that he does nothing all day long but search for food to put in her beak, and the hen has no care but to eat and cackle and take her ease." Meanwhile the husband may not be "as lively as before . . . but she is just as lively as ever. . . . And when the lady is not satisfied with her husband's attentions . . . she thinks that her husband is not so potent as others. . . . And sometimes some women set out to discover whether other men are as lacking as their husbands."

In fact, the wife in the story deceives her husband with a

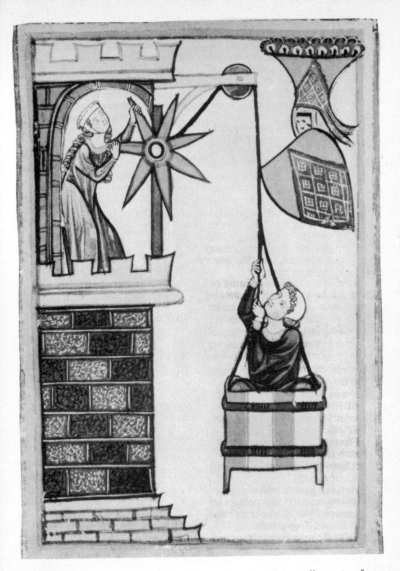

Lady hoists her lover to her window by winch and pulley, in illustration from a fourteenth-century collection of poems of German Minnesingers. *Heidelberger Universitätsbibliothek, Manesse Codex, f. 71v.*

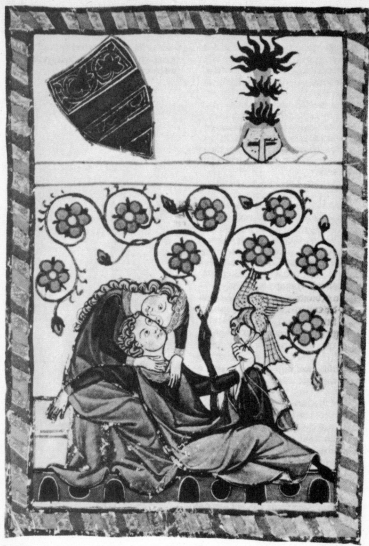

Lovers. "Serve and honor all women" was the typical adjuration of chivalric poetry. *Heidelberger Universitätsbibliothek, Manesse Codex, f. 249.*

succession of gallants. When he catches her in bed with one, her mother, friends, and even confessor conspire to make him doubt the evidence of his own eyes. Worsted in every encounter, he occasionally beats her, but the last word is always hers. Each "joy" concludes, "Thus will he spend his life in suffering and torment and end his days in misery."[21]

The inconsistency of the two literary traditions is as superficial as that found in the sermons. Both troubadour and writer of fabliaux dealt with the same theme, adultery, the one romantically, the other satirically. The ladies of the troubadour verses are married to "cruel, jealous husbands,"[22] and the love is specifically sexual. In the twelfth century, the Countess of Dia, one of twenty known woman troubadours, wrote:

I should like to hold my knight
Naked in my arms at eve,
That he might be in ecstasy
As I cushioned his head against my breast,
For I am happier far with him
Than Floris with Blancheflor;
I grant him my heart, my love,
My mind, my eyes, my life.

Fair friend, charming and good,
When shall I hold you in my power?
And lie beside you for an hour
And amorous kisses give to you;
Know that I would give almost anything
To have you in my husband's place,
But only if you swear
To do everything I desire.[23]

Only the attitude and the social class are different. Medieval literature was neither the first nor the last to treat adultery as romantic for the upper classes and comic for the lower.

The troubadours' sympathy for illicit love was rationalized in the twelfth-century treatise *De Amore* (On Love) by Andreas Capellanus (André the Chaplain), based on Ovid. According to *De Amore*, love could not exist "between two people who are married to each other," but only "outside the bonds of wedlock."[24]

Whether *De Amore* was intended literally or satirically, a point still debated, its ideology, like that of the troubadours, is in unmistakable conflict with medieval living realities which stoutly upheld the ancient double standard in respect to adultery. Kings, barons, knights, and burghers openly kept mistresses and spawned illegitimate children, while erring wives were disgraced and repudiated, their lovers castrated or killed. In a wife's adultery the affront was perceived not to morality but to the husband's honor. Spanish law in the thirteenth century provided that a husband or fiancé could kill the woman and her lover and "pay no fine for the homicide, nor be sentenced to death,"[25] while in some fourteenth-century Italian cities adulterous women were flogged through the streets and exiled.[26]

Despite such pieties as the *Roman de la Rose*'s "Serve and honor all women," wife-beating was common. "A good woman and a bad one equally require the stick!" ran a Florentine saying.[27] The thirteenth-century French law code, *Customs of Beauvais*, stated: "In a number of cases men may be excused for the injuries they inflict on their wives, nor should the law intervene. Provided he neither kills nor maims her, it is legal for a man to beat his wife when she wrongs him."[28] An English code of the following century permitted a husband "lawful and reasonable correction."[29] And a fifteenth-century Sienese *Rules of Marriage* advised husbands:

> When you see your wife commit an offense, don't rush at her with insults and violent blows: rather, first correct the wrong lovingly and pleasantly, and sweetly teach her not to do it

Lover invites his lady to go for a walk in the woods.
Heidelberger Universitätsbibliothek, Manesse Codex, f. 395ʳ.

again.... But if your wife is of a servile disposition and has a crude and shifty spirit, so that pleasant words have no effect, scold her sharply, bully, and terrify her. And if this still doesn't work... take up a stick and beat her soundly... not in rage, but out of charity and concern for her soul....[30]

A contemporary English handbook, however, warned young men that beating their wives would cause resentment because

Though she be servant in degree,
In some degree she fellow is.[31]

If courtly literature did not in its content accurately mirror the life of aristocratic women, its very existence as an artistic form reflected something about their emerging role. The product of the growing affluence of the high Middle Ages, it expressed the sophisticated aspirations of a new leisure class. Women dominated the audience for this new-wave literature. Even in the male-biased context of feudalism, the germ of future court and salon life was discernible. During the battle of Mansourah, one of the Crusading barons remarked to Saint Louis's biographer, Jean de Joinville, "By God's bonnet, we shall talk of this day yet, you and I, in the ladies' chamber."[32] The battle would be discussed and evaluated in a social gathering presided over by women, even as in eighteenth-century Paris or twentieth-century Washington.

The intellectual spirit of the high Middle Ages contributed in another way to the perception of woman's role and character. Science still remained in the dark about the mother's part in conception. Male semen was visible and tangible, and its relationship to reproduction readily deducible, but the discovery of the female ovum awaited the invention of the microscope.

In its absence, medieval thinkers pursued the conjectures of classical writers in explaining the fact, evident in animals as well as humans, that offspring inherited traits from both parents.

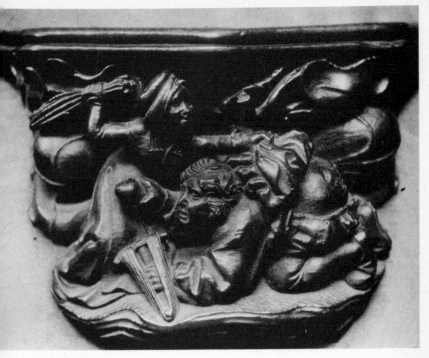

Wife-beating was common in the Middle Ages, but a misericord (choir stall decoration) in Westminster Abbey shows a reversal of custom. Victimized husband is holding a distaff, normally a female symbol.
National Monuments Record.

Aristotle, the universally honored authority, thought menstrual fluid had something to do with the mystery, but even to Aristotle the uncertain nature of the woman's contribution made it seem of secondary importance. The man, he concluded, produced the "active principle" in conception, the life or soul, the essential generative agency; the woman contributed "matter."

Some of Aristotle's contemporaries (said Aristotle) thought

that the female contributes semen during coition because women sometimes derive pleasure from it comparable to that of the male and also produce a fluid secretion. This fluid, however,

is not seminal; . . . the female, in fact, is female on account of an
inability of sort, viz., it lacks the power to concoct semen. . . .
The male provides the form . . . , the female provides the
body. . . . Compare the coagulation of milk. Here, the milk is the
body, and the fig juice or the rennet contains the principle which
causes it to set. . . . We see that the thing is formed from them
only in the sense in which a bedstead is formed from the car-
penter and the wood, or a ball from the wax and the form.[33]

Further, Aristotle declared that women were "weaker and colder
by nature, and we should look upon the female state as being as
it were a deformity, though one which occurs in the ordinary
course of nature."[34] Following these ideas, Thomas Aquinas
pronounced that "woman is defective and misbegotten." The
active force in the male seed produced a "perfect likeness" in the
form of a male child; when a female child was produced, it was
because of "a defect in the active force."[35]

Interpreting and amending Aristotle, the German scholar Al-
bertus Magnus, teacher of Thomas Aquinas at the University of
Paris, propounded a view of woman's sexuality which, to say the
least, runs counter to many latter-day notions of medieval be-
liefs. Albertus demonstrated to his own logical satisfaction that
women experienced greater desire and greater pleasure than
men. Contrary to Aristotle's assertion, he believed that women
as well as men emitted seed in orgasm, and since women both
emitted and received, their pleasure was double. Albertus
thought the *menstruum* was female seed that collected in the
womb between menstrual periods and increased desire until
menstruation provided relief. From this he concluded that
man's pleasure might be more intensive, but woman's was more
extensive. During pregnancy, when the menstruum was re-
tained to form and nourish the fetus, a woman attained the peak
of desire. Albertus's scholarly proof that women enjoyed sex
more than men had its basis, nevertheless, in the notion of male

superiority: woman, an imperfect being, desired conjunction with man, a perfect being, since the imperfect desires to be perfected; therefore the greater desire and pleasure belonged to the woman.

Scientifically speaking, Albertus found sex beneficial and necessary for women, who often became ill when they were "full of spoiled and poisonous menstrual blood. It would therefore be good for such women . . . to have frequent sexual intercourse so as to expel this matter. It is particularly good for young women, as they are full of moisture. . . . Young women, when they are full of such matter, feel a strong desire for sex. . . ."

The sage concluded, "It is therefore a sin in nature to keep them from it and stop them from having sex with the man they favor, although [their doing so] is a sin according to accepted morality. But this is another question."[36]

A physiological concept much closer to reality than those of Aristotle, Aquinas, or Albertus Magnus already existed in the theory of Aristotle's brilliant successor, Galen, whose second-century A.D. medical works were not conveyed to medieval Europe (via the Arabs) till the fourteenth century. Galen foreshadowed William Harvey's seventeenth-century discovery of the ovum by expressing the conviction that women had internal "testicles" located on either side of the uterus "and reaching down as far as its horns," smaller than male testicles but containing seed "just as men's do."[37]

The psychological significance of Galen's theory was apparent in its reception by Western writers who feared that it would enhance feminine pride. "Woman is a most arrogant and extremely intractable animal," wrote a sixteenth-century Italian physician, "and she would be worse if she came to realize that she is no less perfect and no less fit to wear breeches than man. . . . To check woman's continual desire to dominate, nature arranged things so that every time she thinks of her sup-

posed lack she may be humbled and shamed."[38] A Spanish
contemporary added that Galen's notion should be kept secret
from women lest they become "all the more arrogant by know-
ing that they . . . not only suffer the pain of having to nourish
the child within their bodies . . . but also that they too put some-
thing of their own into it."[39]

In the absence of Galen, a passive and secondary role in
procreation might be attributed to women, but in no one's eyes
did it rule out a feminine interest in sex. Quite apart from
Albertus Magnus, the chastity of women was eternally suspect
in the eyes of the canonists (clerical lawyers), who perceived
them as ever eager for sexual gratification. The thirteenth-
century Italian canonist Henry of Susa, known as Cardinal Hos-
tiensis, told the story of a priest who made a journey with two
girls, one riding ahead of him, the other behind; at the end of
the trip he was prepared to swear to the virtue only of the girl in
front.[40]

Saint Paul's recommendation, "Let the husband render to his
wife what is due her, and likewise the wife to her husband,"[41]
was unanimously interpreted by medieval theologians as mak-
ing intercourse mandatory at the request of one spouse or the
other. Wives sighed for satisfaction, declared Cardinal Hostien-
sis, and husbands were morally and legally obliged to honor the
demand. Otherwise the weak, readily stimulated creatures were
led into adultery, which some ignorant women did not even
realize was a sin.

Chaucer's Wife of Bath commended "the proverb written
down and set/In books: 'A man must yield his wife her debt,'"
and inquired merrily, "What means of paying her can he
invent/Unless he use his silly instrument?"[42] The seriousness
with which the Church regarded the marital debt is shown by
the comment of ascetic Guibert, twelfth-century abbot of
Nogent-sous-Coucy, about Sybille, wife of the Count of

Namur, a woman of many lovers and intrigues: "Would she have kept herself in check if [the Count] had paid her the marriage debt as often as she desired?"[43]

Guibert's own mother might have served as an example to him that not all women were sex-hungry. A noblewoman, beautiful, intelligent, and commanding, she was given "when hardly of marriageable age" to a knight, but her frigid piety induced in the young husband an impotence that lasted several years—a situation that their relatives blamed on "the bewitchments of . . . a stepmother." The young man's family first urged divorce, then tried to persuade him to become a monk—not for the good of his soul, "but with the purpose of getting possession of his property." When these measures were ineffective, they pressed the girl to leave her husband, and rich neighbors tried to seduce her. The spell was not broken until the husband, at the suggestion of "evil counselors," had intercourse with another woman and she conceived a child. After that, Guibert recorded, "my mother submitted to the duties of a wife as faithfully as she had [formerly] kept her virginity. . . ."[44]

Officially the Church maintained that marital intercourse was permissible only for the purpose of procreation. The sin involved in sex for pleasure was not, however, a large one, as long as procreation was not prevented. Saint Augustine held that it could be atoned for by everyday acts of Christian charity, like almsgiving, and observed that the sin was not uncommon: "Never in friendly conversations have I heard anyone who is or who has been married say that he never had intercourse with his wife except when hoping for conception."[45] Mortal sin, Augustine thought, could only be involved if one was "intemperate in his lust."[46]

Thirteenth-century canonist Bishop Huguccio recognized that coitus, for whatever purpose, was unavoidably accompanied by "a certain itching and a certain pleasure . . . a certain

excitement," and therefore characterized it as a sin, but "a very small venial sin."[47] Other theologians divided the act of sex into stages and asserted that it could be initiated for a good purpose (in addition to procreation, "good purposes" were the avoidance of fornication and payment of the marital debt) but might reach a point at which one became "submerged in the delight of the flesh,"[48] constituting a venial sin. Others drew an even finer distinction, between "enjoying" and "suffering pleasure."[49]

Like later institutions burdened with the guardianship of sexual morality, the medieval Church felt called on to judge the question of position in intercourse, its ideas coinciding with those of popular morality then and long after: the only "fitting way" was with the woman supine beneath the man. The "normal" position was regarded as natural and appropriate not only because it seemed to symbolize man's superiority to woman, but because it was credited with favoring conception and thus fulfilling the procreative purpose. All deviations were not only sins, but mortal sins. Throughout the early Middle Ages monks who heard confession exacted a carefully graded system of penances for nonprescribed positions: so many days of fasting for intercourse with the woman on top, so many for oral, so many for anal intercourse, so many for contraception, either coitus interruptus or contraceptive potions.

The manuals for confessors that began to appear in the late twelfth century were cautious about explicitly naming the sexual sins, lest the confessor inadvertently put ideas into parishioners' heads. One manual instructed him to begin, "Dearly beloved, perhaps all the things you have done do not now come to mind, and so I will question you." Then he was to interrogate the subject in terms of the seven deadly sins without asking any specific questions about sex, "for we have heard of both men and women by the express naming of crimes unknown to them falling into sins they had not known."[50] A

thirteenth-century book advised the confessor to explain, "You have sinned against nature when you have known a woman other than as nature demands," but not to reveal the different ways; instead he was to say, "You know well the way which is natural," and to continue with tactful and generalized questioning.[51]

Apparently husbands often resented the priests' interrogating their wives. Fifteenth-century preacher Bernardine of Siena reported, "Often a fool woman, that she may appear respectable, will say to her husband, 'The priest asked me about this dirty thing and wanted to know what I do with you,' and the fool husband will be scandalized with the priest." Confessors who had experienced the anger of husbands tended to be gingerly in their questioning. Bernardine urged them to do their duty and inquire.[52]

Contraception was condemned by the Church, sometimes as homicide, sometimes as interference with nature, sometimes as a denial of the purpose of marital intercourse. The early fifteenth-century French preacher Jean Gerson condemned "indecencies and inventions of sinners" in marriage: "May a person in any case copulate and prevent the fruits of marriage? I say that this is often a sin which deserves the fire. To answer shortly, every way which impedes offspring in the union of man and wife is indecent and must be reproved."[53] Bernardine of Siena was even more emphatic: "Listen: each time you come together in a way where you cannot generate, each time is a mortal sin. . . . Each time that you have joined yourselves in a way that you cannot give birth and generate children, there has always been sin. How big a sin? Oh, a very great sin! Oh, a very great sort of sin!"[54]

How far the Church's injunctions about the procreative purpose of intercourse were followed is conjectural. Very pious persons seem to have attempted to obey them. Marguerite of

Provence, consort of Louis IX of France (Saint Louis), told her confessor, William of Saint Pathus, that the king often avoided looking at her, explaining that a man should not look on that which he could not possess. To impress the reader of his *Life of St. Louis* with the king's saintliness, William wrote that he did not consummate the marriage until he had spent three nights praying, and that he remained continent during Advent and Lent, on Thursdays and Saturdays, on the eves of great festivals, and on the festivals themselves, and finally on the days before and after he received communion.[55]

Similarly we are told that when Hedwig, wife of the Duke of Silesia, found she was pregnant, she "avoided her husband's proximity, and firmly denied herself all intercourse until the time of her confinement." Hedwig maintained this scrupulous pattern through the births of three sons and three daughters, after which, apparently with her husband's agreement, she "altogether embraced a life of chastity." She was rewarded with sainthood.[56]

Ordinary people doubtless committed many sexual sins, both venial and mortal. The acts for which the monks demanded penances must have been common, or they would not have been listed in the manuals. Like all epochs, the Middle Ages had to come to terms with human sexuality, and in so doing invented very little and discarded very little.

As from time immemorial, prostitution flourished. By the high Middle Ages it was widely regulated by law, especially in the cities and at markets and fairs, which offered serving girls, tradeswomen, and peasants' daughters an opportunity to earn extra cash. In many places distinctive dress—hoods or armbands—was prescribed, or prostitutes were forbidden to wear jewelry or certain finery. Some towns, like Bristol, banned prostitutes along with lepers from inside the city walls; more, like London, confined them to certain streets. In Paris, where

they are said to have formed their own guild, with Mary Magdalene as patron saint, they were especially numerous in the Latin Quarter, where their brothels commingled with the scattered classrooms and residences of the University, and scholarly disputations on the upper floor competed with arguments among harlots, pimps, and customers below. Famous Paris preacher Jacques de Vitry complained that the girls solicited clergymen on the street and derisively cried, "Sodomite!" after those who hastened past. [57]

Like all established authority, the Church disapproved of prostitution in principle and tolerated it in practice, even protecting the prostitute's right to collect her fee. The prostitute was seen as behaving in accordance with weak female character; consequently heavier penalties were imposed on customers, pimps, and brothelkeepers. Prostitutes were essentially regarded as beneath the law's contempt, a condition inherited from Roman times. They could not inherit property, make legal accusations, or answer charges in person, but they were left unmolested in practicing their profession.

The Middle Ages brought one rather spectacular advance, when eleventh-century Byzantine emperor Michael IV built in Constantinople "an edifice of enormous size and very great beauty" (according to chronicler Michael Psellus). The emperor issued a proclamation that prostitutes might there adopt nuns' habits "and all fear of poverty would be banished from their lives forever. . . . Thereupon a great swarm of prostitutes descended upon this refuge . . . and changed both their garments and their manner of life." [58] Michael's example was imitated in the West, from the twelfth century on. In 1227 Pope Gregory IX gave his blessing to the Order of Saint Mary Magdalene, which established convents in several cities. The nuns wore white and were known as the "White Ladies." Louis IX, after a vain effort to abolish prostitution, endowed similar establishments.

An alternative for prostitutes who wished to reform was marriage. The early Church discouraged such marriages, but the twelfth-century canonist Gratian decreed that while a man might not marry a whore who continued her trade, he could marry her to reform her.

That medieval women in their varied social circumstances resented and resisted male misogyny is suggested by Chaucer's independent-spirited Wife of Bath, whose fifth husband amused himself in the evening by reading to her from the "book of wicked wives." First he read her of Eve

> whose wickedness
> Brought all mankind to sorrow and distress,
> Root-cause why Jesus Christ Himself was slain
> And gave His blood to buy us back again.

Next he read her about Samson and his betrayal by Delilah; then of Hercules and Deianira—"She tricked him into setting himself on fire"—; of Socrates's wives, how

> Xantippe poured a piss-pot on his head.
> The silly man sat still as he were dead,
> Wiping his head, but dared no more complain
> Than say, "Ere thunder stops, down comes the rain."

Next of Pasiphae, Queen of Crete, and her "horrible lust"; then

> of Clytemnestra's lechery
> And how she made her husband die by treachery.
> He read that story with great devotion.

Then of Amphiarus, whose wife, Eriphyle, betrayed him to the Greeks; of Livia and Lucillia, who poisoned their husbands;

> Of wives of later date he also read,
> How some had killed their husbands when in bed,
> Then night-long with their lechers played the whore,
> While the poor corpse lay fresh upon the floor. . . .
> He spoke more harm of us than heart can think . . .

The Wife stood it as long as she could, but finally

> When I saw that he would never stop
> Reading this cursed book, all night no doubt,
> I suddenly grabbed and tore three pages out
> Where he was reading, at the very place,
> And fisted such a buffet in his face
> That backwards down into our fire he fell.

The Wife received a blow on the head in return, and "We had a mort of trouble and heavy weather," but in the end they made up, her husband gave her "the government of the house and land," told her to do as she pleased for the rest of her life, and burned the book. And the Wife concludes triumphantly: "From that day forward there was no debate."[59]

PART TWO

THE WOMEN

5

An Abbess:
Hildegarde of Bingen

In 1098 a girl named Hildegarde was born in the Rhineland village of Böckelheim, on the river Nahe near Sponheim. Though her surname is unknown, her parents were well-to-do landowners. Hildegarde was frequently ill and subject to troubling visions in which she saw lights like shimmering flames and circling stars. These visions may have influenced her mother and father in enrolling the child at seven as a novice in a convent at Disibodenberg. Her biographer explains simply that Hildegarde was her parents' tenth child, and in consecrating her to God they were tithing.

A four-hundred-year-old Benedictine abbey dedicated to an Irish bishop who had helped introduce Christianity to the region, Disibodenberg had only recently added a community of women under the rule of Jutta, the sister of the local count. Jutta took personal charge of Hildegarde's education, not only teaching her the scripture, service books, and music that every novice studied, but also giving her a competence in Latin beyond that of most nuns. Hildegarde's own inquiring mind inspired her to read widely. When she was fourteen, she made her profession.

The social class of both Hildegarde and Jutta was typical of medieval nuns, who were recruited almost entirely from the aristocracy, though the later Middle Ages added women from the country gentry and the upper bourgeoisie. Peasant girls and craftsmen's daughters rarely became nuns, serfs' daughters almost never (though on paying a fine to his lord, a serf could send his son to school to become a priest). But the chief barrier in admission to a nunnery was money rather than class. Although canon law and monastic rule strictly condemned accepting fees from postulants, nunneries from earliest times evaded the ruling by requiring parents to provide girls with dowries of lands, rents, or cash, sometimes even clothes and furniture.

For upper-class women, the convent filled several basic needs. It provided an alternative to marriage by receiving girls whose families were unable to find them husbands. It provided an outlet for nonconformists, women who did not wish to marry because they felt a religious vocation, because marriage was repugnant, or because they saw in the convent a mode of life in which they could perform and perhaps distinguish themselves. The nunnery was a refuge of female intellectuals, as the monastery was for male. Although the majority of nuns were at best literate, most of the learned women of the Middle Ages—the literary, artistic, scientific, and philosophical stars—were nuns. This tradition was especially strong in Hildegarde's Germany.

In contrast to a later day, medieval monasticism was overwhelmingly male. Early thirteenth-century England supported over six hundred Augustinian and Benedictine houses for men, with a population estimated at fourteen thousand, but only a hundred and forty houses for about three thousand women. Further, the male monasteries (the terms *monastery* and *convent* are properly used interchangeably) were nearly always larger and better endowed. Many nunneries existed on the edge of penury.

Female monasticism was a poor relation partly because of the Church's conservatism toward women, partly because of the limited role of nuns in medieval society. In contrast to the extensive social services—teaching, nursing, welfare work—of modern nuns, the medieval sisterhoods existed mainly as refuges of worship and prayer. Many nunneries took a few boarders and pupils; but teaching was scarcely a function. Philanthropy was; but here the nuns' activities were circumscribed by the Church's views of the weakness and vulnerability of women. However, although nursing was never a major activity of medieval nuns, a handful pioneered in caring for elderly and indigent patients in the hospitals that were themselves an invention of the Middle Ages.

On the other hand, nuns were entirely excluded from the priestly duties performed by the male monasteries for outsiders. They could not celebrate mass even for their own communities, or hear their own confessions, but had to employ priests to perform these offices.

By Hildegarde's time, their disabilities had survived five hundred years of female monasticism, dating from the foundation in 512 of a convent by Bishop Caesarius of Arles. This convent was headed by the bishop's sister, Caesaria, and its Rule, composed by Caesarius, actually antedated the famous Rule of Saint Benedict of Nursia. Other settlements followed in central and northern France, in Flanders, Italy, England, and Germany, many founded by queens and ruled by abbesses of royal blood, who wielded notable power and influence. The apogee of authority was reached in the tenth and eleventh centuries by the abbesses of royal nunneries in Saxony who reigned over vast tracts of land; as barons of the king they summoned their own armed knights to war, and they held their own courts. The abbesses of Quedlinburg and Gandersheim struck their own coins. Royal abbesses were even called to the Imperial Diet, though whether they ever attended in person is not

certain—if they did it was a noteworthy exception to the exclusion of women from political councils. In the later Middle Ages we know only of their male representatives attending. Sometimes these abbesses took an active part in politics, like German emperor Otto III's aunt, Matilda, abbess of Quedlinburg, who served unofficially as regent.

In the early years, settlements existed independently, with the founder determining the mode of life. But gradually the Benedictine Rule spread northward from Italy, and convents adopted its provisions for government, material arrangements, and spiritual activities, along with its vows of poverty, chastity, and obedience.

Seventh-century England pioneered the double monastery, with communities of both monks and nuns. The superior was invariably a woman, leading to modern speculation that the house was essentially a nunnery, and that the male element was present to perform male services—manual labor, the celebration of mass, and hearing confessions. Most famous of these double monasteries was Whitby, founded by a Northumbrian princess named Hilda and known for its educational work, training, during Hilda's lifetime, no fewer than five bishops.

Germany's tradition of intellectual nuns began with Lioba, a nun of a double monastery at Wimbourne who traveled as a missionary to Germany in the eighth century and became Abbess of Bischofsheim. According to her biographer, Lioba, who was "as beautiful as an angel... never laid aside her book except to pray or to strengthen her slight frame with food and sleep. From childhood upwards she had studied grammar and the other liberal arts.... She zealously read the books of the Old and New Testaments and committed their divine precepts to memory; but she further added to the rich store of her knowledge by reading the writings of the holy Fathers, the canonical decrees, and the laws of the Church."[1] During her noonday

rest, novices read the Latin scriptures to the abbess, who corrected their mispronunciations.

Lioba's most illustrious successor among many Saxon nuns distinguished for their intellectual accomplishments was Hroswitha of Gandersheim (tenth century), whose writings included legends and contemporary history in verse form as well as six short plays written in imitation of Terence—the first medieval drama, anticipating by two centuries the historic revival of the theater that took place in the late Middle Ages. Hroswitha explained in the prefaces to her plays that "it often brought a blush to my cheek" as she adapted the pagan Roman's treatment of "the shameless acts of licentious women... to glorify... the laudable chastity of Christian virgins."[2]

In her drama *Dulcetius*, three Christian maidens are brought before the Emperor Diocletian and commanded to abjure their religion. When they refuse, they are handed over to Dulcetius, a Roman general, for execution. Infatuated with their beauty, Dulcetius imprisons them in a room next to the kitchen, intending to ravish them. When he tries to enter the room at night, however, a spell overcomes him and he loses his way. Befuddled, he begins to caress the pots and pans, while the girls watch through a crack in the wall. "Why, the fool is out of his mind, he fancies he has got hold of us," reports one of them. "Now he presses the kettle to his heart, now he clasps the pots and pans and presses his lips to them.... His face, his hands, his clothes are all black and sooty; the soot which clings to him makes him look like an Ethiopian." One of her companions comments, "Very fitting that he should be so in body, since the devil has possession of his mind."

The spell broken, angry Dulcetius orders the maidens to be exposed naked in the marketplace; but their garments magically cling to their limbs, while Dulcetius himself suddenly falls into a deep slumber. The emperor then turns the maidens over to

another official, Sisinnius, who also finds himself prey to delusions. Finally two of the maidens are burned at the stake, the third shot to death with arrows. Their souls rise to heaven, while the Roman soldiers exclaim, "Oh, most wonderful! Their spirits have left their bodies, but there is no sign of any hurt!"[3]

Only ruins remain of Disibodenberg, but it is not difficult to recreate the scene where Hildegarde spent twenty-four years as a nun under the rule of Abbess Jutta. Medieval monasteries conformed closely to a common pattern. A high wall enclosed a large tract of land containing gardens, orchards, a fish pond, and wooden outbuildings—stables, granary, bakery, brewery, mill, dovecote—clustered around the main buildings and their courts: church and cloister; infirmary; refectory or frater with adjoining kitchen; dorter where the nuns slept; chapter house where they held meetings; sometimes a guest house; and the abbess's quarters. Outside the refectory were lavers, long shallow troughs with pipes and taps for washing. Sometimes sanitary arrangements were more elaborate; the Abbess Euphemia, who ruled the Benedictine abbey of Wherwell, in England, from 1226 to 1257, "with material piety and careful forethought built, for the use of both sick and sound, a new and large infirmary away from the main buildings, and in conjunction with it a dormitory with the necessary offices. Beneath the infirmary she constructed a watercourse, through which a stream flowed with sufficient force to carry off all refuse that might corrupt the air."[4]

Over the community presided the superior—the abbess, or in lesser houses the prioress—whose chief concern was maintaining the discipline of the monastery. In the twelfth century, no longer a queen, the superior was still a woman of status, usually elected by the community, and confirmed by the bishop. Office was for life, unless she resigned or was removed for incompetence or misbehavior.

Officers of a nunnery. Top row, at right chaplains preside at the altar; behind them, the sacristan pulls the bell rope; next, the abbess with her crozier and the cellaress with her keys. Bottom row, nuns in procession.
British Library, MS Add. 39843, f. 6v.

Under the superior, and in charge of the daily routine, management of properties, household accounts, and staff of servants, were officials known as obedientiaries, chosen from among the older members of the community. On the executive level, there might be a prioress, a subprioress, and a treasuress, while a variety of specialized functions were performed by other obedientiaries. A chantress managed the church services. A sacrist cared for vestments, altar cloths, and sacred vessels; bought wax, tallow, and wicks; and hired candlemakers. A fratress provided and repaired chairs and tables, cloths, and dishes; oversaw the setting of the tables; and kept the lavers clean. An almoness took charge of almsgiving. A chambress ordered the making, repairing, cleaning, and preserving of clothing and bedding. A cellaress had charge of the food and often managed the home farm. A kitcheness superintended the cooking, under the direction of the cellaress. An infirmaress had charge of the sick. The novice mistress supervised and instructed the novices. In small communities, officials often doubled up; in larger ones, they had assistants.

Nunneries had at least one chaplain, who lodged outside the cloister, and who said masses and heard confessions. Sometimes he also managed the convent's financial affairs. If the house was in difficulties, the bishop might appoint a male *custos*, or call on the monks of a neighboring house to help.

The daily routine in every Benedictine monastery, whether for men or women, was strictly apportioned among prayer, work, and study. Prayer, at intervals of three hours, gave shape to the day. The nuns rose at six or seven, depending on the season, to say Prime which, like the other offices, consisted of a succession of psalms, short prayers, and responses. After a breakfast of bread washed down with wine, beer, or water, the community assembled in the chapter house, on the east side of the cloister, for a business meeting, discussing rents and leases, sales of land or wood, and grants. Approved documents were

sealed with the convent's seal. Then moral and spiritual questions were taken up. Wrongdoers confessed, or were accused, and a penance or "discipline" was administered, often with the rod.

A fifteenth-century German bishop, Johann Busch, recorded his visitation to the convent of Dorstadt, where two of the youngest nuns, about ten years old, were chosen for their strong arms to administer the discipline. The bishop suggested to one elderly nun undergoing chastisement that she should tell the girl she had had enough, but was informed, "When I do that, she hits me all the more. And I dare not say anything to her on account of the prioress's presence, but I think to myself, I must bear these blows on account of my sins. . . ." She added, "Before her profession I used to teach her and often beat her with a rod; now she pays me back. . . ."[5]

At midday, the nuns trooped to the refectory, where one of them read from the Scriptures or the Church Fathers as the others dined on vegetables, bread, fruit, and sometimes fish. Meat was served only in the infirmary, a dispensation, however, that admitted of abuse. Fish was sometimes fresh, from the convent fishpond, or from streams running through manors where the convent had fishing rights; sometimes it was dried or salted herring and cod from the sea. On the numerous fast days, a solitary meal might consist of bread, water, and vegetables, but in compensation Christmas, Easter, and other holidays brought "pittances" or extra allowances, often provided by benefactors in their wills.

The hours after dinner were designated for work. "Idleness is the enemy of the soul," Saint Benedict wrote in prescribing six hours' labor a day,[6] originally performed in the fields, at spinning wheel and loom, or at household tasks. In the sixth century, Queen Radegund at Ste. Croix in Poitiers took out garbage, carried water and firewood, stoked the fire, swept, cooked, cleaned, and washed dishes. But the aristocratic ladies of the

Nuns in choir, Franciscan Poor Clares, from a fifteenth-century psalter. *British Library, MS Cott. Dom. A XVII, f. 74v.*

high Middle Ages shirked such chores. Nearly all convents em-
ployed cooks, maids, and laborers, and a large establishment
typically had butler, brewer, baker, maltster, dairy woman,
housekeeper, laundress, even private servants for individual
nuns. The Benedictine labors of the nuns themselves were lim-
ited to such pursuits as embroidery. In a few houses, especially in
Germany, they copied manuscripts.

At the end of the working day, the nuns supped, again ac-
companied by reading aloud, and after a concluding service of
Compline, they retired to the dorter, where they slept, fully
dressed, in cubicles separated by low partitions. In convents
where discipline was strict, beds were straw pallets, with a pillow
and two blankets. As in the monasteries, the night was
punctuated by prayer—the midnight Matins, Lauds at 3 A.M.,
and at dawn Prime and another day.

Except for the canonical services, the meeting of the chapter,
and special periods of relaxation, the twenty-four-hour routine
was supposed to be accomplished in strict silence, with neces-
sary instructions given in abbreviated form or in sign language.

Two rules were fundamental to Benedictine practice, com-
munal life and poverty. Everything was to be done in commu-
nity: prayer, work, meals, sleep. Nuns were forbidden all private
possessions, money, property, furniture, jewels. Their clothes
were supposed to be provided from the common store of the
house, and when new garments were issued, the old ones were
returned.

In practice the longing for privacy and passion for ownership
continually asserted themselves. The bishops' visits of inspec-
tion record endless infractions of the rule of community and
poverty. In 1257 the nuns of Montivilliers, a large abbey near
Rouen, begged Archbishop Eudes Rigaud to permit them keys
to lock the chests in which they kept their small possessions.
Rigaud refused, but they evidently ignored his injunction, be-
cause in 1262 he ordered them to give up their keys, threatening

severe punishment, "for... when the abbess asked them for their keys certain of them would not give the keys up for two or three days, until they had gone through their things and taken away those which they did not want the abbess to see...."[7] Year after year the archbishop commanded the superiors of convents to inspect the nuns' boxes, often and without warning, and to remove private property.

At another convent the archbishop noted that the nuns owned pots and pans and necklaces. At still another they kept their own chickens and quarreled over them; the archbishop ruled that the fowl should be kept in common, the eggs divided among the nuns, and the chickens given to the sick to eat—but the nuns continued to keep their own hens and to bicker about the eggs. Less petty problems arose when wealthy nuns retained lands and income for their own use, rather than turning them over to the community. Others kept gifts or the profits from the sale of needlework.

Community was as difficult to enforce as poverty; in 1255 Rigaud described the nuns at Almenèches as having "chambers with [full] partitions in the dorter," private maids, and their own dishes at table.[8] Five years later he reported, "The frater was often left empty because they did not eat together there, but ate meat in cliques by twos and threes in their chambers."[9] In many of the convents under his jurisdiction, the nuns had separate food allowances and had their food cooked separately.

Another aspect of women's monasticism that presented problems of enforcement was claustration, considered particularly important because of women's famous susceptibility to temptation. Involvement with the world was an evil and threatened scandal besides. Again and again decrees were passed and reforms instituted to enforce strict enclosure, but operating against these commands were the need to provide an income for the community and to purchase and purvey for it, as well as ties with family and friends.

Though a self-contained community dedicated to prayer and worship, the convent had unavoidable links to the world outside. Some were social, as the superior's entertainment of local magnates, or the reception of guests, boarders, and pupils. Some were economic, for every monastery, however small and poor, was a landlord and an employer of labor: plowmen, cowherds, oxherds, shepherds, carters, general laborers. Manors with which convents were endowed provided income in rents or profits. Convents in urban areas sometimes had the rents of whole blocks of houses. Finally, in their role as manorial lords, all monasteries had the proceeds from justice—fines, fees, and forfeitures.

All these secular activities complicated the enforcement of claustration, of which two kinds were recognized, active and passive. Active claustration forbade nuns to leave their convent except for a difficult-to-define "manifest necessity." Passive claustration forbade all outsiders from entering the precincts of the community.

Decrees and bishops' injunctions to the contrary, nuns found many excuses for leaving their convents. Business trips to the city or to fairs to buy supplies that could not be grown on the home farm, such as salt and fish, pots, nails, soap, parchment, and spices, were generally countenanced. Despite Chaucer, pilgrimage was frowned on, because, in the words of Jacques de Vitry, "pilgrims... weary of wayfaring, drink themselves tipsy.... You will find many harlots and evil women in the inns, who lie in wait for the incautious and reward their guests with evil...."[10] Equally inappropriate for nuns were their relatives' or friends' weddings and christenings, notorious for dancing and other revelry.

The world in turn managed to penetrate the convent. Dorter, refectory, infirmary, chapter, and cloister were theoretically off limits to visitors, whose stay was restricted to daylight hours, and governed by rules about conversations. Such rules were more

difficult to enforce than those covering correspondence. Financial need drove convents to take in pupils and other boarders, bringing fresh altercations with Church authority. In 1255 Archbishop Rigaud ordered the prioress and subprioress of Bondeville to send home three little girls, two their own kin. A decade later he ordered "Basiria, daughter of Amelina of Aulnay, who was there as a boarder, to be sent away, and forbade the Prioress henceforth to keep any girl or girls there, except such as had been received as novices."[11] Friends and relatives of the nuns were ordered not to enter the house, and servants and other laywomen not to sleep in the dorter.

Infractions of the vow of chastity in nunneries, much aired by militant or malicious Protestant writers, occurred and were noted in the records of the bishops' visitations, but such lapses were surprisingly rare.

Such was the setting in which Hildegarde of Bingen lived and the routine she followed until she was thirty-eight, when she succeeded Jutta as abbess, an indication that she was one of the leading spirits of the convent. In accordance with convention, she accepted her election only at the entreaties of her sisters and the commands of the abbot of the male community of Disibodenberg, though probably not carrying her reluctance to the point of one English superior who was borne "weeping, resisting as much as she could, and expostulating in a high voice, to the church."[12]

Not long after the new abbess entered upon office in 1136, she began to record the visions that had haunted her for years. "A great flash of light from heaven pierced my brain," she wrote, "and made my heart and my whole breast glow without burning them, as the sun warms the object that it envelops with its rays. In that instant my mind was imbued with the meaning of the sacred books, the Psalter, the Gospel, and the other books of the Old and New Testament."[13]

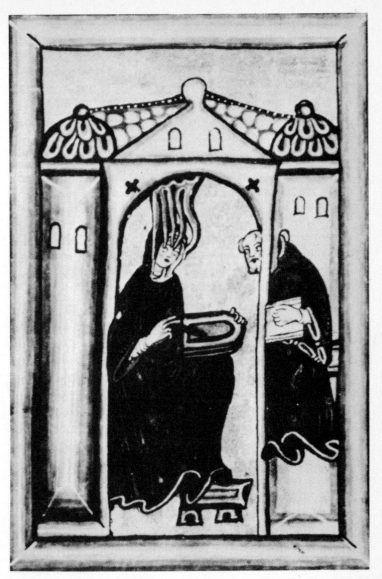

Hildegarde of Bingen receiving a vision in the form of "a great flash of light from heaven," prepares to record her revelations on a wax tablet with a stylus, while a monk waits to make a parchment copy. From a contemporary manuscript of *Scivias. Hessische Landesbibliothek, Wiesbaden Codex B, f. 1.*

A voice accompanying the vision commanded Hildegarde to write down what she saw, but for a time she resisted, afraid to obey. "God punished me for a time by laying me on a bed of sickness so that the blood was dried in my veins, the moisture in my flesh, and the marrow in my bones, as though the spirit were about to depart from my body," she wrote later.

> In this affliction I lay thirty days while my body burned as with fever.... And throughout those days I watched a procession of angels innumerable who fought with Michael and against the dragon and won the victory.... And one of them called out to me, "Eagle! Eagle! why sleepest thou?... Arise! for it is dawn, and eat and drink."... Instantly my body and my senses came back into the world; and seeing this, my daughters who were weeping around me lifted me from the ground and placed me on my bed, and thus I began to get back my strength.[14]

The book that Hildegarde began to write at the divine command, *Scivias (Scito vias Domini*—Know the Ways of the Lord), her principal work, took ten years to finish. During that time, in 1147, she decided to quit Disibodenberg and lead eighteen of her nuns to found a new convent at Rupertsberg, where a bridge spanning the Nahe connected the community with the important town of Bingen across the river. The new monastery was built near the ruins of the castle of the Dukes of Bingen, one of whom, buried on the site, had become Saint Rupert. Eventually the community comprised fifty nuns and seven poor women, and was ministered to by two chaplains.

Scivias, like Hildegarde's *Liber divinorum operum* (Book of Divine Works), written two decades later, belonged to a medieval genre that combined science, theology, and philosophy in a description of the universe, internal (the human body) and external (the earth and the heavens). It dealt with nature, human physiology, the moral world, the cosmos, the soul, all woven into one whole. This idea of a harmonious and ordered pattern of the universe was typically medieval, like the intellectual fas-

cination with numbers, music, and the stars, all helping to explain, in the words of Boethius, "nature's secret causes."[15]

Although expressed in terms of vision and revelation, Hildegarde's ideas unmistakably indicate a familiarity with the works not only of Saint Augustine and Boethius, but of contemporary scientific writers. In a world-view tinged with premonitions of Dante, she pictured the earth as a sphere (the Middle Ages was well aware that it was not flat), its interior containing two great cone-shaped spaces where punishment was administered and from which evil things issued. Itself composed of the commonly accepted four elements—earth, water, air, and fire—the globe was surrounded by four concentric layers of atmosphere, the innermost spherical, the middle two oval, the outermost egg-shaped and consisting of masses of flames; in this outer zone were the sun and the three outer planets, and from here the hot south wind blew. The other zones revolved around each other, propelled by the winds in each zone, carrying the heavenly bodies with them, their movements explaining the seasons and the variations in the length of days.

These manifestations of the outer universe, the macrocosm, were related to those of the inner universe, the body of man himself, the microcosm, in a system which, according to science historian Charles Singer, "held in the Middle Ages, during the Renaissance, and even into quite modern times a position comparable to that of the theory of evolution in our own age.... It gave a meaning to the facts of nature and a formula to the naturalist, it unified philosophic systems...."[16]

Hildegarde's *Liber divinorum operum* opened with a vision of the spirit of the macrocosm, as a man with a face "of such beauty and brightness that it had been easier to gaze upon the sun," a golden circlet on his head, on his shoulders great pinions; on one wing was an eagle's head with eyes of flame, representing the power of divine grace, on the other a man's head from which the light of the stars radiated, representing the

powers of natural man. In its hands the figure held the lamb of God; beneath its feet was a "horrible black venomous monster of revolting shape, upon the right ear of which a writhing serpent fixed itself," a symbol of brute matter.[17] The image spoke in arresting and poetic language:

> I am that supreme and fiery force that sends forth all living sparks. Death hath no part in me, yet I bestow death, wherefore I am girt about with wisdom as with wings. I am that living and fiery essence of the divine substance that glows in the beauty of the fields, and in the shining water, and in the burning sun and the moon and the stars, and in the force of the invisible wind, the breath of all living things. I breathe in the green grass and in the flowers, and in the living waters.... All these live and do not die because I am in them.... I am the source of the thundered word by which all creatures were made, I permeate all things that they may not die. I am life.[18]

In a second vision, Hildegarde described a disk somewhat like the one in *Scivias*, with lines of influence descending from each of its components, stars, planets, winds, to the eagle-winged figure of the macrocosm. She then introduced the microcosm, the human body: "And again I heard the voice from heaven saying to me, 'God, who created all things, made also man in his own image and similitude, and in him he traced all created things, superior and inferior, and he had such delight in him that he destined him for the place from which the fallen angels had been cast.'"[19] A third vision described the body, comparing its organs to the parts of the macrocosm and explaining the effects of heavenly bodies on the humors in man—elements which from ancient times into the modern era were believed to control bodily functions.

Hildegarde's picture of the process of generation evidently owed more to the Bible than to Aristotle (Job 10:10 "Hast thou not poured me out as milk, and curdled me like cheese? Thou hast clothed me with skin and flesh, and knit me together with

bones and sinews"), and consequently contains an interesting implication of a female contribution: "Those whom thou seest [in her vision] carrying milk in earthen vessels are in the world, men and women alike, having in their bodies the seed of mankind, from which are procreated the various kinds of human beings." Some were strong and wise, some "stupid, feeble, and useless," according to the nature of the seed. Sometimes the seed was corrupted by fluid contributed by the devil, and the offspring became "misshapen... bitter, distressed, and oppressed of heart, so that they may not lift their minds to higher things."[20] Then, "I saw the likeness of a woman having a complete human form within her womb. And behold, by a secret disposition of the Most High Craftsman, a fiery sphere... possessed the heart of that form, and touched the brain and transfused itself through all the members."[21] Thus the soul entered the body; at death it left through the mouth with the last breath, appearing as a naked human shape, to be received by either devils or angels.

Even before moving to Rupertsberg, Hildegarde had acquired a widening reputation as a sage and prophet. The abbot of Disibodenberg had taken the first chapters of *Scivias* to Mainz to show them to the archbishop. The book was still unfinished in 1147 when Pope Eugenius III and Saint Bernard met at a council at Trier, and parts of it were submitted to them. Despite the Church's skepticism of unauthorized mystics, in the early months of 1148 Eugenius wrote:

> We are filled with admiration, my daughter... for the new miracles that God has shown you in our time, filling you with his spirit so that you see, understand, and communicate many secret things. Reliable persons who have seen and heard you vouch to us for these facts. Guard and keep this grace that is in you....[22]

From Rupertsberg, Hildegarde's fame spread throughout Germany, into Flanders, France, Italy, England, and as far as

Hildegarde's view of the Universe (right): the earth, a sphere at the center, surrounded by four concentric layers of atmosphere, the middle two oval, the outermost egg-shaped and consisting of flames. *Wiesbaden Codex B. f 14r.* Choir of angels (below). *f. 38r.*

The soul enters the body before birth (left). F. 22r. The soul leaves the body at death, appearing as a naked human shape, to be received by either devils or angels (below). f. 25r.

Greece. Many important people, both clerical and lay, wrote to her, and soon she was conducting a busy correspondence that ultimately included four popes, two emperors, several kings and queens, dukes, counts, abbesses, the masters of the University of Paris, and prelates including Saint Bernard and Thomas à Becket. Her tone in correspondence was that of an equal, if not a superior. She solemnly warned Emperor Frederick Barbarossa, who had solicited her advice: "I see you in a mystical vision, surrounded by many storms and struggles. . . . Take care that the Highest King does not strike you down because of the blindness which prevents you from governing justly. See that God does not withdraw His grace from you."[23] She comforted celebrated divorcée Eleanor of Aquitaine, "Make peace with God and with men, and God will help you in your tribulations."[24] To Eleanor's new husband, Henry II of England, she wrote:

> The Lord says: "Great gifts have been given you in order that, governing, guarding, and protecting your kingdom and providing for its needs, you will achieve the kingdom of heaven." But a bird of ill omen appears from Hell and says to you: "You have the power to do anything you wish; then do this and that, thus and so; you need not pay attention to justice, for if you observe its precepts you are a slave and not a master!"[25]

In the course of her years at Rupertsberg, and in spite of recurring illness (and injunctions about claustration), Hildegarde traveled to Cologne, Trier, Würzburg, Frankfurt, Rothenburg, and into Flanders. Her final years at Rupertsberg were occupied in a struggle against the archbishop of Mainz over the burial of a young man who had been excommunicated, and whose absolution the archbishop declined to recognize. When Hildegarde refused to exhume the body, the convent was placed under interdict. The abbess, now eighty years old, traveled to Mainz to plead the case in person before clerical

tribunals, but without success; only the archbishop's death in battle two years later brought peace back to Rupertsberg.

"From my infancy," Hildegarde wrote in her last decade,

> up to the present time, when I am more than seventy years of age, I have always seen this light in my spirit.... The light which I see ... is more brilliant than the sun, ... and I name it the cloud of living light. And as the sun, moon, and stars are reflected in the water, so the scripture and sermons, and virtues, and works of men shine in it before me....
>
> But sometimes I see within this light another light which I call the Living Light itself.... And when I look upon it every sadness and pain is erased from my memory, so that I am once more as a simple maid and not as an old woman....[26]

Hildegarde died at Rupertsberg in 1179 and was buried before the altar of the church. Although she is often called "saint" and although miracles were claimed for her, she was never canonized; an extraordinary intelligence, a moving voice, and an ardent, noble spirit, she was adjudged by the Church short of sainthood.

Several other German nuns followed the path traced by Hildegarde as intellectual and mystic. Herrad of Landsberg, abbess of the Alsatian convent of Hohenberg, compiled and illustrated an encyclopedia, the *Hortus Deliciarum* (Garden of Delights), said to be one of the most beautiful of medieval manuscripts, destroyed in the German bombardment of Strasbourg in 1870. Elizabeth of Schönau, who corresponded with Hildegarde, recorded revelations in the form of admonitions to different classes of society urging them to renounce their pride and worldly pleasures and abandon their jealousy and quarrelsomeness.

The convent of Helfta, in Saxony, where the nuns occupied themselves as copyists as well as writers, produced three notable

mystics: Mechtild of Magdeburg, Mechtild of Hackeborn, and Gertrude the Great. "Of the heavenly things God has shown me," wrote Mechtild of Magdeburg, "I can speak but a little word, not more than a honey bee can carry away on its foot from an overflowing jar."[27] Despite her protests, she wrote lyric poetry of great beauty:

> I cannot dance, Oh Lord, unless Thou lead me.
> If Thou wilt that I leap joyfully
> Then must Thou Thyself first dance and sing!
> Then will I leap for love
> From love to knowledge,
> From knowledge to fruition,
> From fruition to beyond all human sense
> There will I remain and circle evermore.[28]

God addressed the soul:

> Thou art sweet as the grape;
> Fragrant as balsam;
> Bright as the sun—
> Thou art a heightening of My highest love![29]

and:

> O lovely rose on the thorn!
> O hovering bee in the honey!
> O pure dove in thy being!
> O glorious sun in thy shining!
> O full moon in thy course!
> From thee I will never turn away.[30]

Mechtild's picture of the soul at the Court of God has some of the suppressed eroticism found in the hymns and writings of nuns:

> My body is in long torment, my soul in high delight, for she has seen and embraced her Beloved. Through Him, alas for her! she suffers in torment. As He draws her to Himself, she gives herself to Him. She cannot hold back and so He takes her to Himself.

> Gladly would she speak but dares not. She is engulfed in the
> glorious Trinity in high union. He gives her a brief respite that
> she may long for Him. . . . He looks at her and draws her to Him
> with a greeting the body may not know. . . .[31]

The career of Hildegarde of Bingen coincided with the great
monastic revival of the eleventh and twelfth centuries, when
new orders, especially those of Cluny and Citeaux, enforced a
stricter discipline that soon affected the convents. The old dou-
ble monasteries were discouraged, and claustration was em-
phasized. Though the Church insisted that women's establish-
ments could not exist except as chapters of male orders, the
Cluniacs and Cistercians feared that sister communities of
women might imperil their own chastity. "To be always with a
woman and not to have intercourse with her," tersely com-
mented the Cistercian Bernard of Clairvaux, "is more difficult
than to raise the dead. You cannot do the less difficult; do you
think I will believe that you can do what is more difficult?"[32]

In the twelfth century three new "combined orders" at-
tempted a fresh version of the double monastery: the Pre-
monstratensians and the order of Fontevrault in France, and the
Gilbertines in England. After the death of their founder in
1134, the Premonstratensians expelled women from all their
mixed settlements.

> We and our whole community of canons, [wrote one abbot,]
> recognizing that the wickedness of women is greater than all the
> other wickedness of the world, and that there is no anger like that
> of women, and that the poison of asps and dragons is more
> curable and less dangerous to men than the familiarity of
> women, have unanimously decreed for the safety of our souls, no
> less than for that of our bodies and goods, that we will on no
> account receive any more sisters to the increase of our perdition,
> but will avoid them like poisonous animals.[33]

Fontevrault, established to attract poor women as well as those
of gentle birth, soon became exclusively aristocratic, but sur-

vived, as did the order of Saint Gilbert of Sempringham, founded in the north of England about 1135.

The new "mendicant" orders founded by Saint Dominic and Saint Francis in the thirteenth century stirred enthusiastic response among women, but were slow to incorporate women's communities, evidently fearing not only the threat to their chastity but also that the assumption of the nuns' pastoral care and financial problems would draw them away from their chief task of preaching. Saint Francis himself objected to calling the Poor Clares "sisters" of the Franciscans—"God has taken away our wives, and now the devil gives us sisters"[34] —and when Cardinal Ugolino decided that the friars should be responsible for the Clares, Saint Francis commented, "Up to now the disease was in our flesh and there was hope of healing but now it has penetrated our bones and is incurable,"[35] and succeeded in getting the decision revoked. Backed by the pope, the women's communities continued to struggle for acceptance, and overcoming the friars' opposition, won inclusion in both the Dominican and Franciscan orders.

Yet the overall trend in the age of monastic reform was a decline in the power and importance of women. Gone were the days of the great abbeys of women—Saxon, Frankish, English—headed by queens and princesses, powerful and independent. Most of the nunneries founded in England after the Norman Conquest were priories rather than abbacies; the prioress, below the abbess in rank, was usually subject to an abbot. Some priories were direct dependencies of male abbeys.

Here and there extraordinary abbesses still wielded genuine power. The head of the Cistercian convent at Las Huelgas, in Castile, held her own general chapter, attended by six abbots, three bishops, and seven abbesses, and in 1210 actually assumed the functions of a priest. In 1260 the proud lady who occupied this office refused to receive the abbot of the mother house of Citeaux, and was excommunicated.

Another powerful abbess was the superior of the ancient abbey of Notre-Dame-aux-Nonnains in Troyes, who had extraordinary immunities and privileges dating back to the house's fourth-century beginnings. When a new bishop was installed in the cathedral of Troyes, he was required to travel in procession to the abbey, mounted on a palfrey. The abbess met him at the door, he dismounted, and an abbey servant seized the horse's bridle and led it away, to become the property of the abbess. She then escorted the prelate into the convent, where he knelt, and while the abbess vested him with cope and miter and placed the cross in his hands, he swore to observe the rights and privileges of the convent. The ceremony completed, the bishop was escorted by the abbess to a room where he spent the night—the bed and all its furnishings to become his, as his horse had become the abbess's. The following morning he was carried enthroned to the cathedral for his installment.

In 1266, the abbess of Notre-Dame-aux-Nonnains, Odette de Pougy, dared to resist a project of Pope Urban IV. The Pope was the son of a shoemaker of Troyes, and wanted to build a church where his father's shop had stood. Odette opposed this plan because the site impinged on the abbey's property and went so far as to lead an armed party that drove off the workmen and demolished the work. Two years later the same abbess led a second demonstration that brought excommunication to her whole convent. The sentence remained in force for fourteen years, but formidable Odette never wavered, and the new church, St. Urbain, was not built until long after her death.

By the high Middle Ages the range of life-styles in nunneries was nearly as wide as that in the secular world. Saint Clare's Franciscan community at San Damiano was small and poor; the sisters lived by alms and the labors of their own hands, spinning, making altar linen, and cultivating a vegetable garden. Clare herself slept on vine twigs with a stone for a pillow,

went without food three days a week, and wore a boar's hide shirt next to her skin. The rule of the "Poor Clares" imposed strict claustration, perpetual silence, and continuous fasting. Clare demanded and obtained for San Damiano a special "Privilege of Poverty," the right to own nothing at all, and her nunnery was, at her insistence, without endowment.

In contrast were such establishments as the Dominican abbey of Poissy, where Christine de Pisan visited her daughter in 1400 and memorialized the occasion in a poem. At Poissy, two hundred nuns, all of noble birth and nominated by the king, were governed by Prioress Marie de Bourbon, aunt of Charles VI. In the prioress's lodging, hung with splendid Arras tapestries, Christine's party, seated at a table covered with fine white linen, was served wines and meats in gold and silver vessels. The carved pillars of the vaulted cloister encircled a lawn with a

Nun confessing. *British Library, Hours, MS Stowe 17, f. 191.*

tall pine in the middle. The magnificent church contained hangings, paintings, statuary, and golden ornaments. Gardens, fishponds, and orchards supplied the refectory, which had the unusual luxury of glass windows. At the end of the visit, the nuns presented their guests with belts and purses embroidered with silk and gold thread.

Besides the nuns in the regular monastic establishments, women committed their lives to religion in a number of other ways, both in communities and individually. Canonesses lived in religious communities under a rule of celibacy and obedience but not poverty, and without strict claustration. They received guests, came and went with permission from their superiors, owned property, and had servants, though they lived a communal life and took part in the daily round of services.

Still less strict were the beguines, a semi-conventual movement originating in the diocese of Liège at the end of the twelfth century. The beguines divided their time between prayer and work, and kept vows of chastity and obedience as long as they remained in the sisterhood, but could leave when they wished and could marry without disgrace. Essentially urban, the beguine movement throve in Flanders, France, and Germany in the thirteenth century; English chronicler Matthew Paris reported that there were two thousand beguines in the region of Cologne in 1243. Preacher Jacques de Vitry praised and defended these *mulieres sanctae* (holy women). Robert Grosseteste, bishop of Lincoln, held them up to the Franciscans as an example; begging for alms, by which the Franciscans lived, was a high kind of poverty, but a higher kind was to live by one's own labor "like the beguines," who did not burden the world with their demands.[36]

But as time went on this order that was not an order, existing independently of male monasticism and fitting no regular category, met with increasing suspicion from the Church. The bishop of Olmütz wrote the pope in 1273 complaining about

the beguines and recommending, "I would have them married or thrust into an approved order."[37] A Church council at Vienne in 1312 finally condemned them:

> Since these women promise no obedience to anyone and do not renounce their property or profess an approved Rule, they are certainly not "religious," although they wear a habit and are associated with such religious orders as they find congenial. . . . We have therefore decided and decreed with the approval of the Council that their way of life is to be permanently forbidden and altogether excluded from the Church of God.

In 1318 the archbishop of Cologne ordered beguine associations dissolved and integrated into orders approved by the pope, and in subsequent years the beguines were gradually absorbed into established convents.

Other women committed themselves to living out their lives as anchoresses enclosed in cells attached to churches, monasteries, convents, sometimes even castles. The anchoresses were consigned to their cells with the saying of a mass—usually, as with lepers shut up in their colonies, that of the Dead; holy water was sprinkled in the cell, the recluse prostrated herself on a bier, earth was scattered over her, and the officiating priest left the cell with the instructions, "Let them block up the entrance to the house." The cells were usually composed of more than one room, and often two or more anchoresses lived in adjacent cells, with servants to provide them with food and other necessities. The recluses' time was spent in prayer, and sometimes in work such as embroidery; often they were consulted as wise women and spiritual advisers.

Still other medieval women undertook a religious life but became neither members of communities nor recluses. The celebrated English mystic Margery Kempe, author of the first biography, and first autobiography, in English, decided to separate from her husband and "live chaste" but had difficulty persuading him to agree. On Midsummer Eve, as they returned to

their home in Norwich from York, she "carrying a bottle with beer in her hand, and her husband a cake in his bosom," they sat down at a roadside cross and came to an agreement: he would "make her body free to God," and she would give up fasting and join him in eating and drinking. So, kneeling under the cross, they said three paternosters together, then sat down and ate and drank "in great gladness of spirit."[39]

Margery soon donned white garments and departed for the Holy Land. There she began a career of loud lamentation "as though she had seen Our Lord with her bodily eye, suffering His Passion." At Calvary she "fell down and cried with a great voice . . . she wept, she sobbed, she cried so loud that it was a wonder to hear it"; at Bethlehem she made such a noise that fellow pilgrims would not let her eat with them, saying that she had an evil spirit, that she was drunk, or had the "falling evil"; some wished her "on the sea in a bottomless boat."[40]

Margery's attacks of crying, "turning from side to side . . . all blue and livid, like the color of lead,"[41] which took place unpredictably throughout her life, often during church services or at confession, were generally censured by Church officials. An even more sensitive subject in their eyes was her wearing of white garments, identifying her as a nun, though she belonged to no order. Several times she was subject to examinations by bishops, and at one point imprisoned at York, where the clergy of York Minster questioned her at length: "Woman, what dost thou here in this country? Hast thou a husband? Hast thou any letter of record [of permission from her husband]?" They turned her over to the archbishop, who accused her of being a heretic: "I am evil informed of thee. I hear it said thou art a right wicked woman." Margery replied with spirit, "I also hear it said that ye are a wicked man. If ye be as wicked as men say, ye shall never come to Heaven, unless ye amend whilst ye be here." The archbishop gave one of his servants five shillings and instructed him to "lead her fast out of this country."[42] Later she was brought before him again—"What, woman, art thou come again? I would fain

be delivered of thee!"—and accused of being a member of John
Wycliffe's heretical Lollard sect, but was freed once more with
the stipulation that she not return—"If ever she comes back,"
promised the archbishop's steward, "we will burn her our-
selves."[43]

Margery's mystical experiences had a distinctly erotic flavor;
God gave her a "token which endured about sixteen years, and
it increased ever more and more, and that was a flame of fire,
wondrous hot and delectable, and right comfortable, not wast-
ing but ever increasing, of love; for though the weather was
never so cold she felt the heat burning in her breast and at her
heart." At the same time, according to her account, God told
her that He would be "homely" with her, like a great lord who
was husband of a poor woman; "they must lie together and rest
together in joy and peace.... Therefore I must needs be
homely with thee, and lie in thy bed with thee. Daughter, ...
when thou art in thy bed, take Me to thee as thy wedded hus-
band.... Boldly take Me in the arms of thy soul and kiss My
mouth, My head, and My feet, as sweetly as thou wilt."[44]

In fact, Margery's vow of chastity implied no indifference to
sex; nursing her senile husband in his last years, she touchingly
recalled how when she was young she "had full many delectable
thoughts, fleshly lusts, and inordinate loves to his person."[45]

If the established Church relegated women to a secondary
position in religion and treated their religious communities with
a degree of mistrust, another welcomed them and placed them
in positions of leadership. This was the Albigensian or Cathar
sect, brought to Western Europe in the eleventh century from
Bulgaria. One of a series of dualist heresies, Catharism was
based on the existence of two opposed principles of good and
evil: spirit was good, matter evil. Jesus was pure spirit and had
not really been incarnated, or suffered and died on the cross, or
risen from the dead. Mary was not the mother of Jesus, since He

had never had a body. The Cathars denied the Trinity, and they denied the Catholic Church; they believed in a vernacular Gospel and a priesthood of dedicated lay people who shared the daily lives and labors of their flock. Among numerous other tenets offensive to orthodox Christian theology, the ascetic Cathars condemned marriage as a crime against God since it entangled pure spirits in the flesh, and condemned the family as a source of earthly attachments. In some ways an exaggerated version of Catholic asceticism, Catharism made an upsurge in the South of France in the twelfth century that sent a shock wave through Christendom.

There were no women among the Cathar bishops and deacons, the office being judged too dangerous and taxing for them. But among the *credentes* (believers), women exceeded men in numbers, and among the *perfecti*, the ministers, they formed a respectable minority. Cathar ministers surrendered all their belongings to the Cathar community, abjured the Catholic faith, and swore to abstain from food of animal origin, from sexual intercourse, and from lies and oaths. Adopting a distinctive dress—black robes with a girdle to which was attached a leather bag containing the New Testament—they led a wandering life, traveling in pairs, preaching and praying.

By the end of the twelfth century, not only were there women Perfects, but many noble ladies had turned over their homes and fortunes to the community to found what were, in effect, Cathar convents, where not only the daughters of aristocratic families but of poor *credentes* found refuge. There were also hermitages where women lived in grottoes or huts and spent their time in prayer and meditation.

Among the noblewomen who embraced the sect was Esclarmonde, widowed sister of the Count of Foix. Esclarmonde took part in debates between Cathar and Catholic preachers, including one at her brother's castle of Pamiers during which the Dominican Stephen of Minia rebuked this dig-

nified elderly mother of six with the words, "Go tend your distaff, madam; it is no business of yours to discuss such matters."[46]

After her death, Esclarmonde's castle of Montségur, in the foothills of the Pyrenees, became a sanctuary and last-ditch stronghold of the Cathars—the object in 1243 of a prolonged siege by an army of Catholic Crusaders. At the end of February 1244 the garrison asked for terms. The besiegers stipulated that all persons in the fortress would be freed with light penances, provided that they abjured their heretical beliefs; those who refused would be burned.

During the fifteen-day truce that preceded the surrender, seventeen members of the garrison and their wives, six women all together, were initiated into the Perfects, thus signing their own death sentences, among them Corba de Perella, wife of the lord of Montségur. After the surrender, two hundred Cathars, many of them women, were fettered and led down the slope from the fortress into a palisade enclosure where they were burned. The fall and destruction of Montségur dealt a final blow to the Cathars; they were scattered and, over half a century, the sect was exterminated.

6

A Reigning Queen: Blanche of Castile

In January 1200 a party of ambassadors, French and English, rode south out of Bordeaux toward the Pyrenees. Their purpose was to bring back a bride for Louis, the thirteen-year-old heir to the French crown. Typically for a royal marriage, the mission was part of a peace treaty, in this case sealing the victory in Normandy of French king Philip Augustus over King John of England. John's sister Eleanor, wedded to Castilian king Alfonso VIII, had two daughters of marriageable age: thirteen-year-old Urraca and twelve-year-old Blanche. Heading the party was John's mother, and the princesses' grandmother, Eleanor of Aquitaine, an almost fabulous queen who had astounded her contemporaries fifty years earlier by coolly deserting one king (Louis VII of France) to marry another (Henry II of England and Anjou), and who, at the age of eighty, still played an active role in politics.

At the Castilian capital of Burgos, Eleanor and her fellow emissaries inspected the two princesses. According to a contem-

porary story they considered Urraca slightly more beautiful, but feared that the French would have trouble with her name. Whatever their reasons, they settled on Blanche, whom a contemporary described as "elegant in body, in aspect, singled out for all the noble gifts of nature."[1] Little more is known about the future queen except that her education was the strict and pious one of a Spanish princess.

In March the party recrossed the mountains with their prize, reaching Bordeaux in time for Easter (April 9). The old queen, exhausted, turned her granddaughter over to the archbishop of Bordeaux for the journey on to Normandy.

The marriage took place on May 23, at Pontmort, on the Seine—in English territory because Philip Augustus was under interdict over his own marriage problems. It was performed by Blanche's archiepiscopal escort, who qualified as an English prelate, Bordeaux being in the English province of Aquitaine. As part of the peace treaty, John promised a dowry of estates from his French lands, plus 20,000 silver marks. In return the groom named as Blanche's dower, to be hers for life if he predeceased her, royal French lands in Artois, in northeastern France.

Although consent was a condition theoretically imposed by the Church, the two children had little voice in the marriage. Whether minors or not, young people obediently accepted the dictates of their families, which in the case of a royal marriage included the views of the king's council. The marriage of Blanche and Louis was the decision of John, Philip Augustus, and their advisers, with the agreement of Blanche's immediate family.

Twelve and thirteen were by no means early ages for royal or noble marriages, contracted to seal political alliances or gain property. Sometimes children were married virtually in the cradle, the marriages consummated when both partners reached

Effigies of the great Anglo-French queen Eleanor of Aquitaine, grand-mother of Blanche of Castile, and her son Richard I (the Lionhearted), in the abbey of Fontevrault. *Archives Photographiques.*

the legal age of maturity, twelve for girls, fourteen for boys. In theory, marriages could be voided at that point, and such re-pudiations did take place, but rarely.

What was surprisingly less rare, and what happened in the case of Blanche and Louis, was that the marriage was happy. A chronicler wrote, "Never queen so loved her lord. They were so attached to each other that they were always to be seen to-gether."[2] And Louis "cared nothing for good cheer or de-bauchery; his wife was good enough for him."[3]

When Blanche suffered from homesickness in her first

months in France, her young husband asked Bishop Hugh of Lincoln, in France on a pilgrimage, to call on her. The elderly bishop and future saint had none of the medieval cleric's horror of women; in fact, his monkish biographer was shocked to report that he considered wives as honorable as virgins and allowed women to sit at his side at dinner, even touched and embraced them. "Woman," he was quoted as saying, "has been admitted to a higher privilege than man. It has not been given to man to be the father of God. To woman it has been given to be God's mother."[4] The kindly bishop soon induced Blanche to forget "the grief and depression under which she labored for some days, and her happiness was reflected in her face."[5]

Over the next twenty-six years, Blanche gave birth twelve times. Though royal children received the best care available, seven of the twelve died before maturity. The first, a daughter, born when Blanche was seventeen, died at birth. The second, a boy, lived to the age of nine. Next came twins who died within months. In April 1214 she gave birth to the future Louis IX, followed in 1216 by Robert, the future Count of Artois. Of five more sons and one daughter, three lived to maturity: Alphonse of Poitiers, Isabella, and Charles of Anjou. Against childhood diseases, pneumonia, intestinal viruses, and other infections, doctors and parents, however wealthy, remained powerless.

Infant mortality notwithstanding, Blanche was an excellent mother, as evidenced by the character and accomplishments of her eldest surviving son. The future Louis IX (Saint Louis) was taught to work, exercise, and pray. As a clerical biographer recorded, there was "no going to the woods or the river."[6] In an age when kings did not always know how to read and write their own languages, Louis was fluent in Latin. His friend and biographer Jean de Joinville wrote that God had kept the king from harm "through the good instruction he received from his mother, who taught him both to believe in God and to love

Blanche of Castile gives birth to the future Louis IX (Saint Louis). *Bibliothèque Nationale, MS fr. 2813, f. 265.*

Him. . . . Child as he was, she made him recite all the Hours, and listen to sermons on days of high festival."[7]

But mothering did not consume all Blanche's energies. When her husband, Prince Louis, landed in England in 1216 to lead the barons rebelling against King John, Blanche ably seconded him in Paris. According to the anonymous contemporary "Minstrel of Reims," she confronted her father-in-law,

Philip Augustus, and demanded his help. "Will you let my lord
your son die in a strange land? Sire, in God's name, he is to
reign after you; send him what he needs, at least the revenues of
his patrimony." But Philip Augustus was wary of his son's En-
glish adventure. "Then I know what I will do," Blanche told
him. "By the Blessed Mother of God, I have fair children by my
lord; I will pawn them and see what I can raise on them." The
old king is said to have relented.[8]

True or apocryphal, the story illustrates the contemporary
view of Blanche's firm and even commanding character. Her
appearance in maturity was distinguished: tall, fair, with gray
eyes, she was likened by observers to a stag or an eagle.

When Philip Augustus died in 1223, Louis and Blanche were
crowned in the cathedral at Reims, not quite completely rebuilt
from the fire of 1211, before the assembled peers and prelates of
the realm. The following day Louis VIII and his queen returned
to Paris to hold court in the ancient royal palace (now part of the
Palais de Justice on the Ile de la Cité). The structure was both
royal residence and seat of government; the hall where the curia
regis (royal court) met doubled as main dining hall; the chamber
where the king heard pleas and dispensed justice served as his
private dining room; his bedchamber, up a flight of stairs, was
the meeting place of his private council.

The role Blanche entered on had undergone many fluctua-
tions since the days of the early Frankish queens, who had
exerted power only through personal influence. In Carolingian
times the queen had acquired serious official duties. The royal
treasurer served under her supervision, and the queen awarded
the knights their yearly gifts—in effect, their salaries. A ninth-
century essay on the organization of the royal household ex-
plained that this responsibility was delegated to the queen to free
the king from "domestic or palace solicitude" and to enable him
to devote himself "to the state of the entire kingdom."[9] The

queen had the important responsibility of supervising the activities that stocked the treasury: the workshops on the royal manors, and perhaps the manors themselves.

In the two centuries of the Capetian dynasty, further changes had taken place as the power and territory of the monarchy increased and the machinery of government elaborated into incipient bureaucracy. French queens still could not rule in their own right, but only as wives, mothers, or widows of kings. Nevertheless, in the intimate and unstructured life of the eleventh-century court, the early Capetian queens exercised power, accompanying the king as he traveled to dispense justice, issue charters, and confirm donations, and participating in the curia regis when it sat as a court of law. The queen's name appeared regularly in court documents recording her as "assenting" or "intervening" or "assisting." Some queens helped govern during their dowagerhood. Louis VI's consort Adelaide was included in the dates of his charters ("in the tenth year of the reign of King Louis and the third year of Queen Adelaide") as well as in their texts ("King Louis with the consent of Queen Adelaide," or "acting upon Adelaide's intercession or plea").

But as a staff of permanent advisers supplanted the earlier council of vassals, the queen's role diminished, and Philip Augustus's twenty-year struggle to have his marriage annulled left queenship bereft of power and authority. Thus Blanche inherited a position reduced to the ceremonial and social. Circumstances and Blanche herself dramatically reversed the situation.

In 1226 her husband was returning from the first Albigensian Crusade when he was fatally stricken with dysentery. Blanche had taken the children to meet him, the younger ones with her in a bumpy springless "chariot," when a party coming from the south brought her the grave news.

Seated on his horse a few paces away was the new king, Louis IX—twelve years old. His dying father had had time to dictate a

A medieval "chariot" similar to the one in which Blanche of Castile took her children to meet Louis VIII when he was fatally stricken in 1226. *Bodleian Library, MS Douce 131, f. 43.*

last command, that "his successor, with the kingdom, and all of his children up to their majority," should be placed under the guardianship of the queen, and to bid the bishops of Sens, Beauvais, and Chartres, who had accompanied him on the campaign, to witness that he was still "sound of mind."

The danger in a royal minority was evident. Powerful and ambitious barons, like the counts of Champagne and Brittany, ruled virtually independent states. Smaller lords who owed allegiance to the crown resented the erosion of their privileges to the expanding monarchy. Blanche's cousin, Henry III of England, was sure to welcome an opportunity to recover his father King John's French losses.

The term "regent" applied to Blanche is modern; to her con-

temporaries she continued to be queen of France. Female regents had occasionally governed the Roman Empire (Julia Domna and Julia Mamaea, mothers of Caracalla and Alexander Severus, for example), but the Middle Ages had, without using the name, given the institution heightened importance, because of the personal nature of rule and the frequent absences of monarchs on war, pilgrimage, or crusade. Among others, Eleanor of Aquitaine served as regent of England during Henry II's absence; as had Queen Matilda for William the Conqueror, and Queen Edith Matilda for Henry I. Medieval queens, however, did not automatically assume the powers of regency. Louis VIII's choice of Blanche demonstrated his appreciation of her intelligence and character, a judgment Blanche confirmed by acting promptly and decisively.

Postponing grief to give the dangerous barons no time to organize, she ordered her son's coronation for November 29, and set out with him for Reims, stopping at Soissons to have the boy knighted. Louis made his formal entrance into Reims on a warhorse, and on the first Sunday in Advent the ceremony took place in the cathedral.

Ominously, a number of powerful barons stayed away, and the moment the coronation was over, Blanche moved to forestall revolt. She handed out judicious rewards for fidelity, made treaties, and extracted oaths of allegiance and promises to keep the peace.

Nevertheless, three of the absentees from the coronation, the counts of Brittany and La Marche and young Count Thibaut of nearby Champagne, unfurled the banner of revolt. Blanche at once raised an army, whose menacing approach undermined the conspiracy. Reinforcing stick with carrot, she gave Thibaut a royal grant of four thousand pounds. The count repledged his allegiance, and his fellow rebels grudgingly submitted.

Count Thibaut's reconciliation with the royal power brought him in personal contact with Blanche, with a sequel that be-

came a medieval legend. Although thirteen years younger than the queen (he was twenty-six, she thirty-nine), he fell in love with her. An accomplished trouvère, Thibaut composed songs celebrating Blanche's beauty:

Las! si j'avois pouvoir d'oublier
Sa beauté, sa beauté, son bien dire,
Et son très-doux, très-doux regarder,
 Finirois mon martyre.... [10]

(Could I forget her gentle grace,
Her glance, her beauty's sum,
Her voice from memory efface,
 I'd end my martyrdom....)

As in many a tale of chivalric romance, the affair remained unconsummated.

According to one account, his love for Blanche was itself the inspiration of Thibaut's muse:

The count looked at the queen, so wise and so fair that her great beauty overwhelmed him. He answered her thus: "By my faith, Madame, my heart and my body and all my lands are at your command; there is nothing that might please you that I would not do; never, God willing, shall I oppose you or yours again." Then he left pensively, and he often remembered the sweet glance of the queen and her fair countenance. But when he remembered that she was so great a lady, of so good and virtuous a life that he might never possess her, his sweet amorous thoughts moved him to great sadness. And since profound thoughts engender melancholy, he was advised by wise men that he should study the beautiful sounds of the viol and sweet delectable songs. Between him and Gace Brulé [a trouvère] were created the most beautiful and delectable and melodious songs that were ever heard.... And he had them written on the walls of his hall at Provins and at Troyes.... [11]

The rebellion of the other barons simmered again at Corbeil, south of Paris, where a plot was hatched to kidnap the king.

Forewarned, Louis sent word to his mother, who called out not only her knights but the communal militia of Paris, and marched to the castle of Montlhéry where the young king had taken refuge. Together mother and son rode back to the capital in triumph along roads lined with people, many armed, who greeted them with cheers and prayers.

The barons continued to test Blanche's courage and ability with bursts of military activity, now invading the territory of Count Thibaut, now seeking to free Brittany and Toulouse from royal overlordship. Blanche formally summoned trouble-making Peter Mauclerc, the Count of Brittany, to court, and when he predictably failed to appear, set off with the young king for a surprise attack in the dead of winter. In January 1229 the royal army besieged the count's castle of Bellême. Blanche ruthlessly ordered houses in the village razed to build siege engines, and the castle soon fell.

An even larger threat followed. Henry III of England won support for an invasion from dissident Breton and Norman nobles. Blanche and Louis called on their vassals for the feudal levy, the military service owed the crown. The response was reluctant, many barons sending only two knights, but Thibaut of Champagne came in person with a large force, and Blanche was able to confront Henry with enough power to block him. Again showing herself resolute and ruthless, Blanche rebuilt an obsolete castle of the Counts of Anjou at the cost of demolishing churches and houses, clearing cemeteries and cutting down vineyards while the bishop and canons of Angers vainly protested her seizure of stones, plaster, and lime they had collected for the cathedral. The great brooding castle Blanche built at Angers remains a lasting memorial to the more or less bloodless war.

The barons next aimed a blow at Blanche's devoted Thibaut, invading Champagne and forcing the trouvère-count—now known as Thibaut le Chansonnier (the Songwriter)—to burn his towns. Blanche led a royal army east from Paris and commanded

Blanche of Castile and Louis IX, above, with scribes below, from a thirteenth-century moralized Bible. *Pierpont Morgan Library, MS 240, f. 8.*

the invaders to quit Champagne. She followed up military action with diplomatic, adroitly detaching the Count of Boulogne from the rebel coalition, and one by one forcing the others to agree to peace.

She had meantime placed a capable and loyal soldier, Humbert of Beaujeu, in command of her southern army confronting another powerful dissident, Count Raymond of Toulouse. Through her friend the papal legate, Cardinal Romanus, she now negotiated a highly favorable peace by which the crown gained extensive territory west of the Rhone and south of the Tarn, with the promise of more when the count's eight-year-old daughter, betrothed to Blanche's second son, Alphonse of Poitiers, inherited her father's county.

Blanche defended the monarchy against ecclesiastical as well as secular threats to its rights. Disputes with the archbishop of Rouen and the bishop of Beauvais led to their interdicting royal chapels and cemeteries and excommunicating royal officials; Blanche counterattacked by seizing the prelates' lands, ultimately winning settlements.

On Shrove Monday in 1229, a group of students of the University of Paris became involved in a tavern riot in the suburb of St. Marcel. Put to flight, they returned the following day with reinforcements armed with swords and sticks to plunder the taverns and assault citizens. The complaint reached the royal palace via the cardinal-legate and the bishop of Paris. Blanche ordered the provost (police chief) to suppress the riot, and in the battle that followed a number of students were killed and wounded. Several were hurled into the Seine and drowned. Faculty and students were outraged. The masters of the University closed down their lectures and demanded amends; when Blanche refused, they quit Paris and took themselves off to Reims, Orleans, and Toulouse. Blanche's enemy, Peter Mauclerc of Brittany, welcomed them to Angers, and Henry III promised students and masters advantages if they migrated to England (Ox-

ford University had grown out of a similar earlier migration from Paris). As they traveled the scholars spread scurrilous stories about Blanche and the cardinal-legate, including a ribald Latin verse: *"Heu! morimur strati, vincti, mersi, spoliati;/ Mentula legati nos facit ista pati."*[12] (Alas, we die, beaten, chained, drowned, despoiled; the legate's penis makes us suffer all this.) The Minstrel of Reims, teller of picturesque tales, claimed that Blanche disproved a slanderous tale that she was pregnant by the legate by revealing herself naked to prelates and barons. Ignoring the lurid gossip, Blanche made peace overtures to the University, reconfirmed its privileges, and within two years induced masters and students to return to Paris.

Interestingly, no official date marked the end of Blanche's regency and her son's assumption of authority. Blanche's influence remained so strong that no dividing line could be drawn between the rule of mother and son. Louis's marriage in 1234 made Blanche officially the dowager queen, but even this brought little alteration in her role.

Blanche had been contemplating the political advantages of closer relations with Provence, France's neighbor to the southeast, whose count, Raymond Berenger IV, had four beautiful daughters, all of whom eventually married kings. In 1233 when Gilles de Flagiac, a knight of the royal household, was on a mission to Toulouse, Blanche instructed him to visit Provence and inspect Raymond's eldest daughter with a view to her suitability as a bride for nineteen-year-old Louis. Gilles's report was encouraging: "A girl of pretty face but prettier faith."[13] The following year ambassadors were sent with a formal request for Marguerite's hand, and in May the thirteen-year-old girl was brought to Sens, south of Paris, where the wedding took place in the cathedral of St. Etienne. For the three-day celebration, the king's party was dressed in robes of purple, scarlet, and green trimmed with miniver and ermine; Louis's brothers Robert and

Angels crown Christ, while Louis IX, left, and his consort Marguerite of Provence, right, look on. From the Porte Rouge, Notre-Dame-de-Paris. *Archives Photographiques.*

Alphonse wore enameled golden belts and golden buttons and caps with peacock feathers, while Marguerite's gold crown cost fifty-eight pounds. The wedding was enlivened by trumpeters and minstrels, and the procession wound toward Paris through the forest of Fontainebleau, stopping to rest at the king's hunting lodge.

Bride never faced more formidable mother-in-law. And although forty-six-year-old Blanche had chosen Marguerite herself, she was jealous. According to Joinville, she exerted every

effort to keep the young couple apart except at night.

> The palace in which the young king and his wife had most liked
> to live was at Pontoise, because there the king's room was on an
> upper floor and [Marguerite's] room just below it. They had so
> arranged matters that they had managed to meet and talk to-
> gether on a spiral staircase that led from one room to the
> other.... Whenever the ushers saw Queen Blanche approach-
> ing her son's room, they would knock on the door with their
> rods, and the king would run quickly up to his room so that his
> mother might find him there. Queen Marguerite's gentlemen of
> the bedchamber did the same when Queen Blanche was going to
> her daughter-in-law's room, so that she might find the young
> queen safely installed within.[14]

Joinville described another scene: after the birth of one of her
children, Marguerite was critically ill, Louis remaining at her
side, when Blanche came into the room, took the king by the
hand, and said, "Come away, you're doing no good here."
Joinville reported: "Queen Marguerite, seeing that the Queen
Mother was taking the king away, had cried out: 'Alas! Whether
I live or die, you will not let me see my husband.' Then she had
fainted.... The king, convinced that she was dying, had turned
back; and with great difficulty they had brought her around."[15]

While no information has survived about Blanche's own
education, a treatise written for Marguerite by the encyclopedist
Vincent of Beauvais, *De Eruditione Filiorum Nobilium* (On the
Erudition of Noble Sons), furnishes a glimpse of the training of
Louis IX's four daughters. Vincent briefly quotes Saint Jerome's
letter to his pupil's daughter-in-law: "Have a set of letters made
for her, of boxwood or of ivory, and tell her their names. Let her
play with them, making play a road to learning...." Literacy,
however, won only perfunctory notice from Vincent, a
Dominican friar whose remaining advice on the education of

girls dealt entirely with their morals—chastity, avoidance of ornament and makeup, modesty, sobriety, humility, the desirability of early marriage, virtuous behavior of wives, all expounded at length in a text cumbered with citations from the Bible and the Church Fathers.

As dowager queen, Blanche had her own independent fortune and domains. Her dower lands lay in distant Artois; in 1237, granting Artois as an appanage (property given for the maintenance of a member of a royal family) to his oldest brother Robert, Louis arranged to exchange Blanche's dower for royal lands close to Paris. In the city itself, Blanche had several houses, the principal one (later the site of the Hôtel de Soissons of Catherine de Medici) on the right bank just east of the Rue du Louvre. Most of her time, however, was still spent at court, where she maintained her own household, including her own cook and a surgeon who bled her at intervals. Several Spaniards were in her employ, including her personal attendant Mincia, although Blanche had the political sagacity not to elevate her own countrymen to positions where they might arouse jealousy.

Among the expenses of her household were sums dispensed as alms, at home and on the road, and gifts in kind such as bread distributed from her chamber. A favorite charity was the provision of dowries for poor girls, the daughters and sisters of her own servants, and even strangers. Her largest donations were to religious establishments—principally the Cistercian abbey of Maubuisson which she founded near Pontoise in 1236, endowing it with rents and tithes from her dower lands.

Joinville's description of a feast at Saumur in 1241 to celebrate the knighting of Louis's brother Alphonse of Poitiers illustrates the uniqueness of Blanche's position. She was the only woman present at this masculine gathering. The dinner was held in the great hall, modeled after a Cistercian cloister. At the high table sat the king; his newly knighted brother, the Count of

Dreux, who had been knighted with Alphonse; the Count of La
Marche; the Count of Brittany; and Thibaut of Champagne, "in
tunic and mantle of satin, well set off by fine leather belt, a
brooch, and a cap of gold tissue." Sixteen-year-old Joinville,
who carved the meat for his lord, Thibaut, while the king's
brother Robert of Artois and the Count of Soissons served the
king, described the scene:

> Behind these knights [guarding the royal entourage] stood a great
> company of sergeants [foot soldiers] in suits of taffeta embroi-
> dered with the arms of the Count of Poitiers. The king himself
> was wearing a tunic of blue satin and a bright red surcoat and
> mantle of the same material lined with ermine.... By the wall of
> the cloister where the king was dining ... there was also room for
> a table at which twenty bishops and archbishops were sitting, and
> in addition to all these prelates, Blanche the queen mother had a
> table near them at the far end of the cloister, facing the one
> occupied by the king.
>
> In attendance on Queen Blanche were the Count of Boulogne
> [Alphonse, son of Blanche's elder sister Urraca], who later be-
> came King of Portugal, the good Count Hugh of St.-Pol, and a
> young German lad of eighteen, who was said to be the son of St.
> Elizabeth of Thuringia. On account of this, so it is said, Queen
> Blanche kissed the boy on the forehead, as a pure act of devotion,
> because she thought his own mother must often have kissed him
> there.
>
> At the end of the cloister, on the other side, were the kitchens,
> the wine cellars, the pantries, and the butteries, from which the
> king and the queen mother were served with meat, wine, and
> bread. To right and left of the main hall and in the central court
> so many knights were dining that it was more than I could do to
> count them.... It was said that no less than three thousand
> knights were present....[16]

Dowager though she was, Blanche remained the real queen

of France. Louis did nothing without her assistance, she ac-companied him everywhere, and royal agents continued to ad-dress themselves directly to her. In 1242 when Hugh of La Marche and his wife, King John's widow Isabelle of An-goulême, secretly planned to rise against the king and blockade La Rochelle, it was one of Blanche's agents who discovered the conspiracy and reported it by letter to the queen mother.

Once more Henry III landed in France to join Hugh and Isabelle and their Poitevin followers. This time there was a major battle at Taillebourg, south of La Rochelle, where Louis routed the English. Isabelle—"rather Jezebel than Isabelle," pronounced acid-penned Matthew Paris[17]—is said to have sought revenge by hiring servants to poison Louis and his brothers, but the plot was discovered, the servants were hanged, and Hugh and Isabelle submitted to the king on their knees.

Joinville pointed out that in financing this campaign, as many others, Louis refrained from making demands on "his barons, his knights, his men, or any of his fine cities in such a way as to cause complaint. Nor is this to be wondered at; for he acted thus on the advice of the good mother at his side, whose counsels he always followed. . . ."[18]

Blanche accompanied Louis to Cluny in 1245 to confer with Pope Innocent IV about his troubles with German emperor Frederick II, and queen mother, king, and pope spent a week in secret discussions. Three years later, when Louis departed on a long-projected Crusade, Blanche, now in her sixties, was his choice for regent, again simply as "queen of France." She traveled with him to St. Denis where he received the wallet and staff of a pilgrim, and accompanied the party southward for three days until the king entreated her to return, reminding her that he had left her his kingdom to govern and his children to guard. At the moment of parting Blanche is said to have col-

lapsed; Louis lifted her to her feet, kissed her, and amid tears mother and son parted. They never saw each other again.

Blanche returned to Paris, where as the months passed letters arrived from the Crusading party. Robert of Artois sent an account of the taking of Damietta, in Egypt, and the news that Countess Beatrice, Queen Marguerite's sister, wife of Louis's brother Charles, had given birth to a son at Cyprus, "very pretty, very well-made; she left him there with his nurse."[19]

Soon the news from Egypt was less happy. Racked by scurvy and dysentery, the Crusaders were overrun by the Saracens at Mansourah. Robert of Artois was killed and Louis captured. Queen Marguerite, in Damietta, expecting a child at any moment, placed herself under the protection of an elderly knight, with instructions to kill her if the city fell. After her child, a son, was born, she persuaded the Italian merchants of Damietta to remain in the town, while Louis borrowed ransom money from the wealthy Knights Templar and later joined Marguerite in Acre. There a message arrived from Blanche urging him to come home because his kingdom was "in great peril." Louis thought it over for a week and decided to stay in the Holy Land but sent brothers Alphonse and Charles back to France.

Although Blanche's principal source of uneasiness, the fact that no final peace treaty had been concluded with England, was not without basis, in reality only one political disturbance had threatened the peace of the kingdom during Louis's absence, a revolt at Albi, in the south; Blanche sent the bishop of Bourges, one of her trusted counsellors, to pacify the city. But the death of her second son and the dangers with which Louis was threatened had shaken the indomitable lady. She was disappointed in the feeble support that Pope Innocent IV had given the Crusade, and in exasperation even seized the lands of French barons who had joined the pope's "crusade" against Frederick II's son and successor, Conrad. Matthew Paris re-

ported her as saying, "Let those who fight for the pope be supported by the pope, and may they go away and never return."[20]

A bizarre event seemed momentarily to promise aid for Blanche's son in the Holy Land. In Picardy, a fanatic who called himself "the Master of Hungary" claimed that he had a revelation from the Virgin ordering him to raise an army of shepherds (*Pastoureaux*) to rescue the Holy Land. At Easter 1251 Blanche sent for the Master, interrogated him, and gave him presents. But the Shepherd movement turned wantonly violent, assembling a mob that attacked priests and monks. After riotous scenes in Paris, the Shepherds moved on to Orleans, and Blanche finally ordered their excommunication and destruction. The Master of Hungary perished in a street fight, the mob roamed on southward and gradually dispersed. A handful took the Cross and embarked to join the king.

In her second regency, as in her first, Blanche did not hesitate to challenge ecclesiastical lords in jurisdictional disputes, most dramatically the Chapter of Notre Dame cathedral, which had levied a feudal tax, or tallage, on its serfs, in Orly and neighboring villages. The peasants claimed the tax was illegal, the Chapter imprisoned several of them in the cellar of Notre Dame, and their comrades appealed to the queen.

Blanche at first addressed the canons civilly, asking them to release the prisoners and offering to conduct an inquiry. The Chapter tartly replied that she had no right to intervene, and locked up the prisoners' wives and children with them. Some of the unfortunates died. Blanche summoned the castellan of the Louvre and the provost of Paris, and placing herself at the head of a troop of men-at-arms, invaded the canons' cloister on the north side of the cathedral. The canons had prudently withdrawn, closing the doors but not barring them. Even an unopposed entry was a breach of jurisdiction. Blanche directed her

men to get the keys to the cellar; when they could not be found, she had the doors broken open and the serfs rescued. "This justice and many another good one performed the queen," wrote a chronicler, "while her son was in the Holy Land."[21] But Blanche was judicious enough to charge the bishops of Paris, Orléans, and Auxerre to inquire into the Chapter's right to tallage the serfs of Orly, and the right was confirmed after her death.

If she lost none of her moral force, Blanche at sixty-five had lost some of her youthful physical vitality. In the words of Matthew Paris, this "guardian, protectress, and queen of France" had suffered

> manifold sorrows, amongst which were the death of her hus-
> band, King Louis [VIII] . . . leaving the French kingdom depen-
> dent on her . . . [Louis IX's] assumption of the cross and his
> pilgrimage . . . his capture by the infidels . . . also the disgraceful
> flight and subsequent death by drowning of Robert, count of
> Artois [an inaccurate description of Robert's rash and courageous
> death]; the incurable disease of Alphonse, Count of Poitiers; and
> lastly the news which had been brought to her that her eldest
> son, the French king, who was fighting for God in the Holy
> Land, intended to remain there all his life and to die there, and
> thereby to obtain a heavenly kingdom in exchange for his earthly
> one.[22]

Alphonse, who recovered from his "incurable disease" (paralysis and eye trouble), announced plans to rejoin Louis in the Holy Land.

Blanche was in Melun in November 1252 when, according to another chronicler, "her heart began to pain her."[23] She packed up and returned to Paris, where she took to her bed. Five or six days before her death, she received her last communion from the Bishop of Paris, and donned the habit of a Cistercian nun. Charles of Anjou described her death:

Having received the sacraments, and death approaching, she had lost her powers of speech. The priests and clerks present hesitated, not knowing what to do. All at once she herself began to intone the prayer for the dying, *Subvenite Sancti Dei*, and gave up her soul little by little, murmuring between her teeth the rest of the prayer.[24]

Blanche's royal vestments were put on over her nun's habit, her crown over her veil, and she was borne through the streets of Paris to the Abbey of St. Denis on a bier ornamented with gold. The next morning, after the funeral mass, a procession accompanied the queen's body to Maubuisson, where she was buried. "Thus," concluded Matthew Paris, "did the noble lady Blanche, a woman in sex, but a man in counsels, one worthy to be compared with Semiramis, bid farewell to the world, leaving the French kingdom comfortless and void of all consolation."[25]

Marguerite, a strong personality herself, tried in vain to take Blanche's place as counsellor to Louis after their return to France in 1254. When her efforts failed, she turned her attention to the heir-apparent, Philip, and in 1263 persuaded him to take an oath to make her his guardian until he was thirty. Louis found out, and got Pope Urban IV to absolve the boy from his promise.

Unlike Marguerite, Blanche had never really exhibited a taste for power. When power was thrust upon her she had accepted it without hesitation and wielded it without fear, but it had never corrupted her. She remained a loyal wife and mother, serving the interests first of her husband and then of her son, and by her selflessness serving those of the country. A modern (but slightly old-fashioned) French scholar wrote, "To all intents and purposes she may be counted among the kings of France."[26] Among the greater kings, one might amend.

7

A Great Lady:
Eleanor de Montfort

One of the best-known figures of medieval literature is the lady of the castle, the heroine of romance. An example of the type is Blonde, of *Jehan et Blonde*, by Philippe de Beaumanoir, a poetically gifted lawyer who in a more serious vein drafted the important thirteenth-century legal code, the *Customs of Beauvais*. His hero Jehan is a French knight who goes to England to seek his fortune and falls in love with Blonde, the daughter of the Count of Osenefort, his patron. Blonde's hair is, of course, golden, her forehead white and smooth, her eyebrows dark, straight, and delicately traced, her nose neither too small nor too large, her eyes gray and clear and sparkling, her mouth dainty, her teeth small and perfect, her breath sweet, her neck so white that when she drinks red wine one can see it flow down her throat, her arms slender and shapely, her hands graceful, with long, straight fingers, her breasts small, her waist narrow, her feet well made. Serving her at meals, Jehan becomes so distracted that he falls ill.

When Blonde learns of Jehan's plight, she promises to love him, but when he recovers explains that she only promised in order to make him well. "You cannot imagine that I would give you my heart; it would be too great an abasement," the highborn heroine explains. At that Jehan falls ill again, and this time Blonde overcomes her scruples and cures him by a kiss from "her sweet mouth."

Two years pass in which Jehan and Blonde love (but chastely); then a messenger brings news from France that Jehan's father is dying. Jehan hastens home to do homage for his fief to the king of France. When he returns he finds Blonde about to be betrothed by her parents to one of the wealthiest lords in England. The lovers flee to France, where they are married; King Louis raises Jehan to the rank of count, gives him rich fiefs, and reconciles him with Blonde's father. At Pentecost the reunion is celebrated with a great feast in the presence of the king and queen of France. [1]

There is little doubt about the inspiration for Philippe de Beaumanoir's tale. During the early 1260s he served as a squire in the household of the great French-English rebel Simon de Montfort, Earl of Leicester. The original of Blonde was Eleanor de Montfort, youngest daughter of King John, and sister of King Henry III. Like Jehan, Simon was a French knight; like Blonde, Eleanor was a highborn English lady. But Eleanor's real-life story, though not lacking in romance, was less about love than about money and power, and her role was not sweetly passive like that of Blonde. A woman of strong will with an eye for her own interests, she ably seconded her husband's political ambitions, commanded his castle against his enemies, and pursued her own property claims with an unyielding obstinacy that actually delayed for two years an important peace treaty between France and England.

Born in 1215, the year of Magna Carta, Eleanor was a year

old when King John died and her nine-year-old brother Henry
acceded to the throne. Eleanor was sought in marriage at an
early age by one of Henry's chief vassals, William Marshal II,
Earl of Pembroke. After lengthy debate by Henry's counselors
over the advantages and drawbacks, the ceremony took place in
1224, when she was nine and William was in his early thirties.

She was sixteen and childless when William was taken sud-
denly and fatally ill. At the time of the marriage, Henry, as her
guardian, had settled on her a dowry of ten manors with an
income of just over two hundred pounds a year, hers for life in
the absence of children. That was a trifle compared to her
dower, her share of the vast Marshal estates in England, Wales,
and Ireland. By feudal law she was not William's heir, nor was
there any sense of community property. If the marriage had
produced sons, the eldest would have inherited; if only
daughters, the estates would have been divided among them.
Since it produced no heirs at all, William's eldest brother
Richard inherited. But Magna Carta had codified what had long
been custom: the widow was entitled to a third of all her hus-
band's lands for her lifetime.

The dower third was supposed to be turned over to the widow
within forty days of the husband's death, but the Marshal case
proved knotty and Eleanor's dissatisfaction with the outcome
became a lifelong obsession. The enormous extent of the lands
aroused rather than assuaged greed. Richard Marshal even
seized household furniture willed to Eleanor, tried to appro-
priate manors from her dowry, and sought to shift the estate's
debts to her.

As a substitute for land in settling the Irish estates, King
Henry, as his sister's guardian, eventually accepted a payment of
four hundred pounds a year, a figure Eleanor criticized as too
low; besides, Richard and his heirs proved laggard debtors.
Exasperated, Henry advanced money to his sister himself, and

her rights in England and Wales were at length similarly settled for yearly income of five hundred pounds.

Meantime Eleanor had rashly allowed herself to be persuaded by her governess and companion, Cecily de Sandford, also recently widowed, to join her in a vow of chastity, rendered the more binding by a ceremony conducted by the Archbishop of Canterbury, whereby the two women put on wedding rings to symbolize their marriage to Christ. Though adopting a nun's habit of homespun, they stopped short of assuming veils.

Cecily's chastity evidently suited her, because she kept her vow and on her deathbed refused to surrender the ring even to her confessor. Spirited Eleanor, still in her teens, began to tire of perpetual continence and homespun clothing. Without ever abjuring her vow, she reverted to the life of a lady, traveling with her retinue from one of her manors to another, and frequently visiting her brother's court.

In 1236 she was in Canterbury for the celebration of Henry's marriage to Eleanor of Provence. Among the barons performing ceremonial duties was twenty-eight-year-old Simon de Montfort. Simon had just arrived from France to press a claim to the earldom of Leicester, which had been granted to his father by King John, had reverted to the crown on his father's death, and had been re-granted by Henry III to Simon's cousin the Earl of Chester as part of a general shuffling of French and English holdings by royal vassals. Simon had a great name, his father having commanded the Crusading army that crushed the Albigensians, but he had at the moment little else. A second son, he had persuaded his older brother to resign to him the Leicester claim, which to everyone's surprise he made good—thanks apparently to his formidable personal charm.

In his own words,

> [I] prayed my lord the king that he would restore to me my father's inheritance. And he answered that he could not do it

Henry III, brother of Eleanor de Montfort, effigy in Westminster Abbey. *National Monuments Record.*

because he had given it to the earl of Chester and his heirs by charter.... The following year my lord the king crossed to Brittany and with him the earl of Chester who held my inheritance. And I went to the earl at the castle of St. Jacques-de-Beuvron which he held. There I prayed him that I could find his grace to have my inheritance.... The earl graciously agreed and the following August took me with him to England, and asked the king to receive my homage for the inheritance of my father, to which, as he said, I had greater right than he, and all the gift which the king had given him in this he renounced....[2]

Whatever accounts for the Earl's unbaronlike generosity, Simon became at a stroke one of the great magnates of England, and soon after a court favorite.

Simon and Eleanor had probably met before the royal wedding. In any case, far from being fatally stricken by her beauty, like Jehan in the romance, Simon continued to pursue two marriage projects with Continental heiresses. Only when both failed—one, with the Countess of Flanders, through the intervention of Blanche of Castile—did Simon turn his attention to Eleanor.

Eleanor meanwhile had wheedled a castle out of her royal brother. Odiham, northeast of Winchester, built by their father,

King John, as a hunting lodge, consisted of an octagonal tower with a basement on the first floor, a large hall above, and on the top floor Eleanor's chamber. Rather modest as castles went, Odiham nonetheless permitted a life-style that soon left its mistress short of cash and borrowing from the king.

She was twenty-one years old when Simon turned an interested eye on her. Reconnaissance was followed by action. The courtship remains the intriguing mystery it was to their contemporaries, but was clearly carried on in a quite different manner from that depicted by Philippe de Beaumanoir. Where unrequited love made Jehan ill, Simon turned on his practiced charm and evidently encountered little resistance.

Early in 1238 word leaked out that Eleanor and Simon were married. The ceremony had been performed in secret in the king's private chapel during Christmas court at Westminster. The scandal was not only as spicy as it was startling—few had difficulty in finding an explanation—but potentially dangerous. If a foreign adventurer had, by a means congenial to adventurers, assured himself of the property, power, and status of a king's sister which properly belonged either to a native magnate (like William Marshal) or to a royal suitor (both Eleanor's sisters had married kings), then the barons, jealous of their rights as royal counselors, had been hoodwinked. Besides, there was Eleanor's vow of chastity, which at least the English clergy took seriously.

What exactly had happened? Did Eleanor confide to her brother that she and Simon were lovers? Did a third party give him information? However he found out, Henry probably also concluded that Eleanor was pregnant, so that there was no time to be lost. He decided it was safest to confront the barons with a fait accompli. They predictably took offense at what Richard of Cornwall called the "underhanded marriage,"[3] but Simon successfully cajoled Richard with flattery and gifts, and the other barons grumbled and gave in.

That left Eleanor's vow of chastity. Some clerics flatly refused to recognize the marriage and stuck to their refusal. The monk who wrote the Annals of Dunstable referred to Eleanor only as "countess of Pembroke" or "the king's sister," never as "countess of Leicester" or "Eleanor de Montfort." In the spring, "seeing that the hearts of the king and Earl Richard, as well as those of all the nobles, were estranged from him, and finding that the marriage which he had contracted with the king's sister was looked upon by many to be, as it were, annulled," wrote Matthew Paris, Simon borrowed heavily and sailed for Rome, "hoping by means of his money... to obtain permission to enjoy his unlawful marriage. The countess of Pembroke in the meantime lay concealed, in a state of pregnancy, at Kenilworth castle, awaiting the issue of the event."[4]

Temporarily granted to Simon and Eleanor by Henry, the royal castle of Kenilworth was one of the finest in England, an imposing Norman keep of red sandstone surrounded on three sides by an artificial lake. Eighty by sixty feet in plan and eighty feet high, the keep had square projecting turrets at the corners and a battlemented forebuilding. The amenities included a well with a bucket and pulley, three tiers of latrines to accommodate the castle's two floors and the upper battlements, a fishpond, and, hugging the wall, outbuildings—kitchen, chapel, storehouses. Eleanor's comfort was assured by gifts of venison from the king, and "six tuns [barrels] of better wine."[5]

Simon returned in October, his papal dispensation granted doubtless in return for bribes (Matthew Paris sarcastically noted that "perhaps... the Roman court had in view something of deeper meaning than we could understand").[6]

But gossip received a setback when Eleanor failed to deliver until November 1238, eleven months after her marriage. Henry stood godfather, and the baby was named after him. Whatever

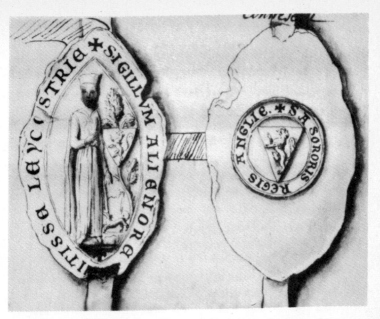

Seal of Eleanor de Montfort reads: "Seal of Eleanor, Countess of Leicester, Sister of the King of England."
Bibliothèque Nationale, MS Clairembault 1188, f. 17r.

Henry's deeper feelings about the marriage, he was evidently reconciled to it.

During Christmas at Winchester he formally invested Simon with the earldom of Leicester and presented Eleanor with elaborate gifts, a robe richly embroidered and trimmed with miniver and feathers, made of "baudekyn," a material woven with a warp of gold thread and woof of silk; a mantle of scarlet cloth; a mattress for her bed and a coverlet of gray fur lined with scarlet, both packed in canvas and sent to Kenilworth.

The following June when the new queen bore her first child, the future Edward I, Simon was a member of the royal christening party. Eleanor accompanied him to London, where at first

all went well. But in August when the Montforts joined the procession to Westminster Abbey for the queen's ceremonial purification ("churching"), Henry suddenly turned on Simon with angry accusations. The trouble, according to Matthew Paris, was the king's discovery that Simon had named him as security for money he had borrowed to bribe Rome for the cancellation of Eleanor's vow of chastity.

The Montforts withdrew to the palace of the bishop of Winchester, where they were staying, to await the cooling of the royal temper, but it did not cool. Instead, still according to Matthew Paris, the king ordered them evicted, and to their "tears and lamentations" returned a furious answer:

> You seduced my sister before marriage, and when I found out, I gave her to you in marriage, although against my will, in order to avoid scandal; and, that her vow might not impede the marriage, you went to Rome, and by costly presents and great promises you bribed the Roman court to grant you permission to do what was unlawful. The archbishop of Canterbury here present knows this, and intimated the truth of the matter to the pope, but truth was overcome by reiterated bribes, and yielded to Roman avarice; and on your failing to pay the money you promised, you were excommunicated; and to increase the mass of your wickedness, you, by false evidence, named me as your security, without consulting me, and when I knew nothing at all of the matter. [7]

The verbatim accuracy of so long a quote (probably at second hand) may be doubted, but Matthew Paris captured the sense of the king's resentment, as we know from other sources; that night, to escape a threat of the Tower, Simon and Eleanor boarded a small boat, with only a few servants, sailed down the Thames to the Channel coast, and took ship for France.

They settled in at the Montfort family castle at Montfort-l'Amaury, where a second son, Simon, was born. Perhaps to aid

reconciliation with Henry, Simon in 1240 joined Richard of Cornwall and other English nobles on a small Crusade. Eleanor and her two boys traveled with him as far as Brindisi, in southern Italy, where she settled down in a castle lent her by Frederick II, husband of her sister Isabella. She was again pregnant, with a third son, Guy.

In England, Henry gave a sign of relenting by ordering renovation of his sister's castle and manor at Odiham, completing a kitchen outbuilding which Simon had begun, and building a separate hall and kitchen on the manor. By 1244 he had forgiven his erring brother-in-law and welcomed the pair back to England.

They arrived in time for Richard of Cornwall's marriage to Sanchia, sister of Queen Eleanor and Queen Marguerite of France. Present was Countess Beatrice of Provence, the mother of the bride and the queen, described by Matthew Paris as "a woman of remarkable beauty."[8] Eleanor and Simon apparently enlisted Beatrice as a court ally, and at the Christmas feast at Richard of Cornwall's castle of Wallingford, she reminded Henry that he had never given his sister a dowry for her marriage to Simon. Henry responded generously by granting the Montforts a yearly income of five hundred marks, and an additional three hundred marks a year to their heirs. He also arranged to have Eleanor's dower lands turned over to her if the last of the four Marshal brothers defaulted in his payments; furthermore, he pardoned both Eleanor and Simon for debts to the tune of some 1,750 pounds.

Finally, he granted Kenilworth to Eleanor for life. The castle the Montforts took over had undergone extensive improvements in strength and comfort during their absence. Henry had ordered walls and outbuildings repaired and a new roof for the great chamber. The chapel had been paneled, and the paneling whitewashed and decorated with paintings, with seat of painted

Surviving tower of the Montfort family castle at Montfort-l'Amaury. *Archives Photographiques.*

wood for the master and mistress. The mistress's chamber had been paneled and painted, and its fireplace and latrine repaired. Henry had even ordered a "fair and beautiful boat" to be built and anchored at the door of the great chamber.[9]

Relations between the Montforts and the king reached a new plateau of goodwill in the 1240s when the ever-turbulent barons threatened insurrection and Simon skillfully played the role of mediator, gaining prestige with both sides.

Eleanor was now thirty. During this peaceful era in the Montforts' life they divided their time among Odiham, Kenilworth, and the court, their needs supplied by their manors scattered across England, from which they derived money, grain, meat, fodder, and cloth. As the large household moved from one estate to another, it consumed the produce of the demesne (the land exploited directly by the lord) of each manor in turn. Sale of the surplus added to revenues from rents and fines. All the same, there was a chronic shortage of cash to pay servants and purchase luxuries and necessities—wine, spices, silks, jewels—not raised on the manors. As with many baronial families, borrowing was an integral element of the Montfort domestic economy. Henry sometimes helped out—once by simply canceling a debt of 110 pounds and 11 shillings to David, a Jew of Oxford.

The kitchen accounts listed numbers of oxen, sheep, calves, chickens, pigs, kids, as well as large quantities of eggs, butter, cheese, and milk. The king continued to send them venison from the royal forests. In Lent, besides the staple of salt herring, the castle table displayed salmon, cod, eel, sole, mackerel, sturgeon, and shellfish—oysters, crabs, shrimp. Freshwater fish were supplied by a fisherman and his assistants. Spices, nuts, rice, and dried fruits were purchased in London or at the fairs.

Eleanor's household staff comprised more than sixty servants, headed by a steward. Except for the laundress, all were male:

cook, butler, baker, and with helpers, two chamber boys, several tailors, smiths, carters, messengers, and other outside servants. Two more sons, Amalric and Richard, had been born; each child had his own nurse, of higher status than the servants—one was referred to as "the lady Alice." Eleanor also had personal attendants who served as her companions.

In her role of hostess, Eleanor entertained royal officials, clerics, Simon's fellow barons, personal friends. Among the clerics were the distinguished scholar and scientist Robert Grosseteste, bishop of Lincoln, in whose household two of the Montfort sons were educated, and the abbot of Waverly, ten miles from Odiham, the first Cistercian monastery in England, where on Palm Sunday in 1246 the Montforts attended mass, Eleanor bringing the gift of a costly altar cloth.

Another clerical friend, a Franciscan monk named Adam Marsh, wrote the Montforts letters that shed some light on their personalities as perceived by others. An Oxford lecturer and a preacher whose outspoken sermons to the royal court often offended the king, Brother Adam was not afraid to give the earl and the countess frank advice. Both evidently suffered from shortness of temper. He cautioned Simon, "Better is a patient man than a strong man, and he who can rule his temper than he who storms a city."[10] In a letter to Eleanor prefaced by an apology for brevity that did not prevent him from going on for several pages, he warned her about the "demoniacal furors of wrath that do not shrink from disturbing the most loving peace of marriage," quoting the Old Testament (Job 5:2), "For wrath killeth the foolish man, and envy slayeth the silly one." He sermonized on:

> Truly now, gentleness is dispelled by wrath, our likeness to the divine image is marred, wisdom is lost, life is lost, justice is relinquished, partnership is destroyed, peace is broken, truth is obscured. Through wrath are strife, disturbance of mind, con-

Norman keep of Kenilworth Castle, granted to Eleanor de Montfort by her brother Henry III in 1244, and defended by her son in a memorable siege in 1265. *Department of the Environment.*

tumely, clamor, indignation, pusillanimity, and blasphemy brought forth. Wrath makes the heart pound, impels us against our nearest relations, drives the tongue to curses, creates havoc with the mind, generates hatred of our dearest, and dissolves the covenant of friendship.

He advised Eleanor to banish this pestilence from her soul before it dragged her into the pit, and to submit herself to "the most placid grace of the most pious Virgin Mary."

The letter continued, mingling adjurations to meekness with a lecture on a favorite clerical subject, the evils of ostentation in dress, in the words of Saint Peter (I Peter 3:1–4): "Likewise, ye wives, be in subjection to your own husbands... whose adorning let it not be that outward adorning of plaiting the hair, and of wearing of gold, or of putting on of apparel; but let it be... in that which is not corruptible, even the ornament of a meek and quiet spirit, which is in the sight of God of great price." He appended another text (I Timothy 2:9–10), recommending that women "adorn themselves in modest apparel, with shamefacedness and sobriety; not with braided hair, or gold, or pearls, or costly array; but... with good works." Finally he urged Eleanor to use her influence to moderate Simon's behavior. [11]

In another letter he enigmatically informed Eleanor that he blushed to hear evil reports about her; "I ask, I advise, I adjure you" to behave in such a way as to put a stop to the gossip. [12] Although Eleanor's spirit was far from meek and quiet, she accepted Brother Adam's moralizing in good part, and Simon named him one of the executors of his will.

In 1248 Henry appointed Simon to the high post of seneschal (governor) of Gascony. The Montforts sailed to Bordeaux, where Eleanor bore a daughter who died in infancy. Simon's governorship was not an unqualified success, his alleged high-

handedness drawing so many protests that in 1251 Henry recalled the Montforts to England for an interview which turned into another noisy quarrel. Nevertheless Simon returned to Gascony, leaving Eleanor at Kenilworth. She was again expecting, and another daughter, Eleanor, was born in the fall of 1252.

Despite his Gascon troubles, Simon was one of the negotiators in 1257 at the preliminaries to a major treaty with France, looking to the relinquishment by Henry, in return for an annual payment, of claims to French provinces that had once belonged to the English crown. Simon encountered one serious obstacle in the negotiations: his own Eleanor, whose simmering dissatisfaction with the way her Marshal dower had been handled now surfaced. As King John's surviving daughter, Eleanor had to give her consent to the surrender of the family claim to the lost French lands. She refused to do so until something was done about her dower, for which she insisted she had never been adequately compensated.

While Eleanor stubbornly blocked the treaty, her brother Henry foolishly rekindled the quarrel between crown and barons. He had concluded an agreement with the pope by which his youngest son, Edmund, was to be named king of Sicily in return for Henry's financial backing of a military expedition against the pope's enemy, Frederick II's illegitimate son Manfred. The barons had no objection on principle to the worldly bargain, but were shocked by the sum, 135,541 marks, which presaged extraordinary tax levies. Henry's attempts to raise the money escalated into a crisis, and in 1258 Simon played a leading role in the resolution of the affair. The result, however, was not a compromise of differences, as a decade earlier, but a humiliating defeat for the monarch, who by the Provisions of Oxford agreed to accept a permanent council chosen by the barons to oversee his administrative functions. In the negotia-

tions, a subtle but significant shift took place in Simon's position. From the king's counselor he moved to mediator between the two sides, and ultimately emerged as spokesman for the barons, who began to acknowledge him as their leader.

Meantime Eleanor started a new legal battle, this time against her stepbrothers and stepsisters, offspring of her mother Isabelle of Angoulême's second marriage. Isabelle had divided her inheritance among her second family, ignoring the claims of her first. Eleanor now began a lengthy litigation for her share of her mother's estates.

Early in 1259 Henry, his brother Richard, and their sons all renounced their French lands. Obstinate Eleanor held out, arguing that she had been cheated of two-thirds of her dower income for the last twenty-seven years, and demanding the arrears. Henry bestowed ten more manors on her, and though she remained far from reconciled, she signed the treaty, with the stipulation that fifteen thousand marks of the compensation due Henry be held in escrow for two years until her dower was settled to her satisfaction.

While Eleanor fought for her personal claims, Henry sought to overturn the constitutional revolution of the Provisions of Oxford, and in 1262 obtained a papal bull revoking them. The barons refused to accept the pope's verdict and turned to Louis IX for arbitration, but meanwhile prepared to fight. In 1263 Simon de Montfort took his family to visit the king in London for several months, apparently in an attempt to mediate the quarrel. But late in the summer Eleanor and the children ominously returned to Kenilworth, which Simon had strengthened with siege machinery brought over from France.

In January 1264 Louis IX announced his decision on the Provisions of Oxford, which he found incompatible with royal authority. Untroubled by the fact that Louis had been their arbiter, the barons at once took the field, with Simon as their

commander. The two armies, baronial and royal, met in battle at Lewes, near Brighton. Pitched battles were uncommon in the warfare of the Middle Ages, and when they occurred the outcome was likely to be unpredictable and decisive. At Lewes, Simon and the barons won a dramatic victory, the king, his son Edward, and his brother Richard of Cornwall all becoming Simon's prisoners.

That Christmas, the Montforts celebrated at Kenilworth with royal splendor, almost as if Simon were king and Eleanor queen, entertaining alike allies and associates of doubtful loyalty, as well as their royal captives.

The dazzling Montfort triumph proved momentary. Success was fatal to baronial unity, while forces loyal to the king rallied. In March, after a "parliament"—a meeting of magnates prefiguring the later institution—that aired some of the divisions, the Montfort family gathered for a last reunion at Odiham before the renewal of war. On April 2 Simon took leave of Eleanor and went off to marshal his forces in Wales.

On the home front at Odiham, Eleanor continued to entertain numerous guests: the abbot of Waverly, the prioress and nuns of the convent of Witney, who embroidered an Easter cape for her chaplain, the prioress of Amesbury, local knights and ladies. She ordered a miniver-trimmed Easter robe for her daughter, as well as two pairs of shoes, twenty-five gilded stars to decorate her cap, a black satin hood, and a scarlet robe. At one point the daughter was evidently ill, for a horse was sent to Reading to bring back a barber to bleed her.

At the same time, Eleanor sent presents to her captive relatives: eels, hakes, and figs to her nephew Edward, now confined at his own castle of Wallingford; spices, wine, and scarlet cloth for her brother Richard of Cornwall, still a prisoner at Kenilworth; a robe, tunic, and cloak of "rayed" or striped cloth for Richard's son Edmund.

Dover Castle, the Channel stronghold commanded by Eleanor de Montfort in 1265. *Department of the Environment.*

In June Eleanor moved on to the castle of Portchester, near Portsmouth, and finally, escorted by her son Simon at the head of a strong force and accompanied by a train of hired or borrowed horses and carts, to the great castle at Dover. Some of her baggage was even sent by sea, indicating the intention of a prolonged stay at this major stronghold. It was important to keep the support of the strategic Channel coast towns, and in Winchelsea she stopped to entertain the leading citizens, feasting them on two oxen and thirteen sheep. Three days after her arrival in Dover she invited citizens of Sandwich to dinner, and

a month later the burghers of both Winchelsea and Sandwich were once more entertained.

Leaving his mother in command of Dover, young Simon led his own band off to Kenilworth, where his father was to join him. As the summer passed, provisioning crowded Dover became a problem. Wagons and boats were sent out to bring fodder and food. By August Eleanor's manors could no longer provide meat for the castle, and oxen and sheep were obtained by foraging.

Suddenly that problem lost its urgency. Early in August messengers brought news of catastrophe. Simon's army had been surprised and routed near the abbey of Evesham. Simon and their son Henry were killed.

Overcome by shock and grief, Eleanor donned mourning and refused food for several days. Then she pulled herself together and sent a message to her brother seeking reconciliation. Henry did not reply.

Her sons wanted to keep on fighting. On August 11 Richard, the youngest, arrived at Dover by sea at the head of a hundred men, while young Simon, in command of the garrison at Kenilworth, prepared for a siege.

In September a parliament met at Winchester. Distraught Eleanor sent messengers but got no more reply than she had from the king.

The baronial cause was clearly lost and with it the Montfort family fortunes. Eleanor still held two cards: the royalist prisoners in Dover Castle, now hostages for her own safety, and a large sum of money, the war chest collected by the barons and entrusted to her keeping. Henry had ordered the Channel ports closely watched, but Eleanor succeeded in getting Richard, Amaury, and the money out of Dover and across the Channel. She was less successful with her own household belongings, which were captured by pirates.

In October the hostages bribed their guards, freed themselves,

and attacked the garrison from within while Prince Edward launched an assault from outside. The disheartened garrison was overpowered, and Eleanor forced to surrender. Edward, more generous or less aggravated than his father, agreed to receive back into his favor the chief followers of "his most dear aunt, the lady countess of Leicester."[13] He even agreed to restore the lands of these lesser rebels, but Eleanor and her children were sentenced to banishment and confiscation. At the end of October she and daughter Eleanor sailed from Dover to take up residence, like a pair of wealthy penitents, in the Dominican convent of Montargis, south of Paris. She was fifty years old.

At Montargis in the following year (1266) she received the news of the prolonged siege of Kenilworth, where young Simon, refusing generous terms and holding out to the bitter end, was finally overcome by starvation and dysentery among his men. Even as the castle surrendered in December, Simon escaped, hid out in the fen country for months, and eventually made his way to France.

Eleanor, far from retiring from the world, made the convent at Montargis a new headquarters to fight her legal battles, with more success than the family had enjoyed in the civil war. The French parlement in 1267 decided the case of her claims on her mother's land in Angoulême in her favor; when her stepbrother the Count of La Marche was slow in paying, Eleanor successfully appealed to Louis IX, who ordered the count to pay up and directed his seneschal to enforce the order.

Louis went further, sending arbiters to England to mediate Eleanor's English claims and obtaining generous terms: young Simon was to be allowed to resume possession of his father's lands, with the stipulation that the king or one of his sons could purchase them at a price set by Louis. Eleanor was to have five hundred pounds a year for her dower lands in England. For a

moment reconciliation seemed at hand, but Henry, after agree-
ing to the settlement, refused to carry it out. Backed by Louis,
Eleanor took her case to the Papal Curia, where Pope Clement
promised her a hearing despite Henry's objection.

At this point Eleanor's sons Simon and Guy put an end to all
hopes by a foolish act of violence. In Italy to seek their fortunes,
they waylaid Henry of Almain, Richard of Cornwall's son, in a
church in Viterbo, killing him in revenge for what they re-
garded as his treachery to their father's cause. Simon died in
hiding within a year, and Guy later in a Sicilian prison.

In 1272 the aging Henry III died at Westminster. Prince
Edward, now Edward I, returning home from Louis IX's last
Crusade, wrote his chancellor from France: "We . . . have re-
mitted to Eleanor, Countess of Leicester, all indignation and
rancor of our mind which we had conceived against her on
account of the disturbance lately had in our realm, and we have
admitted her to grace and our firm peace."[14] Eleanor was to be
allowed to plead against the king or anyone else for her rights.
During his stay in Paris, generous Edward loaned his aunt, as
usual in need of cash, two hundred pounds. Soon after, he
restored her dower lands and ordered the Marshal heirs to an-
swer to the Exchequer for the money they owed Eleanor.

Eleanor briefly enjoyed her improved financial condition be-
fore dying on Easter Eve, 1275, at the age of sixty, in the
convent of Montargis. Not until nine years later were final pay-
ments made settling the law case she had pursued through the
courts of England and France for forty-four years.

Eleanor's daughter and namesake, betrothed before Simon's
death to Prince Llewelyn of Wales, sailed from France with her
brother Amaury late in 1275, but was intercepted by King Ed-
ward who saw their arrival as a threat. He imprisoned Amaury
in Corfe Castle and kept Eleanor under surveillance at court for
three years before allowing her to marry Llewelyn. She inter-

ceded for her brother's release "with joined hands, bent knees, and tearful sobs,"[15] and in 1282 her brother was freed. Two months later Eleanor died in childbirth. Her daughter was brought up in England by nuns of the order of Saint Gilbert of Sempringham, where she lived in obscurity until her death in 1337. Amaury never regained his English estates. By the end of the century the entire Montfort family had disappeared.

So ended the story, not lacking in drama, romance, and tragedy, but also including avarice, banality, and pettiness, of the real-life model of a heroine of medieval romance.

8

Piers Plowman's Wife

Most of our information about the Middle Ages, political, social, economic, is concerned with the tip of the iceberg, the perhaps one percent of the population—kings and queens, prelates, lords, ladies—that ruled the other ninety-nine percent. In addition, the developing (and literate) middle class of merchants, merchant-craftsmen, notaries, and officials contributed to the historical sources letters, accounts, cartularies, and diaries. But the bulk of the medieval population, the peasants whose surplus agricultural products supported the royalty, aristocracy, and clergy, the class that, in the words of an eleventh-century bishop of Laon, "owns nothing that it does not get by its own labor," and that provided the rest of the population with "money, clothing, and food.... Not one free man could live without them,"[1] remained illiterate and, for the historical record, largely inarticulate.

Yet the peasants did leave records: custom books, manor accounts, tax surveys, and manorial court rolls. The custom books tell us how much land was held by different tenants and what services they owed the lord of the manor at various seasons of

the year. The accounts tell us what crops they raised, what were the average yields per acre, what uses the crops were put to—sold, paid out as wages, malted for ale—what servants and laborers were employed, by whom and for what pay. The tax surveys give us the value of land held by different tenants, as well as what livestock they owned. The rolls of the manorial courts—the lowest in the judicial hierarchy of the Middle Ages, and the only ones in which most of the peasants ever appeared—are the richest source of information, registering transfers of property and recording legislation as well as court cases that give us vivid if fleeting glimpses of village life.

This chapter will focus on the women of the small English village of Cuxham, population something over 110 in the mid-fourteenth century, located in Oxfordshire (northern Midlands), a settlement with unusually complete records, and affording a classic example of the medieval village community and of the manor—the lord's estate farmed by tenants who owed him rents and services. In Cuxham, village and manor coincided, which was not always the case. Information about other English villages and other peasant women will be used to fill out the picture.

The unusual lord of the manor in Cuxham from the latter half of the thirteenth century was the Oxford college of Merton, its warden and fellows. The situation came about in the following way: in the 1230s the lord, a bon vivant named Ralph Chenduit, had quarreled with the Abbot of St. Albans and been excommunicated. According to Matthew Paris, one day in front of many people at Westminster Ralph jeered, "Look at the monks of St. Albans, just look at them! Why, they have excommunicated me for so long, and so often and so well, that here I am, hale and hearty, and so fat that my saddle will hardly hold me when I ride."[2] But Divine Providence and cholesterol caught up with Ralph, who soon afterward had a stroke and died, to be succeeded by his son Stephen. A courtier and close

friend of Earl Richard of Cornwall, Stephen borrowed so freely from the Jewish moneylenders that he was forced to sell the manor to the king's chancellor, Walter Merton, who used the investment to endow a house of scholars he had founded at Oxford.

At the center of the village stood the twelfth-century church and the walled "curia," the nucleus of the demesne (the land held directly by the lord), with its hall, kitchen, bakehouse, dairy, barns, pigsty, granary, dovecotes, byre, latrine, yard where straw and hay were stacked, malting house, and fishpond. The houses of the village straggled along the southern bank of a small stream, with a handful of cottages of the poorer peasants on the opposite bank. The long narrow strip of settlement formed an island in a sea of undulating furrows on every side.

The proportion of free and unfree tenants in English villages varied greatly, a community with many free peasants sometimes existing side by side with one where most of the villagers were unfree; the former might be due to Danish colonization, the latter to an earlier Anglo-Saxon settlement. In the early thirteenth century Cuxham had several free tenants, who held their land clear of most labor services and paid money rents, but by the 1290s there was only one freeholder, Robert ate Grene, with two houses (one of which he sublet) in the village and fourteen acres in the fields. The ate Grenes (whose name derived from their original house, near the village's Lower Green) were the wealthiest family in the village, their holdings assessed at about a third as much again as the wealthiest of the unfree tenants. When Robert's son John married Matilda, a daughter and heiress of Hugh Frelond of Watcombe, the family acquired a substantial amount of land in nearby Watlington. The ate Grenes owned not only their own oxen, but a flock of sheep, and apparently drew their income chiefly from wool.

Less well off than the ate Grenes, but one of the more pros-

perous families of the village, were the Benyts, whose house
with its yard and garden stood near the center of Cuxham, only
the church between it and the curia. Robert Benyt was a leading
villager, who served as reeve (manorial overseer) for twenty-
three years. The Benyts had sufficient land to support
themselves—strips of arable in the village's three fields amount-
ing to a "half-virgate" of about twelve acres; in other villages the
better-off peasants held from fifteen to thirty-six acres in the
fields. Yet the Benyts were villeins—unfree—subject to a
number of fines and disabilities and, most important, owing
labor services to the lord of an average of two days a week, plus
special services at harvest time. By the thirteenth century these
labor services were pegged to prices—day labor such as digging,
muck spreading, threshing, 1 penny, or 1½ pence at harvest
time; mowing, 2 pence; carrying services with a cart on the
demesne, 1½ pence at harvest time—and were often "sold,"
that is, the tenants contributed money in lieu of the services,
which were performed by hired laborers or demesne servants.

Lowest on the village economic scale were the poor cottagers.
Typical of these were Henry le Dryver and his wife, who lived
north of the stream, whose land was insufficient to provide a
living, and who had to hire out to their richer neighbors or to
the lord's demesne. The Dryvers were also villeins. In some
villages this poorest element was, like the wealthiest, legally
free, though such freedom, without land, was worth little. In
Cuxham the cottagers held their land by individual contract.
Henry le Dryver held his for the duration of his own and his
wife's life. They paid small money rents, and were required to
do up to six days' work on the demesne at harvest, and some-
times such services as making and stacking the lord's hay and
moving the sheepfold (to spread its manure). They too had their
own holdings in the arable fields, but no more than three or
four acres.

Villein or free, rich or poor, the peasant's wife was a partner

to her husband in a way that the lady of the castle, whatever her responsibilities, was not. And, the obverse of the partnership, she fully shared her husband's day-in, day-out drudgery. Her "inside" work was not merely service, such as cooking and cleaning, but production and manufacture of the family's food and clothing. She milked the cows; soaked, beat, and combed out the flax; fed the chickens, ducks, and geese; sheared the sheep; made the cheese and butter; and cultivated the family vegetable patch. Sometimes she spun and wove to eke out a cash income. She also worked along with her husband "outside"—sowing, reaping, gleaning, binding, threshing, raking, winnowing, thatching. At times she even helped with the plowing, wielding the goad that drove the oxen while her husband gripped the handles of the plow.

Like the castle lady's, the peasant woman's life was intricately involved with landed property. The village holding, in an area like Cuxham where traditional open-field agriculture was practiced, usually passed to a single heir. There were two reasons for this arrangement: from the peasant's point of view, the holding could normally support only one family; from the lord's point of view, keeping the holding intact meant a stable arrangement for rents and labor services. If there were sons, the heir was usually the oldest son. Preference was given to male heirs, but daughters inherited if there were no sons—sometimes the eldest daughter, sometimes an unmarried daughter who had remained at home. In some places, the holding was divided among the daughters, but not at Cuxham; when Robert Benyt's widow Alice died in 1343, her daughters Matilda and Joan, who had married outside the manor, did not share in the inheritance, which passed intact to still unmarried Emma.

For both women and men, marriage on the peasant level remained closely connected to inheritance. The daughter who inherited became a matrimonial prize. In many villages she had to marry to take possession of the holding, on the theory that a

woman could not work the land by herself. Sometimes she was fined if she did not marry, and the lord of the manor even chose her husband. But the male heir, too, was expected to marry, and a wife and family were regarded as indispensable to his operating the holding. Normally he alone was allowed to marry. His brothers could stay and work for him, but if they wished to marry they had to leave the village and seek their fortunes elsewhere.

This intimate connection between the land and the family bloodline was considered more important than male domination of inheritance. The feeling of right to land through blood was so strong that it triumphed even in periods when the competition for land was intense and the respect for law was weak. In spite of the fiction under which feudalism operated—that all land in England belonged to the king, who granted it to his barons, who in turn granted it to lesser lords, who granted it to

Milking the cow, thirteenth century.
Bodleian Library, MS Bodley 764, f. 41v.

the peasants—a pervasive sense of hereditary rights prevailed among the peasants, as among the barons. The man who married an heiress often took her family's name, so that it remained attached to the holding. If they had no children, the land reverted to her family on the wife's death; if there was an heir, the husband was allowed to hold the land for his lifetime, after which it went to the child, who was thus regarded as his wife's heir rather than his own, and kept the land in the family's name and bloodline.

Sometimes the same principle applied to widows as to heiresses; in Cuxham, Robert Waldrugge, who later succeeded Robert Benyt as reeve, married Agnes, widow of Robert Oldman, and changed his name to Robert Oldman; Gilbert Bourdoun, who married Sarah, the widow of Robert le Wyte, was usually afterward called Gilbert le Wyte. Like the husband of the heiress, the man who married a widow was regarded as a kind of custo-

Feeding the chickens, peasant woman still holds her distaff under her arm. *British Library, MS Add. 42130, f. 166v.*

dian, who could keep the land for life if the marriage produced an heir, but after whose death the holding reverted to the original bloodline.

The marriage of the peasant woman was always arranged, but she had an advantage over the lady of the castle in that she at least knew the man she was to marry. Usually the groom's father initiated the proceedings, sometimes with the intervention of a go-between who negotiated with the girl's father. The two men discussed the girl's dowry—not land, but money or chattels, clothes, furniture, tools, utensils, livestock—and the lands with which the groom would endow her at the church door. Finally both fathers presented themselves at the manorial court. If the girl's parents were unfree, they had to obtain permission for her to marry, and pay a fine (merchet). If she married outside the manor, they had to pay an additional fine. Thus widow Alice Benyt, a villein, paid not only merchet but extra fines in 1328 and 1331 when her daughters, Matilda and Joan, married outside the village.

In contrast to the child marriages of royalty and nobility, peasant unions typically involved people in their twenties or older. The bride's age at marriage was determined by the availability of marriageable men; the groom often did not marry until his father died. A living father might turn over his holding to a son, who agreed to furnish his parents a room and a ration of food. This custom was immortalized in the medieval story "The Divided Horsecloth," which exists in several versions, the most common of which is: a peasant, whose elderly father has retired in his favor, grows tired of supporting him and decides to turn him out of the house, the peasant instructs his young son to fetch the old man a horse blanket and send him on his way. The boy cuts the blanket in two and gives his grandfather only half, explaining to his father, "I will keep the other half until I am a man, and then give it to you."

Most parents did not leave the arrangement to chance and

Medieval peasant women carried milk on their heads like women in modern developing countries. *British Library, MS Add. 42130, f. 163v.*

children's gratitude, but took care to have the details spelled out
in manorial court, with infractions punishable by fine. In the
Ramsey Abbey manor of Ellington in 1278, William Koc ad-
mitted that he had not paid his father the grain, peas, and beans
that he owed him for the year, as part of the arrangement by
which the older man had surrendered his land; a new agreement
was made, and William's two pledges, peasants who had vouched
for him, were fined sixpence each (not as trifling a sum as
it sounds at a time when pennies were silver).

In 1294 one family at Cranfield, another Ramsey Abbey
manor, even made allowance for the possibility that the old
couple and the younger might not get along together. Elyas de
Bretendon and his son John agreed that John would provide
lodgings and "suitable food and drink" for Elyas and his wife
Christine in his house, but in the event that "trouble and dis-
cord should in the future arise between the parties so that they
are unable to live together, the above John will provide for Elyas
and Christine, or whichever of them should outlive the other, a
house and curtilage [yard] where they can decently reside," as
well as specified amounts of grain, peas, and beans. In the event
of a quarrel, the older couple would also retain all their furni-
ture, tools, and other belongings.[3]

The marriage agreement was followed by betrothal, in which
the couple joined hands, the man gave the woman a ring, and
they "plighted their troth." In the countryside, the distinction
between the wedding ceremony and this rite, something more
than an engagement and something less than a marriage, was
even more ambiguous than in castle and city. The betrothal was
often followed by a feast and by the couple's going to bed, the
church ceremony postponed until the woman was pregnant, or
sometimes until after she had had a baby—perhaps to assure the
groom that she was not barren.

Many peasant women did not marry, thanks to the shortage

Women also worked at "outside" jobs; here a woman is gleaning.
Bodleian Library, MS Add. A 46, f. 14v.

of eligible landholding partners. A girl might remain on her father's land and work for her brother in return for food and lodging; or she might leave, taking with her the dowry that would have been hers if she had married. She might become a servant in another village household. Peasants, and not necessarily the most impoverished, frequently put their daughters out to service in other peasant households in return for wages and clothes. Or she might become one of the *famuli*, the permanent workers on the manorial demesne, including house servants and farm laborers. At Cuxham, the *famuli* slept in rooms next to the kitchen of the curia and ate in the hall. Some were women— usually the dairy assistant and the woman who prepared the malt for ale. Women were also often among the hired laborers, forming a valuable reserve at harvest time, or when a sick tenant had to hire a substitute to perform his labor services for the lord. They did much the same work as the men: haymaking, weeding, thatching, mowing, reaping, and binding. Sometimes they lived in the village, in cottages, or as lodgers in other people's houses. Sometimes they formed part of the floating population that roamed the country at harvest time.

Wages for women were often lower than for men, particularly in the case of the *famuli*. Dairymaids were typically paid less than male plowmen, carters, and herdsmen. Women were also often paid less for the same work; but on the other hand there is evidence, at least in the late Middle Ages, that in many places independent female laborers gained the same wages as men for the same manual jobs.

One recourse for single girls of the aristocracy and the wealthy merchant class—the convent—was not normally available to peasants. The demand for women's labor on the land fortunately made this outlet less necessary to peasant girls whose families could not afford the dowries which convents demanded, and whose low birth usually excluded them to begin with.

How did the peasant woman's life compare in material comforts with that of the lady? The lady lived in a commodious if drafty castle or manor house equipped with a sufficiency of clumsy, cushionless furniture. She wore garments of silk, fine wool, and fur, drank wine, and ate meat, eggs, and fish.

In comparison, a better-off peasant woman like Alice Benyt or Matilda ate Grene of Cuxham, while living above the subsistence level, fared less well on all counts; while cottagers like Henry le Dryver's wife barely managed to keep alive. At best village houses were insubstantial, usually of timber-frame wattle-and-daub construction; that is, with the spaces between the framing filled with oak or willow wands covered with mud and straw. Roofs were thatched with straw. The poorer peasants' cottages often consisted of a single room, but houses of the better-off peasants in Cuxham all had at least two. The hall— the main living quarters—had an open hearth in the center, the smoke venting through the roof. The floor was earth, covered with rushes. Sometimes one end of the hall was divided vertically by a platform, creating a loft reached by a ladder, where children and servants slept. In the second downstairs room slept the householder and his wife. Occasionally there was an additional room for his parents. The interior of the house was dark, drafty, and when the fire was going, smoky. Windows were shuttered, not glazed. A separate lean-to served as kitchen, and outbuildings housed the livestock. In addition to their homesteads, and apart from their strips in the arable fields, the half-virgaters had enclosed plots where they could raise vegetables or additional grain, or even cultivate a bit of orchard.

Most villages contained a few craftsmen: miller, carpenter, smith, butcher, tinker, and often a handful of clothmakers— weaver, tailor, dyer, fuller. Merton College erected a water-driven fulling mill in Cuxham in 1312, presided over by Robert le Degher (Dyer); there were also tenants named Taylor, at least one of whom seems to have plied that trade, leading to the

conclusion that though peasant women spun their own yarn and wove it into cloth, cloth and even garments could usually be purchased in the villages.

A peasant woman's wardrobe was limited, the garments bequeathed from one generation to the next. Her everyday garb was a long dress of coarse wool—russet or burel—perhaps with a linen undergarment; in cold weather she wore a woolen mantle. Servants wore their mistresses' hand-me-downs. On the manor farm the *famuli*, as part of their perquisites, received "robes," a set of garments including a pair of tunics, one worn over the other, and a cloak.

In the absence of cabinetmaking and upholstering techniques, the main difference between the furniture of the castle and that of the peasant's house was profusion. The typical dwelling in the village had a trestle table, a couple of benches and stools, a chest for storage, a bed or simply straw mattresses, and bedding. The peasant woman owned an iron cooking pot or two, and ate and drank from wooden bowls, cups, and spoons, with some coarse pottery ware.

Her diet, in contrast to that of the castle lady, was largely carbohydrate—bread, pottage of barley with some beans or peas, and ale brewed from barley or oat malt. Most of the half-virgaters of Cuxham owned a cow and could supplement their diet with milk and cheese; some had chickens and pigs, but feeding livestock over the winter was a serious problem. On the manor farms, animals were stall-fed with hay, oats, peas, and beans, carefully measured out, and often limited to the plow oxen and breeding cows. On peasant holdings, livestock competed with human beings for food, and therefore had to be kept to a minimum number.

Contrary to some assertions, the typical medieval village household was not an extended family. At most it comprised grandparents, the married eldest son and his wife and children, any unmarried brothers and sisters who remained on the hold-

ing, and perhaps a servant or two. At its smallest, it consisted of a single widow or widower, or an unmarried man or woman. If this solitary householder married, as he was frequently under pressure to do, another nuclear family was formed, which might evolve into the three-generation household.

The number of children was seldom large. No chroniclers listed the names of peasant offspring to tell us which died and which survived, nor were there yet registers of births and deaths, but apart from infant mortality, doubtless highest among the peasants, late marriages and early adult deaths held the birth rate down. Necessity may also have led to abortion or to such contraception as was available, since a family holding could feed only a limited number of mouths. Overall, throughout Western Europe, population grew slowly in the thirteenth century, but in the early fourteenth, even before the Black Death (1347), growth seems to have halted or even declined.

The prominence of widows on the village scene indicates that if a woman survived the perils of childbirth she had a good chance of outliving her husband. Various provisions were made for widows. As we have seen with Cuxham's cottagers, a family might occupy a holding under leases for the life of a husband, his widow, and one or more of their sons or daughters. Another means, available only to the fairly well-to-do peasant, of providing for a widow (or widower) after a son had taken over the family property was to purchase from a monastery a kind of old-age or disability pension called a "corrody," which consisted of a daily ration of bread and ale, with a dish of pottage from the monastery kitchen. Firewood, a room, a servant, a new robe, shoes, and underlinen once a year, candles, and fodder and stalling for horses might be included, and sometimes a house and garden. Some corrodies were modest, providing the bare necessities; others were elaborate, like the corrody purchased in 1317 from Winchcombe Abbey for the considerable sum of 140 marks that provided a woman with a daily ration of two "monk's

loaves" of bread and one small white loaf, plus two gallons of convent ale, as well as a yearly ration of six pigs, two oxen, twelve cheeses, a hundred stockfish, a thousand herrings, and 24 shillings' worth of clothing.

In some villages the widow took over her dower—her "free bench," as it was called in England, referring to the widow's right in former times to a special seat by the fire—a third or sometimes half of the holdings according to common law, hers for life, reverting to the heir on her death. But in other areas local custom provided much more generously for widows, who inherited the entire holding in a kind of community-property or co-tenancy arrangement. Unlike most tenants inheriting land, the widow usually did not have to pay an entry fine, a substantial sum of money.

Such a widow might then turn the land over to her son. In 1312 when John Bovecheriche (Near-the-Church) of Cuxham died, his widow Joan inherited, but yielded the house in the village and half-virgate in the fields to her son Elias, retiring to a cottage that had also been part of John's holding. Sometimes the son agreed to build his mother a cottage and furnish her with stated amounts of food and clothing. Or she went on living at home in "a room of her own at the end of the house," with her son and his wife, who provided her with rations of food and drink, clothing and shoes.

Like the agreements of fathers who retired in favor of their sons, these compacts between mother and son were strictly enforced by the manorial courts. For example, at the Ramsey Abbey manor of Warboys in 1334, Stephen the Smith was fined sixpence because he "did not keep his mother according to their agreement," and the jurors ordered that the land should be returned to Stephen's mother for the rest of her life, "and the above Stephen may not have anything of that land while his mother is alive."[4]

A widow who inherited might, on the other hand, remain to

work the land herself. In some manors, widows who inherited holdings were pressured to remarry. In Cuxham widows as a matter of course took over their husbands' land and often worked it themselves for years. Robert Benyt's widowed mother Cecilia remained in possession of the family holding during the first decade of her son's reeveship. After Robert's death in 1311, his widow Alice continued to operate the holding herself for over thirty years, never remarrying. Her constancy earned her a new surname, Revelove, by which her daughter Emma also became known.

When an unfree tenant died, the lord exacted a fine, the "heriot," usually his best beast—"even if he has only a single animal, the lord shall have it," said a Cuxham court roll.[5] The heriot was recognition of the rights of the lord over the chattels—the personal property—of the unfree tenant, just as the fine the successor paid on taking possession of the property was a recognition of the lord's rights over the land. Alice Benyt paid a cow as heriot in 1311 when her husband died, her daughter Emma another cow in 1343 on Alice's death, and Emma's heir a third cow in. 1349. The parish church claimed a "mortuary" of the second-best beast. Occasionally a tenant left no animals at all. When Adam ate Hethe of Cuxham died in 1316 his heriot was a brass bowl. In an Evesham Abbey manor in 1271, a dispute arose over heriot and mortuary of a tenant who had transferred his holding to his son and kept his only movable property, a cow, until his death. The manorial court jury said that since neither father nor son had accumulated any goods in all their lives, the only mortuary the parish church could claim was a tunic; but the church finally took a half-share in the cow, the other half to go as the lord's heriot. On a manor in Sussex in 1322, a widow took over her husband's holding until their son was of age, paying a heriot of "one little pig worth 8 d."[6]

Alice Benyt, without any sons, had to depend on hired labor

to work her holding and to provide the labor services she owed on the demesne—in addition to the average of two days' work a week, two men to work two days at harvest and one man to work one day. Sometimes these hired laborers were permanent residents of the village, cottagers, or landless people; sometimes they were itinerant agricultural laborers, like the "strangers" harbored at harvest time in Cuxham by six of the villeins and two cottagers in 1295, for which they were fined. Alice also owed customary rents at certain times of the year: at Michaelmas (September 29) a quarter of wheat for seed; at Martinmas (November 11) half-pence plus a peck of wheat, four bushels of oats, and three hens; at Christmas a cock, two hens, and either two loaves or sixpence. She was responsible for keeping her own outbuildings in repair, which may also have required hired labor.

Occasionally women landholders contracted with their neighbors to help with heavy work—haying, plowing, manuring—paying with a portion of the crop. Or they leased their land to someone outside the family, who engaged to provide them with food and lodgings. Margaret at the Green of the Ramsey Abbey manor of Girton made such an agreement in 1291 with Thomas Rodbaund, leasing him a half-virgate of land in return for an allowance of wheat, barley, and "two shillings of silver," plus

> a residence for Margaret in a certain solar [room on the upper story] in his hall. And in the same home where Thomas and his family live he will allow Margaret to eat at her own expense separate from the vessels and food belonging to Thomas. . . . And he will bake bread for Margaret whenever he bakes his own bread. And Margaret will also have a cow in the courtyard of Thomas at the expense of Margaret in the summer and of Thomas in the winter. And the same Margaret may keep a pig, a hen, and five chickens all year in the courtyard of Thomas at her own expense.[7]

Widows who were unable to provide the services they owed the lord and to maintain their buildings were liable to fine and even forfeit of their land; on the Ramsey Abbey manor of Abbots Ripton in 1299 a widow named Alice atte Dam was accused of not performing labor services and letting her house and outbuildings fall into disrepair, and had to find pledges to guarantee that she would improve her performance.

Village women occasionally engaged in business activities—most prominently in the brewing of ale, drunk in vast quantities by the peasant class. In Cuxham, where most of the villeins brewed ale at one time or another, the most frequent brewers were men, but elsewhere women predominated, and in some places a lively competition flourished between brewers, both male and female.

Similarly, one village office was from time to time filled by women—that of ale-taster, appointed to test the ale brewed in the village, to determine whether it was up to the standard set by the royal assize of ale. The ale-taster regulated brewing practices, and had to be a responsible, sensible, and mature person, who served under oath and was liable to fine if the office was not properly performed.

Women in the villages sometimes pleaded their cases in person in the manorial courts, and sometimes like the men "owed suit to"—in other words, were bound to attend—the courts. But like castle ladies, their political role was limited. Women were never reeves or constables, they never headed the groups known as tithings, formed for police purposes, and they were not included among the respected villagers who had the responsibility of forming the juries (medieval juries were not judicial bodies, but sworn witnesses) of the manorial courts.

In the villages, women's legal status generally compared quite favorably with that of the castle ladies in terms of independence, inheritance customs, and responsibilities shared with men. Where Alice Benyt inherited her husband's entire holding,

Eleanor de Montfort was entitled to a third, and had to fight for
that. As Christine de Pisan wrote: "Although they are fed with
coarse bread, milk, lard, and pottage, and drink water, although
they have care and labor enough, yet is their life surer, yes, they
have greater sufficiency than some that are of high estate."[8]
Nevertheless, legal advantages hardly outweighed poverty and
toil. In Chaucer's words, describing the widow of the "Nun's
Priest's Tale," owner of Chanticleer:

> Sooty her hall, her kitchen melancholy,
> And there she ate full many a slender meal;
> There was no sauce piquante to spice her veal,
> No dainty morsel ever passed her throat. . . .
> She drank no wine, nor white nor red had got.
> Her board was mostly servéd with white and black,
> Milk and brown bread, in which she found no lack;
> Broiled bacon or an egg or two were common . . . [9]

In *Piers Plowman's Creed*, William Langland presents a
memorable picture of a poor peasant couple at work in the
fields:

> His coat of the cloth that is named carry-marry,
> His hood full of holes with the hair sticking through,
> His clumsy knobbed shoes cobbled over so thickly,
> Though his toes started out as he trod on the ground. . . .
> Two miserable mittens made out of old rags,
> The fingers worn out and the filth clotted on them,
> He wading in mud almost up to his ankles,
> And before him four oxen, so weary and feeble
> One could reckon their ribs, so rueful were they.
> His wife walked beside him, with a long ox goad,
> In a clouted coat cut short to the knee,
> Wrapped in a winnowing sheet to keep out the weather,
> Barefoot on the bare ice, so that the blood flowed.
> And at the furrow's end lay a little bread-bowl,
> And in it lay a little child, lapped in cloths,

adame fesonas tenes au roi parler
hertes dist la pucelle ia ne le quier tier
ors dreche en souriant son douch viaire cler
elleot biel ꝧ bn fait por aler enamonter
re dist elle au roi ne me deues celler
la foi ke deues a vos barons porter
la haute roine doit vos voi coroner
ꝯ me dites le voir gardes vous de fauser
nels ij choses vos font plꝰ de bn en amer
ame ce dist li rois bn le sarai monstrer
ouenirs ꝗ espoirs moi vienent oforter
ut ie sui a meschief de mes maus endurer
por tut men lo mies ꝗ plꝰ men doi loer
e de quatre ie puis eniuers mꝰ trouer
ouenirs moi secourt encore desterer
ouenirs moi ramasne ꝗ il me voit irer
ouch vis ꝗ douch samblat bel tenir bel aler
ouenirs me va querre sens point del arrester
ouch espoir saucrous por moi reconforter
ꝗ chil doi se vienet deles moi aiouster
l nest riens en che monde ki me puisse grener
re dist la pucelle biel saues recorder
anꝰ ꝗ de ses biensꝗ le doue ꝗ lamer
nt dame fesone ot demander son plaisir
u roi ki pas ne met ꝗ pas ne vuet metir
oir pla pdoiꝰ a trait ꝗ par loisir
re dist la pucelle plꝰ ne me vuel tasir
ꝯ me dites le voir gardes vous de faslir
e ia vos puist amours nul seruiche merir

Peasant woman carrying baby in cradle.
Pierpont Morgan Library, from Voeux de Paon, Glazier Collection, **24,** f. **34.**

And two of two years old upon another side,
And they all sang a song that sorrowful was to hear;
They all cried an anguished note.
The poor man sighed sorely and said, "Children, be still!"[10]

Not all village women, even those of villein status, shared such wretchedness. Alice Benyt had the enterprise and wherewithal to buy land outside Cuxham, while Cuxham's only free tenant family, the ate Grenes, grew steadily richer, buying up scattered acre and half-acre strips in neighboring parishes, subletting property in Cuxham, and practicing sheep farming. Their descendants in the sixteenth century moved to Henley, to seek their fortune in town and become part of the rising middle class.

9

A City Working Woman: Agnes li Patiniere of Douai; Women and the Guilds

"In making cloth she showed so great a bent/She bettered those of Ypres and of Ghent,"[1] says Chaucer of his Wife of Bath. Women throughout history have plied the several arts of clothmaking, but in the Middle Ages they came for the first time to play an outstanding role in a commercial textile industry. Ypres and Ghent were two of the principal cloth towns of Flanders, a region of northwest Europe favored by nature for textile manufacture. Lying just across the Channel from the pastures where England's long-fleeced sheep grazed, Flanders possessed a soil that was congenial to dye plants, contained an abundance of fuller's earth, and was watered by streams needed for cloth finishing.

As clothmaking made the momentous transition from home industry to organized production for profit, men took over most of the looms and many of the other functions, but women did not retire from the trade. On the contrary, the major part of the

population of every Flemish and Italian cloth town, men, women, and children, was conscripted into the new "putting-out system." An insight into the operation of this historic medieval innovation and its social implications for women and men is furnished by a unique parchment document of about 1286, found in the town hall of Douai (now in France, then in Flanders), that attests to the thirteenth-century existence of, among others, Angnies (Agnes) li Patiniere, daughter of Druin le Patinier and wife of Jehan Dou Hoc. Consisting of eleven sheets sewn together end to end in a roll five and a half meters long, the document is the minutes of a legal proceeding against the estate of Agnes's employer, Douai wool merchant Jehan Boinebroke, by forty-one of his former workers and some others. Agnes's family were in the textile-dyeing branch of the wool-cloth industry, specializing in the blue dye extracted from the leaves of the woad plant. Dyeing was occasionally done while the wool was in its original raw form ("dyed in the wool") but typically either the spun yarn or the woven cloth was treated by dipping in a tub of hot water containing the dye matter along with alum, a fixative, and wood ashes as a tempering agent. Despite using wooden poles, the men and women in the trade were universally recognized by the color under their fingernails.

Agnes's family probably lived on the edge of a canal fed by the Scarpe river that runs through the center of Douai, in a two-story wooden dwelling little different from the thousand others that housed the town's labor force. Like all medieval cities, Douai presented an aspect somewhat like that of a nineteenth-century small town of the American Midwest, though compressed by walls into a narrower space: half-urban, half-rural, with barns and stables, garden patches, orchards, fields, and public wells interspersed amid the jumble of rude dwellings that crowded the narrow streets and quais. In each house one or more families shared space with loom, stretching frame, or other equipment.

Woman carding (combing) wool. *British Library, MS Royal 10 E VI, f. 138.*

Boinebroke, in contrast, occupied a large house near the Porte Olivet, in Neuville, the more recently settled upper town where most of the wealthy patricians lived. Behind the house, on the canal, stood his own dyery, and near it an establishment for stretching cloth. He also owned a number of workers' houses which he rented (one of the plaintiffs in the suit was a tenant whom he had cheated). His rental properties were scattered throughout Douai: in the old lower town where the city had begun, on the Rue des Foulons (Fullers Street); in the marshy, low-lying quarter between lower and upper towns, where willows shaded the riverbanks, and where Boinebroke rented a

whole block of houses to his workers; and in the upper town where he himself lived.

Of the twenty-five or more crafts associated with the cloth industry (spinning, weaving, cleaning, carding, shearing, fulling, stretching, dyeing, and various auxiliary functions), some were male-dominated, some female, some mixed. Spinning, still done by distaff (the spinning wheel first appears late in the thirteenth century), remained almost wholly in the hands of women, together with many of the finishing processes, a division of labor destined to last for centuries. Dyeing and weaving were done by men and women more or less interchangeably. Twenty of the forty-one employees mentioned in the legal proceeding against Boinebroke were women. But more significant than the sexual division of labor was the familial labor force of the medieval wool industry, the association of a family group as a work unit in the putting-out system.

A Flemish entrepreneur like Boinebroke bought raw wool in England, shipped it home, parceled it out to a family to clean, spin, card, and weave, took it back and gave it to another to full, then to another to dye, and to another to stretch, tease (raise the nap), and shear. Retrieving it for the last time, he gave it to an agent to sell, typically at the nearby Flemish or more distant Champagne fairs. The working unit was not necessarily a conventional family with father, mother, and children, but might be a pair or trio of sisters, or brothers and sisters, or mother and daughters.

Work was from dawn to dusk, six days a week except for feast days, regulated by the "workers' clock" in the town hall which sounded the "morning chime," noon and afternoon "chimes for eating," and the vesper or "quit-work chime." In other respects, too, work was strictly regulated. Though in form the weavers were independent craftsmen and craftswomen, buying the raw wool from the entrepreneur and selling him back the woven cloth, they were actually proletarian pieceworkers whose factory

Women carding and spinning, using the late-thirteenth-century invention, the spinning wheel. *British Library, MS Add. 41230, f. 193.*

was scattered through the town. The minute specialization of their labor was enforced in the interest of their employers, who wanted all operations uniform. Finally, to hold labor costs down by keeping the workers in a state of dependency, they were forbidden to work for anyone except their own entrepreneur, who sat with his fellow merchants on the town council and ran the government.

The system also protected the merchants against loss through market fluctuations, war, or other calamity since at any point in the process of manufacture the entrepreneur could simply opt out, leaving the weaver, fuller, or dyer with the cloth on his hands.

Not surprisingly, the putting-out system bred class conflict. History's first strike, in 1245, was recorded among Douai's weavers, and numerous proletarian protests bloodied the streets in the cities of Flanders and Italy throughout the high Middle Ages. The largest insurrection was that of the washers and card-

ers known as the *Ciompi* in Florence in 1378. The lowest-level workers in the Florentine wool-cloth industry, the *Ciompi* were so called because of the wooden clogs they wore at work. Joined by other workers, including numbers of women spinners, warpers, and weavers, they momentarily seized power, but, thwarted by the adhesion of small craftsmen to the side of the big merchants, were routed in street fighting and suppressed as a political force.

In Douai in 1322 a much smaller conflict reflecting the same class divisions and outcome is shown in the recorded punishment of eighteen workers, including two women, who "in the full marketplace" had urged assault on grain merchants for hoarding supplies. Charged with being especially vocal, the two women had their tongues cut off before being banished from the city for life.

The document recording the legal proceedings against Boinebroke to which we owe knowledge of Agnes li Patiniere is richer and more revealing of the operation and inequities of medieval industrial society. Agnes is one of forty-five plaintiffs (forty-one employees of Boinebroke, four having other relations with him), all members of the Douai working class, who claimed varying sums owed for unpaid wages, overpriced materials, underpriced payment for the finished product, property unfairly seized, and unjust evictions. Boinebroke emerges from the testimony of plaintiffs and witnesses as a cynical exploiter who never missed an opportunity to rob a widow or cheat an orphan. Not all medieval businessmen were scoundrels, but the system, political as well as economic, provided an untrammeled arena for rugged individualism.

Agnes's complaint was on behalf of her mother Mariien, from whom Boinebroke had seized a vat of dye in payment of a debt of her late husband. The vat, according to Agnes, was worth twenty pounds more than the debt. To support her deposition she brought to court Jehanain As Cles, Saintain Caperon,

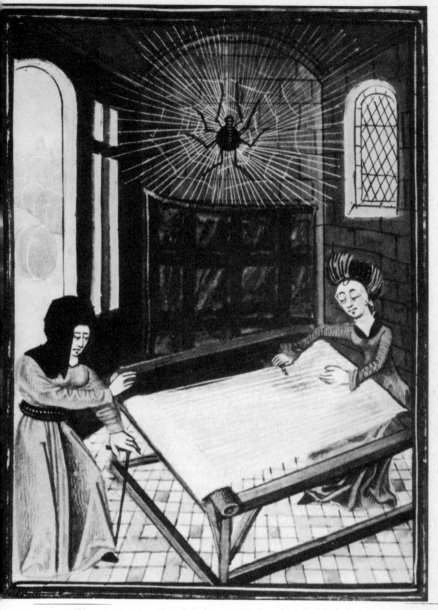

Women weaving. *British Library, MS Royal 17 E IV, f. 87v.*

and Isabelle le Françoise, who took their oaths, as did Agnes, on the holy relics, and confirmed her story. Their testimony drew a lively verisimilitude from their recollections of the words used by the domineering capitalist in rebuffing Agnes's mother when she appealed to him: "Granny (*Conmère*), go and work in the tannery, since you need money; I hate to see you like this!" She tried to appeal to his religious feelings, pleading, "Sire, if you want to treat me right and reward me out of pity, you'll be doing the same as giving alms, because I'm in need!" To which Boinebroke derisively replied, "Granny, I don't know what I owe you, but I'll put you in my will."[2]

Although he spoke roughly to both men and women and was capable of reducing men to tears, his sharpest retorts seemed to be reserved for women, whether his employees or not. A woman cloth-stretcher who tried to collect rent from him received the threat, "Granny, if you take a lien on my property, I'll have you fined 60 pounds!"[3] Another woman who complained that construction he had undertaken on a house next to hers had done extensive harm to her own house was told, "Shut up! The business you do isn't worth the price of damages!"[4]

One of the largest claims was made by the widow of a Boinebroke agent, herself a cloth worker. Her husband, before leaving for the Champagne fairs with a consignment of his employer's cloth, had assured her that he was leaving her well off, that he had just had an accounting with Boinebroke and owed him no more than 12 pounds, plus 32 pounds for a sack of wool. The agent died at the fair. Boinebroke summoned the wife to his house and took her into his counting room, where he handed her a document showing that she owed him a staggering 131 pounds. To her protests, he replied only with assurances that he would make her "a good and faithful accounting." To pay the debt the widow had to sell her property and turn to her relatives for help. Boinebroke then claimed a second debt of 32 pounds, evidently

for the sack of wool. "Sire, for God's sake," the widow cried, "why do you demand so much from me? You are doing me a great wrong." Boinebroke only reiterated that he would give her "a good accounting."[5]

From two other dyeresses besides Agnes's mother, Boinebroke claimed debts so large that they were forced to sell their cloth to him to raise the money, and he took care to buy at a price well below market value.

The court ordered the Boinebroke estate to pay at least part of a great number of claims—Agnes li Patiniere received 100 sous (five pounds)—demonstrating a capacity for justice on the part of the exploiting class that mitigates some of the harshness of the image of Boinebroke.

Yet the most significant point about the Boinebroke document is its revelation of the hold over the workers that the putting-out system, with its rigidly maintained restrictions, provided for an entrepreneur. Several of the claims dated back many years, the claimants not having dared to sue while their oppressor was alive lest he refuse to give them any more work. "I took wool to my lord Jehan and I lost greatly by it," one woman worker told a witness, who asked, "Since you lost, why did you take it?" "Because I could not do otherwise!"[6] Boinebroke's relationship with his employees was signalized by the terms in which the witnesses described his actions. He "summoned" them to his house, which served as residence, office, warehouse, and salesroom; he issued "commands"; he "required" them to do such and such; he "led them into his chamber," where he questioned them, made accounts, presented them with bills. In contrast, their posture toward him was that of supplicants; they implored him—"For God's sake," "For mercy"—and tried to appeal to his heart. Boinebroke's death at last freed the workers to seek another employer, and thereby freed them also to sue for their losses.

To supplement the civil power liberally brandished and wielded without constraint by Boinebroke and his fellow businessmen, the power of the Church was sometimes employed. Florentine clothmakers obtained pastoral letters from their bishops to be read in the parishes threatening censure and even excommunication to careless spinsters who wasted yarn. But for most women as for most men in the cloth industry, threats and exploitation were lesser evils than the specter of unemployment. When war or depression hurt the cloth market, the town-factories of workers were turned into encampments of beggars—men, women, and children who poured from their hovels daily to throng the streets and crowd the church doors crying for alms.

In the cloth industry being a woman was no serious disadvantage, but it was no advantage either. Were Agnes and her sisters of Douai, Ghent, Ypres, Bruges, and the other great cloth towns worse off than the peasant women of the medieval countryside? They were probably better off than the landless laborers; no worse off than the bulk of the peasantry, whose livelihood was largely at the mercy of elements beyond their control; and not so well off as the more affluent free peasants who owned a few animals and were exempt from heavy labor services.

They were also not as well off as many of their sisters in other crafts. The mass of medieval townswomen, like medieval countrywomen, worked as a matter of course. A married woman usually worked at her husband's trade, but might work at a trade of her own. Widows were a universal element in the city crafts. Daughters as well as sons served as apprentices. From time immemorial girl children had learned sorting, cleaning, carding, and spinning, and in the Middle Ages they undertook these arts both for home use and as part of a production system, as in the Flemish wool industry. Like boys, girl apprentices usually took an oath not to get married, frequent taverns, reveal trade

secrets, or rob their masters, though the marriage prohibition might be waived for a money payment.

A single woman working at a craft was known on both sides of the Channel as a *femme sole*, and enjoyed a status of recognized equality, as did married women who worked at crafts other than their husbands'. These latter were subject to widespread regulations providing immunity for their husbands in case of litigation—"if she be condemned she shall be committed to prison till she be agreed with the plaintiff, and no goods or chattels that belongeth to husband shall be confiscated," reads an English statute.[7] Although doubtless written mainly for the husband's benefit, the rule was, in Eileen Power's words, "a notable advance in the position of married women under the common law."[8]

Outside the textile industry, centered in Flanders and Italy, and apart from domestic service, working women were employed mainly in two great groups of trades. The first consisted of the hundred-odd crafts—shoemaker, furrier, tailor, barber, jeweler, chandler, mercer, cooper, goldsmith, baker, armorer, hatmaker, saddler, harnessmaker, glovemaker—in which women worked side by side with men, usually, but not always, their husbands. In some they dominated or even monopolized the work—as in the silkmaking crafts of Paris and London. By mid-fourteenth century, London's "silkwomen" were sufficiently self-conscious and self-confident to deliver a written protest to the mayor and the aldermen against the alleged machinations of Nicholas Sarduche, a "Lombard" (Italian), affecting the price of silk. A century later, in 1455, their great-granddaughters petitioned for the prohibition of imported silk, and got a restrictive tariff act passed.

The second great group of women workers clustered around the manufacture and sale of food and beverages. Like the village women, city women brewed beer and ale ("brewsters" and "ale-

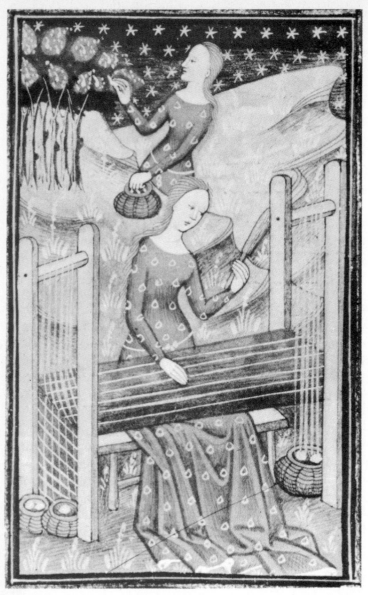

Women silk workers; the silk making crafts were dominated by women. *British Library, MS Royal 16GV, f. 54v.*

wives"). Malt beverages were in tremendous demand in non-wine-producing countries, notably England, and not infrequently abused—city women were warned by the moral manuals of the time not to be seen drunk in the streets and taverns and not to sit up too late drinking ale even at home.

In the fourteenth century, a London brewer bequeathed his daughter five quarters of malt and the lease of a brewhouse for eight years to set herself up in business. By the time of Henry V (reigned 1413–1422) thirty-nine women were listed in the livery of the London Brewers' Company. As in the villages, city women were often given the post of "ale conner" to check the quality of the guild's product in the interest of the common reputation; the Ordinances of Worcester specified that the two conners should be "sadd and discrete persones."[9] The London assayer of oysters made a practice of farming his similar office to women.

The famous Margery Kempe, daughter of a mayor of Norwich and wife of a prominent burgher, tells how, in order to buy finery for herself, she became "one of the greatest brewers in the town of Lynn for three years or four, till she lost much money, for she had never been used thereto."[10] Margery later took up grinding grain in a horsemill, but had no better luck, her business failures helping her to see the light and turn pilgrim.

In England women made and sold charcoal. As "regratresses" they retailed products that had been purchased wholesale, joining the ranks of the fishmongers, poulterers, and butchers. Avarice, a character in *Piers Plowman*, recalls his wife as "Rose the Regrater. . . . /She hath holden huckstery all her lifetime."[11] Many women were innkeepers and restaurant proprietors, usually as widows inheriting from husbands. Women even plied such traditionally male trades as those of blacksmith and armorer: in a poem of François Villon, "*La belle Héaulmière*," the beautiful helmetmaker grown old laments the loss of her beauty.

Another occupation that was already an accepted, if rare,

female profession was schoolteaching; in 1408 a wealthy London grocer left twenty shillings to "E. Scolemaysteresse."

Despite the prevalence of women among the crafts, it was long believed that the medieval guilds, the organizations, half trade union, half trade association, that dominated city working life, excluded women, but this has been shown to be false. Women were admitted to a large number of guilds as wives or widows of masters. Sometimes they belonged to guilds as *femmes soles*, even dominating some, such as the spinners' guild of Paris. The famous 1292 Paris tax list of Etienne Boileau shows five exclusively female guilds, several others in which independent women enjoyed master status, and some eighty (of the 120-plus) with women members, presumed to be widows of former guild members. The basis of their admission was no mere courtesy to deceased guildsmen, but recognition of the obvious—a woman married to a craftsman necessarily learned the craft. Such widow guildswomen enjoyed full master's privileges, including the decisive right to train apprentices. Should such a widow remarry, she retained her status provided her husband was also a member, but if he belonged to another craft, she lost her right to take apprentices.

In other French cities a similar situation prevailed. Statutes of Toulouse specifically mention admitting women to their guilds as weavers, finishers of cloth, candlemakers, wax merchants, and dealers in small-weight merchandise (*avoir de poids*, a regular classification at markets and fairs). In Arras the tailors' guild admitted daughters as well as wives to master status at a reduced fee. In Poitiers the pastry cooks' guild admitted women as masters, but qualified their status by decreeing that "Mistresses, when they are widows, can keep one or two workers, but they are permitted to carry only one single box of wafers through town."[12]

The right to membership was disputed in some places. In

Pontoise, near Paris, in 1263, the bakers sought to take the privilege away on the specious grounds that women were not strong enough to knead dough. The women appealed, and the Parlement of Paris overruled the bakers, further granting the women the unusual right to continue their profession even if they remarried outside it.

Although women were admitted to guilds in France, they were not always invited to the organizations' social gatherings. In Arras the guild of cooks, roasters, pastry cooks, and caterers decreed that widows might enjoy the privileges of masters as long as they remained unmarried, "but they may not be present at the assemblies of the body, at the chefs-d'oeuvres [the meetings at which aspirants to the status of master presented their "masterpieces"], and at the receptions of masters."[13] At Poitiers in the thirteenth century, the guild of glovemakers admitted widows of masters to the craft, but specified that at the dinner given by the newly received master all the masters of Poitiers and their male children were guests, "but the wives, daughters, and servants of the glovemakers are expressly excluded."[14] On the other hand, the pastry cooks' guild of Poitiers gave deceased mistresses the same six masses accorded the masters, in contrast to the valets, or journeymen, who got only two.

In the Florentine clothmaking industry, women were not admitted to the "greater guilds," such as the Arte di Calimala (Wool Cloth Guild), dominated by wealthy trading companies, but had equal-to-male membership in the Linaiuoli (Linenmakers), on payment of the matriculation fee.

Women's status in the English guilds was inferior to that on the Continent, but even in England a widow of a guild member remained in the guild and commonly conferred guild status on her second husband provided he worked at the craft. Widows could train apprentices; the Company of Soapmakers of Bristol lists in its records such notices as: "The Widdowe Dies took to

prentice Michaell pope the Son of Richarde pope of Bristeltowe for the terme of VII yeares begininge the IIII of October 1593 and to serve a covenante yeare after," and "We Reseved into the fellowship of Sopmaken and changleng [candlemaking] Richard Lemewell for that he sarved his Apprentisshipe with Alice Lemwell wedow to sopmaken and changlyng. . . ."[15]

The charter of the Drapers of Shrewsbury also speaks of both "brothers" and "sisters," with women listed as wives of brethren, widows, and independent tradeswomen. The Tailors of Exeter permitted a widow to have as many workers as she wished as long as she paid her taxes. The Leather Dyers assigned three members and their wives as sworn overseers of the guild ordinances.

Guilds provided masses, tapers, and burial for women as for men, and in some cases through their eleemosynary auxiliaries, the "brotherhoods," even furnished dowries for poor girls. The Guild of Tailors of Lincoln decreed that "if a brother or sister dies outside the city" the guild "shall do for his soul what would have been done if he had died in his own parish."[16]

The London parish guilds, organizations that cut across craft lines to embrace the most affluent tradesmen of the parish, admitted women freely. One of the largest and richest, that of Holy Trinity, based at the church of St. Botolph's Aldersgate, listed 274 women members in the late fourteenth and early fifteenth centuries, along with 530 men. Most were wives of craftsmen joining with their husbands, but there were also women who entered alone: a marbler's wife, a huckster, and Juliana Ful of Love, occupation not designated.

Nevertheless, there was discrimination. Many guilds enacted regulations like that of the London Girdlers, who in 1344 ruled that members could not employ any women except their wives and daughters, or that of the Fullers of Lincoln: "None of the craft shall work in the trough; and none shall work at the

wooden bar with a woman, unless with the wife of a master or her handmaid."[17]

The problem was evidently the practice, widespread in city as in countryside, of paying women less for the same work. Documents of a later date attest to cheating that was doubtless prevalent in the earlier centuries—passing off daughters-in-law or nieces or even unrelated "wenches" as daughters, and hiring maids ostensibly for household duties and putting them to work at the distaff, wheel, or loom at lower wages than men. Another source of discrimination with echoes in a later age was the prohibition of the usual succession to mastery of a widow when the guild was one of those required to perform town military service or guard duty. Discrimination in pay and status forced many women to eke out their income by prostitution or thievery—women silk workers in Paris were threatened with the pillory for abstracting raw silk entrusted to them, and were further accused of luring scholars of the Latin Quarter into street recesses where they could be separated from the satchel-purses they wore at their belts.

Domestic servants, mostly single women, were the worst-paid women workers, if not in every case the worst off, toiling mainly or even entirely for their keep. After nine years' service in the household of Walter Rawlys, Edith Nyman and her husband John claimed only 4 pounds 16 shillings in wages, making it appear that fourteenth-century free servants did little better than the slaves who were imported at that time as a result of the Black Death. Other evidence from England suggests a pound a year as typical servants' pay. However, masters and mistresses often bequeathed legacies to servants, just as they often bequeathed freedom to slaves. London records include bequests of a hall and two shops; in another case land and houses; in still another an annuity of 9 pence a week, in a fourth, 20 marks and the next vacancy in the testator's almshouse; and from poorer masters

and mistresses such sums as 40 shillings, or even "12 d. and one of my old gowns to make hir a kirtell."[18]

At the opposite end of the spectrum from women servants were a tiny but significant number of city working women who profited as merchants. Most worked with and succeeded their husbands in a lucrative trade. In the fourteenth century, Alice, the wife of Thomas de Cantebrugge of London, dealt in armor on a scale that permitted her to be robbed of merchandise worth two hundred pounds. In 1304 two women wool merchants, Aleyse Darcy and Thomasin Guydichon, sold the Earl of Lincoln "one piece of cloth, embroidered with divers works in gold and silk . . . eight ells [thirty feet] in length, and six ells [twenty-four feet] in breadth,"[19] for the huge sum of three hundred marks. A male colleague who acted for a woman merchant, Elizabeth Kirkeby, in a transaction in Seville, Spain, sued her for no less than four thousand pounds. Margery Russell, a fourteenth-century merchant's widow of Coventry, also got into the legal records through commercial activity with Spain. Robbed by Spanish pirates of merchandise reputedly worth eight hundred pounds, she sought and obtained "letters of marque," royal documents licensing her to seize as compensation Spanish-owned merchandise in English ports. Acting for all the world like a male businessman in similar case, she seized more than her due, provoking a counter-protest from the Spaniards. Wealthy and independent women such as these must have been among the four percent of London's taxpayers in 1319 who were women living alone, most of them supporting themselves by practicing a trade.

Many other businesswomen have been identified in the later Middle Ages as dealing in large transactions. An outstanding example is Barbara Baesinger Fugger, daughter of a master of the mint in Augsburg, Germany, who after bearing eleven children found herself in 1469 a widow with no sons old enough to assume direction of her late husband's textiles-and-other-things

emporium. Barbara was equal to the challenge in business ability as well as in character, keeping the shop going and even expanding it while training sons Ulrich and George in management. A younger son, Jacob, she sent off to Rome to study for the priesthood, but when deaths of other children caused Ulrich and George to ask for Jacob's help, Barbara canceled his clerical career, and thereby introduced to the commercial stage the greatest businessman of the Middle Ages, "Jacob the Rich" Fugger, whose loans to prelates and financing of the sale of benefices and indulgences played no small role in bringing on the Protestant Reformation.

The rising affluence of the high Middle Ages, most visible in the growth and prosperity of the cities, brought improvement in condition and status to a great number of city women. By comparison with later times, their situation remained hard and hazardous, but what is most striking to the modern eye is the extent of medieval women's direct participation in production and distribution. In the last quarter of the twentieth century, in the most advanced countries, the economic contribution of city women remains less significant.

10

Margherita Datini:
An Italian Merchant's Wife

The substantial masonry house that merchant-prince Francesco di Marco Datini built six hundred years ago on the Via del Porcellatico in Prato, a few miles northwest of Florence, would be scarcely noticed amid the rich medieval architectural litter of Italy were it not for an accident of renovation a few years after his death. Datini's entire collection of business papers and personal correspondence was stored in a stairwell sealed off by that renovation, to be preserved intact until the vast jumble of documents was recovered during another renovation in 1870.

Today the Datini archive, sorted and labeled, but still preserved in the same house in Prato, attracts scholars from all over the world. In mining the trove of fourteenth-century business papers, they have exposed the life of an outstanding representative of the Italian-led Commercial Revolution, a pioneer of business methods such as double-entry bookkeeping and the use of checks and bills of exchange. By an added stroke of fortune for historians, he happened to be separated from his wife Margherita for many of their thirty-five years of marriage, and the archive includes hundreds of their letters, unpolished, hardly literary, but often touching, and faithfully revealing the daily

life of their class of well-to-do city people, merchants, bankers, and professionals. The Margherita Datinis of the Middle Ages, less exalted than the ladies of the castle and less numerous than the peasant women, were, like their entrepreneur husbands, a wave of the future.

The household over which Margherita presided, much of the time in the absence of her husband, was a serious and complex responsibility on which Datini, something of a worrier, tirelessly lectured her, not infrequently provoking tart rejoinders. Neither these exchanges nor her childlessness, which was the tragedy of their life, destroyed their mutual affection. At first forced to have her husband's letters read aloud and to dictate her own, Margherita learned to read and write in order to carry on the correspondence in privacy. In her late years her chief anxiety was to persuade her husband to turn some of his attention from business to thoughts of the next world, a familiar concern of businessmen's wives into modern times.

Margherita was sixteen when she met Francesco. Both were living in Avignon, where the pope had settled sixty years earlier in the "Babylonian Captivity," and where, in consequence, a small army of Italian merchants had established themselves to service the wealthy papal court. Datini, who had been orphaned in the original pandemic of the Black Plague in 1347–48, was a self-made man who by 1376, the year he met Margherita, had established himself in the forefront of the business community of Avignon. His shop sold a variety of expensive consumer goods: jewelry, armor, saddles and harnesses, religious vestments, and saints' pictures. In addition he ran a tavern, a draper's shop, and a money-changer's counter. He was forty years old when he chose his bride, who was also an orphan. Her father, Domenico Bandini, a member of the minor Florentine nobility and a leader of the Guelf (pro-papal) political faction, had been executed by the victorious Ghibelline (pro-emperor) party following a petty civil war.

The marriage was remarkable in that owing to the confisca-

tion of her father's property Margherita brought Francesco no dowry, a circumstance that implies a beauty barely hinted at in the only surviving portrait, made in later years. Her social status, a bit loftier than Francesco's, was a secondary consideration. In commerce-oriented Italy the distinction between wealthy merchants and landowners was much less clear than in north-west Europe, where marriage alliances between the two classes were perceived as advantageous socially for the merchant and financially for the landowner. Normally, everywhere, merchants married merchants' daughters (or widows), and the deferral of marriage by a man usually had the effect of strengthening his bargaining power in respect to the dowry.

Though Francesco's relatives and friends had urged him for years to marry and provide himself with a legitimate heir (he already had at least one illegitimate child), he evidently fell in love, and the long correspondence indicates that the sentiment was shared. The wedding was celebrated during the pre-Lenten period known as Carnival, on a scale suited to Datini's station: the wedding feast included 406 loaves, 250 eggs, 100 pounds of cheese, two quarters of oxen and 16 of mutton, 37 capons, 11 chickens, two boars' heads and feet for jelly, pigeons, waterfowl, with local Provençal wines and Chianti imported from Tuscany.

Over the next six years the only serious disappointment in the marriage, Margherita's failure to conceive, manifested itself, giving rise to an endless succession of suggestions from friends: a poultice, to be rubbed on the belly, which however was reported to "stink so much that there have been husbands who have thrown it away,"[1] a belt "to be girded on by a boy who is still a virgin, saying first three Our Fathers and Hail Marys in honor of God and the Holy Trinity and St. Catherine; and the letters written on the belt are to be placed on the belly, on the naked flesh. . . ." Her brother-in-law, offered the latter remedy on behalf of Margherita's sister, added, however, "But I, Niccolo, think it would be better. . . if she fed three beggars on three

Fridays and did not hearken to women's chatter."[2] Nothing worked, the marriage remained barren.

Meantime the pope quitted Avignon for Rome, and family and friends importuned Francesco and Margherita to return home to Prato, where Francesco's foster-mother, Monna Piera, longed to see him before she died. She got her wish when in the winter of 1382–83 Francesco packed household and goods for a journey over the Mont-Genèvre Pass and via Milan to Florence and Prato. The whole trip took thirty-three days, including a week's rest in Milan. Francesco had reason to be glad he had finally made the decision; old Monna Piera succumbed shortly after.

The Prato to which the Datinis returned was, like Douai, a clothmaking town, its dark, narrow streets with their masonry and wooden houses threaded with canals, whose banks bristled with fulling mills and dyeing sheds. Within the city walls were vegetable gardens, orchards, and vineyards, and every day the produce of the country poured in to market—grain, vegetables, fruit, olive oil.

Monna Piera had bequeathed to Francesco her house, which he had given her, and in addition he had invested the profits of his business in twenty other houses in Prato. None, however, was large enough for the Datini household, and Francesco commissioned an architect to build him a mansion on a lot he owned on the Via del Porcellatico. While the walls were rising, he caused a pleasure garden to be planted behind it, "full of oranges, roses, and violets, and other lovely flowers," a luxury for which he later momentarily chided himself—"I would have been wiser to put [my money] into a farm."[3] The tall, square house fronted directly on the street, its façade decorated with frescoes between the two rows of shuttered windows. Datini's arms—three red bands on a white field—decorated the cornice, and on the entrance wall was a large fresco of Saint Christopher, the house's guardian. The main door was framed with hewn

stone; one entered the ground floor to a sense of spaciousness created by lofty vaulted ceilings over the hall, the green-painted loggia or parlor, the downstairs guest room and kitchen, and the office. Floors were of polished and waxed brick. The hall repeated Francesco's crest on two shields, with a third shield showing a lion.

On the second floor a "great room" formed the central salon, with the master's chamber, other bedrooms, and a large kitchen radiating from it. Heating was by stone fireplaces, decoratively carved, one of them with Francesco's crest, and equipped with andirons, tongs, shovel, and bellows; lighting was by horn lantern, wax torches on poles, tallow candles, and small brass oil lamps. A commode with chamber pot stood in the hall, another in the principal guest room. Stands held basins for washing, and in the kitchen was a barber's basin for shaving.

Above the second floor was a summer loggia, or penthouse, used as a living room in hot weather, and also for beating carpets and blankets, airing furs and wools, and drying linens.

Furniture was meager by later standards—curtained beds, chests, trestle tables, benches, wooden chairs—but lavish by earlier ones. Margherita in the Via del Porcellatico was probably more comfortable than Blanche of Castile in the Palais de la Cité or Eleanor de Montfort in chilly Kenilworth.

Similarly, her clothes, less costly than those of the queens and castle ladies of earlier centuries, were better made, of finer material, and of greater variety. Her undergarment was a shift of fine linen (no drawers), over which in winter she wore a petticoat of wool or fur—otter, cat, or miniver—topped by a gown and surcoat. The gown was long-sleeved, the surcoat sleeveless, or rather with detachable fur sleeves. A woman had only one or two gowns but a number of surcoats—in 1397 Margherita had eleven, only two of which dated back to an earlier listing in 1394. Her wardrobe in 1397 included purple lined with green, blue damask trimmed with ermine, camlet (camel's hair and

Francesco Datini's house on the Via del Porcellatico in Prato.
Ufficio Cultura e Turismo, Prato.

angora) lined with pale blue taffeta, ash-color bordered with miniver, Oriental damask, and aristocratic old rose. She also had a rich coat or overgown of heavy silk which Francesco had imported, via his agent in Genoa, from Rumania. All the gowns were floor-length, but varied widely in cut, some requiring twice as much material as others. For going out in cold or rainy weather Margherita wore a cloak of full, heavily draped cut; in 1397 she owned six. She also had a number of headdresses of a variety of shapes, sometimes topped by a fur or cloth cap, or in summer by a straw hat. She had a blue belt and a black belt, each with a silver-gilt buckle—the Florentine sumptuary laws that had sought vainly to curtail women's finery had apparently succeeded in at least limiting the amount of silver. Margherita preferred heavy belts, returning one to Francesco's Florentine partner because it was too light, provoking a rather cross reply: Florence's noble ladies were now wearing light belts, but if Margherita wanted to wear what the peasant women wore, all right.

The lists do not include shoes but the correspondence refers to two types—wooden pattens with leather laces, the foul-weather gear of southern Europe, and *pianelle*, backless leather slippers with thick soles built up of several layers of leather. White linen undersocks were covered by long hose of silk or wool.

In the realm of accessories Margherita carried at times a veil (one specified as silk, made in Venice), a purse (two described as embroidered wool), a fan (peacock feather), a handkerchief (one of "silk, made in Sicily, to wear at one's side").[4]

The profusion of garments enveloping the well-to-do fourteenth-century woman required some pains and attention. The contemporary "Goodman of Paris" advised a young wife to

> "take care that the collar of your shift, and of your *blanchet*, *cotte*, and *surcotte*, do not hang out one over the other, as happens with certain drunken, foolish, or witless women . . . who walk with

roving eyes . . . their hair straggling out of their wimples, and the collars of their shifts and cottes crumpled the one upon the other. . . . Have a care that your hair, wimple, kerchief, and hood, and all the rest of your attire be well arranged and decently ordered, that none who see you can laugh or mock at you."[5]

Fifteenth-century English marriage handbooks also stressed modesty of dress and demeanor for merchants' wives, who were advised not to try to compete with ladies in fashion and not to go out to wrestling matches and cockfights, where they might be taken for strumpets.

At the foot of the garden Francesco built his warehouse, which also housed his business office. The interior was painted green and severely furnished with chests, cupboard, and writing desks. As an exotic touch to the garden, Francesco purchased several birds and animals—a monkey, a porcupine in a cage, a pair of peacocks, and a sea gull.

To his holdings Francesco presently added a number of other residences in Florence, Pistoia, and Pisa, and several pieces of land in the country—orchards, small farms, and one sizable property, Il Palco, whose villa he improved and enlarged, and whither the household usually moved for part of the summer. Il Palco and the other farms supplied wheat, olive oil, wine, fowl, pigeons, eggs, and vegetables, both for the household and for sale. When Francesco was in Florence or Pisa, Margherita two or three times a week supervised the loading of a mule with flour, eggs, oil, wine, fresh bread, fowl, fruit, vegetables, herbs, chestnuts, figs, and jellied meats.

The Datinis also bestowed gifts from the farm on friends, and gave produce to the poor and to the religious communities for their tithe. In this Francesco showed a businessman's prudence: when a feared condottiere in the service of Milan threatened the neighborhood, he wrote Margherita to bring all movable produce from Il Palco to Prato, and also to distribute bread and wheat to all who asked—"This is a time to gain Paradise for our

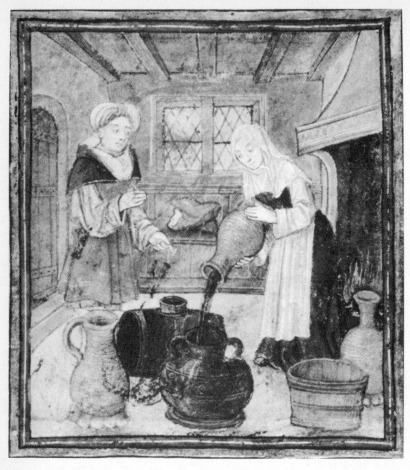

Decanting wine. *British Library, MS Harl. 2838., f. 37.*

souls.... For God will pay us in full."[6] When the Milanese
band withdrew and the Florentine Signoria (city council) tem-
porarily lifted the duties on food entering the city in order to
replenish larders, Francesco wrote Margherita to have a bushel
of wheat ground at once, "And send the flour speedily before
Saturday, that I may make some money out of the Commune,
which has made so much [in taxes] out of me!"[7]

Even without such emergencies, Margherita's hands were
full. A large household without benefit of modern domestic
technology demanded ceaseless attention. A fifteenth-century
book of advice by Leon Battista Alberti entitled *I Libri della
Famiglia* strongly emphasized to wives that "everything should
be set where it is absolutely safe, yet accessible and ready to
hand, while encumbering the house as little as possible.... If
you think something would be better placed elsewhere, more
convenient and securely locked, think it over carefully and then
arrange things better. And so that nothing gets lost, just be sure
that when something has been used it is immediately put back
in its place, where it can be found again." He recommended
that all keys be kept in the hands of the mistress of the house
except those used daily, "like the pantry keys and those to the
storeroom," which should be entrusted to one of the most reli-
able servants. In his scheme, the husband purchased the
household supplies, and it was incumbent on the wife to check
all needs well in advance and warn of impending shortages so
that the necessary commodities might be bought "at the lowest
cost and the highest quality. Things bought in haste are often
bought out of season, unclean, about to spoil, and expensive."
He added that true thrift meant always buying quality, whether
in food or garments.[8]

At first Margherita had only three live-in household servants,
but after a couple of years two female slaves were added, a
thirteen-year-old and a grown woman Giovanna, and later a
manservant named Domenico, his wife and little girl, another

slave girl named Lucia, and a half-paralyzed old blind woman named Monna Tinca di Simone whom the Datinis kept out of charity. Still another slave girl was purchased from Venice in 1393 to "wash the dishes and carry wood and bread to the oven, and work of that sort."[9] In addition to the household slaves and servants, there were a number of men employed in the stables and cellars, two or three messengers or porters, and a Tartar slave named Antonetto bought as a boy by Francesco. Finally, Margherita had several girls who came in by the day to help with cleaning, laundry, baking, spinning, and weaving. "Your great pack of females," Francesco called them, and Margherita referred to "my flock of little girls,"[10] who, according to their then twenty-two-year-old mistress, were incapable of doing anything without her supervision.

Mainly because of the servant problem, Margherita daily rose early; the door of the house was not opened until she was up. Francesco warned about the habit of one servant, Bartolomea, to "say she goes one place and then [to go] elsewhere," and of another, Ghirigora, who "has little sense" and should not be left alone,[11] while the foreign slaves were less reliable still and even dangerous; Margherita herself wrote, "They might soon rise up against you, as they did in Provence."[12]

The reference remains tantalizingly cryptic. The revival of slavery in Europe was a consequence of the Black Death, which had so decimated households that the Church relaxed its prohibition, requiring only that the slaves be infidels. The stipulation was not rigidly enforced, but most of the slaves were imported by purchase from the East, especially from the Italian colonies in the Crimea. Most were Tartars, ethnically and linguistically divided from their European masters. Speaking their own tongue to each other, they formed in every household a subgroup that Petrarch called "domestic enemies," and that had the reputation of being dishonest, quarrelsome, lecherous, and quick with knives. The slave trade, in which Francesco Datini did not

Margherita Datini, from a fresco in the refectory of S. Niccolo in Prato. *Ufficio Cultura e Turismo, Prato.*

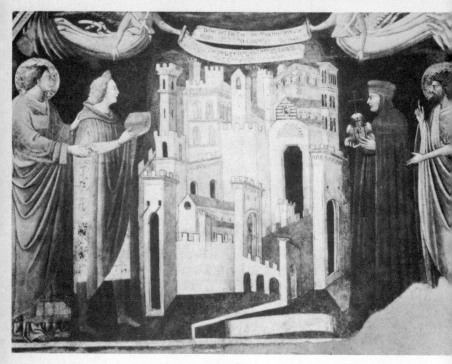

Fourteenth-century Prato; Francesco Datini, second from the right, presents his charitable foundation to the city, from a fresco in the Palazzo Pretorio in Prato. *Ufficio Cultura e Turismo, Prato.*

engage (but among whose known practitioners, interestingly, was a woman, Catherine of Sebastopol), was as always brutal, and the slave markets as always pathetic—that of Constantinople was called "the vale of lamentation."

It would be a mistake, however, to confuse fourteenth-century Europe's slaves with the unhappy war captives of the classical empires (or for that matter with the black slaves of nineteenth-century America). The slaves that Margherita Datini and other affluent European housewives supervised were viewed as members of the *famiglia*, little different in status or

condition from the free servants. Slaves, servants, and children were treated much alike—severely in theory, indulgently in practice. The Datinis' slave cook did not hesitate to complain when extra guests appeared for dinner, and a slave Francesco had freed (manumission was common) but who still worked for the household departed in a huff after being reprimanded for not properly caring for the mule. A runaway slave was regarded by law as a thief, that is, he had stolen property consisting of himself.

The husband represented in *I Libri della Famiglia*, in advising his wife on the servant problem, stressed a calm demeanor:

> It is an ugly thing if women like you, dear wife, who are honorable and worthy of all respect, are seen with wild-eyed contorted expressions, screaming, threatening, and throwing their arms about. . . . Some women talk in the house as if the whole family were deaf, or as if they wanted the whole neighborhood to hear every word. This is a sign of arrogance, a peasant habit. It suits the mountain girls who are used to calling to each other from slope to slope. You, dear wife, should admonish people with gentleness of gesture and of words, not with an air of indulgence and laxness, but with calm and temperance.[13]

Servants must also be spared hunger and thirst. "If they lack necessities, they will serve us poorly and not give zealous care to our concerns."[14]

In 1382 Francesco established a branch office at Pisa, the port of Florence and Prato near the mouth of the Arno. Finding it necessary to prolong his stay, he wrote home suggesting that Margherita and the household join him, since otherwise "I should have poor comfort here, and you but little there."[15] Margherita wrote back that she was "resolved to go not only to Pisa, but to the world's end, if it please you."[16] But out of a combination of logistical problems, inertia, changes of mind by

Francesco, and business demands, the move never took place. Instead a quite different one had the effect of complicating their life and enforcing chronic, if not continuous, separation. Francesco's company was prospering, expanding its trade in such international commodities as Spanish and English wool, Florentine cloth, Luccan silk, spices from the East, grain, and wine. Francesco aspired to membership in the Florentine silk merchants' guild and the famed Arte di Calimala, the guild of fine wool-cloth manufacturers. He needed a warehouse in Florence and wanted to open a retail shop there. Inevitably he made the decision to locate his main headquarters in the larger city, and between his duties there, his attention to the Pisa branch office, and other demands, "temporary" separation insidiously became the norm.

It was at this point that Margherita, resigned if not reconciled, enlisted a family friend, Ser Lapo Mazzei, to teach her to read and write. Ser Lapo began by writing messages in large print until she had grasped the rudiments. When she visited Francesco in Florence, Ser Lapo wrote to his "disciple," telling her that it was "a marvel" that she had mastered her letters "at your age, when other women are more apt to forget what they already know."[17] Francesco was pleased with his wife's accomplishment but uxoriously bade her not to let it interfere with her business in life, which was running the household: "Order all other matters that they go well, and then you may read as much as you please."[18]

Literacy was not regarded as necessary for a woman, but neither was it an odd or unexpected accomplishment. No one contradicted Christine de Pisan's assertion that "if it were customary to send little girls to school and to teach them the same subjects as are taught to boys, they would learn just as fully and would understand the subtleties of all arts and sciences. Indeed, maybe they would understand them better . . . for just as wom-

en's bodies are softer than men's, so their understanding is sharper."[19]

In Margherita's letters, amid the reports of purchase and errands assigned and advice solicited or given, is many a *cri du coeur*, sometimes in bitter words, voicing her distress at their separation, or her jealousy, or her anxiety over Francesco's health and well-being. "If I have said anything to offend you," she wrote in 1386, "pray forgive me; great love drives me to speak."[20] And again, "You tell me to enjoy myself and to have a good time; but nothing in the world can make me happy; you could make me happy if you chose, but you do not wish to."[21] And, "I would like to know whether you are sleeping alone or not; if you are not sleeping alone, I would like to know who is sleeping with you...."[22] And, "You tell me that it was midnight when you wrote the letter, and if you had someone to comfort you, you would not stay up so late; it seems to me that you stay up later than anyone else, that does not keep you from you-know-what.... If I'm sad, they say I'm jealous; if I'm happy, they say that I am cured of Francesco di Marco...."[23] And again,

> As for your staying away till Thursday, you can do as you please as master, a fine office, but to be used with discretion; ... I am fully disposed to live together as long as God wills it.... I do not see the necessity of your sending a message to me every Wednesday to say that you will be here on Sunday, since every Friday you repent. It would be sufficient to let me know Saturday afternoon so that I could lay in supplies; at least we would fare well on Sunday. I have found companions in my female friends; sad would be the woman who had to depend on you![24]

In January 1386 whe wrote him in Pisa:

> I have gone out very little ... and if it were not for Lapa, I would go out much less. You tell me that I am not a little girl any

more . . . you speak the truth. And it's a long time since I was a little girl; but I wish that you were not always the Francesco that you have been since I have known you, who has never done anything but torment soul and body. You say, always sermonizing, that we will have a fine life, and every month and every week will be the one [when it will commence]. You have told me this for ten years, and today it seems more timely than ever to reply: it is your fault [that it has not started]. God has given you the knowledge and the power and has given you what not one man in a thousand has. You think of succeeding in your projects with honor, and that before you seize this "fine life."

If you delay so much, you will never seize this "fine life," and if you say, "Look at the hardships that I undergo every day, never can one live in this world without them": that is no excuse for not living a fine life for the soul and the body; and I want to say that it is wrong what you have to do in Pisa. About this I say no more.[25]

In 1393 when the Florentine priors tried to exact a large "forced loan," in reality a tax, on Francesco, who protested that he had already paid his taxes in Prato, representatives from the Florentine government came to Prato to question Francesco's friends. Margherita promptly wrote to Francesco in Florence; they were asking when the Datinis had returned from Avignon, how long they had occupied their house, whether Francesco had ever talked about becoming a Florentine citizen, and how wealthy he was; later the Florentines questioned Margherita herself. "They came here four times. . . . They stayed more than five hours and it seemed that no answer I could give them satisfied them. . . . They said that when you returned to this area you had 20,000 florins. . . ."[26] Francesco fought the case and had to appear before the Florentine Signoria, but a compromise was eventually reached whereby the charge was dismissed in return for a substantial payment.

Some of the affection that Margherita was unable to give children of her own she expended on others, especially three girls. One of these was Caterina, daughter of a friend, whom Margherita took with her to Pistoia in 1390 when she fled Prato to escape an outbreak of the plague. A second was Tina, daughter of Margherita's sister Francesca, whose husband had gone bankrupt. Margherita took Tina into her own house, where Francesco spoiled her. "She said," Margherita wrote Francesco, "that if you were there she would not have to walk [to a christening]. I sent her on foot... whether she wanted or not. But she found Castagnino and wheedled him into carrying her on his mule; someone asked whose daughter she was, and she said at once that she was the daughter of Francesco di Marco; she is bolder than you, and it's because you do what she tells you; she says, 'If Francesco were here, we wouldn't do thus and so;' it would be better if she remained with her mother; then she wouldn't be so fresh."[27]

The third was Francesco's illegitimate daughter Ginevra, whose mother was one of the Datinis' household slaves. The mother was married off, with the Datinis providing the dowry, and Ginevra at first placed in a foundling hospital, then with foster parents, but at the age of six brought to live in the great house on the Via del Porcellatico. Whatever Margherita's feelings may have been at Francesco's habit of siring illegitimate children, she became genuinely fond of Ginevra, writing with a stepmother's pride, "In my presence she is the best child that ever was, but when I am not there, she will do naught she is told."[28] And, "Vex yourself not about Ginevra, but be assured that I look to her as if she were my own, as indeed I consider her...."[29]

Ginevra was raised in accord with the conventions for girls of middle-class family, learning cooking, baking, washing, bed-making, spinning, weaving, and embroidery, but also, unlike

Margherita, to read—when she was nine Francesco made an entry in an account book of one gold florin "for Ginevra to give his mistress who teaches her how to read."[30] At about the same time he (and doubtless Margherita) began thinking about Ginevra's marriage, which following prolonged negotiations was arranged with the young cousin of a business partner. Francesco noted that many suitors had appeared, but that they sought Ginevra's hand "not for her own sake, but to get my money," whereas he was determined to find her "a companion who will not despise her, nor feel shame to have a child by her."[31]

Ginevra's dowry was a handsome one thousand florins, most of it in the form of an elaborate trousseau—both trousseau and cash to be returned, the contract specified, if Ginevra died of the plague within two years.

The wedding feast was unsparing—fifty guests, a special cook hired at a high fee, servants in new attire, immense quantities of fish, pasta, roast meat, and fowl, much of it served in the form of a pie with pork, chicken, ham, eggs, dates, almonds, and flour, seasoned with spices, including costly saffron. Margherita performed the symbolic act of placing a child in the bride's arms and a gold florin in her shoe to bring her fertility and riches. The bride was escorted by a procession enlivened by drums and trumpets to her new home where the bridegroom played out a ritual comedy by hiding while, whispering and giggling, the bride's friends left her at the threshold of the marriage chamber.

In addition to her household duties and the responsibility of bringing up Ginevra, Margherita acquired another strenuous chore in these years, Francesco assigning her numerous commissions to find and supervise wet nurses from Prato for wealthy Florentine families. The wet nurses—peasant women and girls who had lost babies, legitimate or illegitimate, or simply had a surplus of milk—had to be interviewed for character and health,

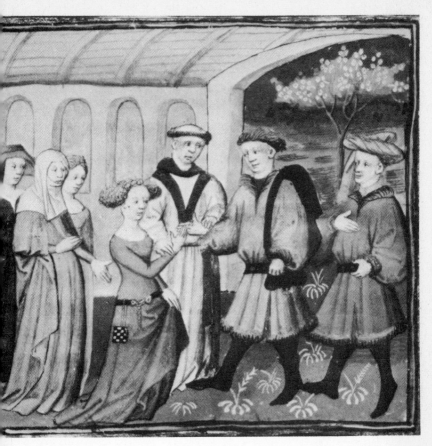

A fifteenth-century wedding. *Pierpont Morgan Library, MS M394, f. 9v.*

and for appearance, the thought being that the nurse should somewhat resemble the child's mother. The nurse's breasts came in for scrutiny; if too large they might flatten the infant's nose. It was also desirable to get a nurse who did not conceive too readily, since babies were normally nursed for two years before being weaned—to wine rather than milk. The nature of the job inspired a certain callousness: "I have found one in the Piazza della Pieve whose milk is two months old," wrote Margherita, "and she has vowed that if her baby, which is on the point of death, dies tonight, she will come as soon as it is buried."[32]

The custom of putting babies out to be nursed by peasant women did not insure health to the infants of the affluent. Margherita's friend and mentor Ser Lapo placed all fourteen of his offspring to nurse the day after they were born and only five survived. Saint Bernardine of Siena sternly rebuked women for the practice:

> Is there one who hath borne a child? [he demanded of his congregation.] Didst thou ever give him to a nurse to be suckled? What moved thee to do this? Why? To procure thyself more pleasure . . . ! When thou didst give him to a nurse at once didst thou place pleasure before God, and thus didst thou fall into sin. . . . Thou hast done worse than the she-ass, for the she-ass when she hath brought forth her foal doth rear it and nurture it. . . . If thou shouldst give thy child to a nurse because thou art weak in health or if thou has not milk to suffice it, or for other such lawful reasons, thou sinnest not; but if thou do so in order better to disport thyself, I say that then thou sinnest.[33]

Although medicine had made certain valuable and even revolutionary advances in the Middle Ages—the first medical schools, the first hospitals, the theory of contagion—its capacity for dealing with illness remained mainly illusory. For headaches Margherita washed her head with a sort of pudding

mixed with wine, and for indigestion, colds, malaria, and various other complaints drank hot wine and millet. Against influenza, leprosy, "flux," "pox," "sweating sickness," and other notorious afflictions, medicine was powerless, as it was against the plague.

Dominating the history of public health and medicine, indeed the entire history of the Datinis' generation, the rat-and-flea-borne Black Death had begun with its most virulent outbreak in 1347, killing an estimated 25 million Europeans, including Francesco Datini's parents. Utterly irresistible, perceivable only as a meaningless calamity or a visitation of God, it returned in 1399 in a fury only less catastrophic than that of fifty years earlier, slaying men, women, and children in Prato and Florence, including many of the Datinis' friends and relations. Francesco joined a pilgrimage of affluent citizens who trudged the countryside for nine days carrying lighted candles; when the plague refused to abate he made a second pilgrimage, pledged his fortune to the poor, and set out with Margherita on muleback for Bologna.

The two survived and returned home safely. Margherita seized the opportunity to press her husband to take warning, give over the affairs of this world, and fix his thoughts on the next. "Let me remind you," she wrote in one of the few letters of this period, when they were less often separated, "to my mind, only two things are needful: the first, to do what is pleasing to God, and the second, to spend the little time that is left you so that you may give back to God what He, in His goodness, has lent you."[34]

Francesco took her advice and came home to the house on the Via del Porcellatico, where he doubtless enjoyed the comforts enumerated by the Goodman of Paris for the burgher blessed with a loving wife (and servants), "to have his shoes removed before a good fire, his feet washed and to have fresh shoes and

stockings, to be given good food and drink to be well served and well looked after, well bedded in white sheets and nightcap, well covered with good furs, and assuaged with other joys and amusements, private matters, loves, and secrets, concerning which I am silent; and on the next day fresh shirts and garments."[35]

Francesco's last ten years were lived in semi-retirement, mostly staying home in Prato where among the stream of friends and relations the Datinis entertained many illustrious strangers including even royalty—Louis II of Anjou.

At his death in 1410 at the age of seventy-five, Francesco, in accordance with his vow in the plague year, bequeathed his entire estate to a charitable foundation. Margherita, named one of the four executors, was provided with a hundred gold florins a year as long as she remained "a widow and chaste" (the usual formula), and a house, land, and furnishings during her lifetime. Ginevra was given a legacy and dowries for her daughters. The servants came in for gifts, the slaves were all freed, and a number of debtors, such as "Betto, the trumpeter of Prato, a very poor person,"[36] released from their debts.

Margherita survived until 1423, living mostly with Ginevra and her husband in Florence, where she is buried in Santa Maria Novella.

Thus she lived sixty-three years, sixteen as a maid, thirty-four as a wife, and thirteen as a widow. Competent, intelligent, affectionate, attentive to her duties, devoted to her husband, Margherita Datini appears as one of the most modern of the medieval women whose lives are well documented. A personality and a life experience similar to hers might belong to the wife of a businessman of London or New York in the Victorian age. Command of a household of servants, a daily routine full of decision-making, an active social life, extensive correspondence, a large wardrobe, strong religious convictions—all

the principal paraphernalia of Margherita's physical and psychological life seem as natural to the nineteenth and early twentieth centuries as to the fourteenth and fifteenth.

Was her life a success? Was she happy? The two questions overlap rather than coincide, for the fourteenth century and probably for long after. Margherita would confess herself a failure in a matter of paramount importance until very recent times, her childlessness. Yet in the fourteenth century, as before and after, while childbearing could provide a woman with a sense of achievement, it could bring her only a dubious measure of happiness. Childbirth was painful at best, frightful at worst, assuaged mainly by sympathetic magic. "Your maid has been about to give birth since Tuesday even," Francesco's brother-in-law wrote him, "and it is the most pitiful sight ever seen, for never did woman suffer so greatly; there is no heart so hard it would not weep at the sight of her. She must be held down, or she would kill herself; and there are six women who care for her in turn. This morning they think the child is dead in her belly."[37] At the same time, handbooks and sermons enjoined acceptance of the death of children without rebelling against God. English religious reformer John Wycliffe advised grief-stricken mothers to be grateful for the "great mercy" on God's part in taking a child out of the world.

Gregorio Dati, a Florentine businessman and contemporary, perhaps acquainted with the Datinis, left a diary whose laconic entries depict in a peculiarly touching form the fate of one "successful" wife and mother:

> Our Lord God was pleased to call to himself the soul of Isabetta, known as Betta, on Monday, 2 October, between four and five in the afternoon. The next day, Tuesday, at three in the afternoon, she was buried in our grave at S. Spirito. May God receive her soul in His glory. Amen.

Children, 1393

In praise, glory, and benediction of Almighty God, I shall record the fruits that His grace will grant us, and may He in His mercy vouchsafe that they be such as to console our souls eternally, amen. On Sunday morning, 17 May 1394, Betta gave birth to a girl whom we called Bandecca in memory of my wife. . . .

On Friday evening, 17 March 1396, towards two o'clock in the morning, the Lord blessed our marriage with a male son whom we named Stagio and whom we had baptized in the love of God on Sunday morning by Fra Simone Bartoli of the Augustinian Hermits, my partner Nardo di Lippo, and Sandro di Jacopo, a pauper.

At two o'clock in the night of Monday, 12 March 1397, Betta gave birth to our third child, a girl. We called her after Betta's mother, giving her the names Veronica Gostanza, and Sandro di Jacopo baptized her in the love of God.

At midday on Saturday, 27 April 1398, Betta gave birth to our fourth child which was a boy. We called him Bernardo Agostino and he was baptized the same day in the love of God by Monna Agnola del Ciri and Monna Francesca Aldobrandino. God grant he turn out well.

At dawn on Tuesday, 1 July 1399, Betta had our fifth child and we baptized him in the love of God the same day, calling him Mari Piero. The sponsors were Master Lionardo and Fra Zanobi.

On Tuesday evening, 22 June 1400, Betta gave birth for the sixth time. The child was a girl. We called her Filippa Giovanna and she was baptized on Friday morning in the love of God. Fra Simone Bartoli held her.

Our Lord God was pleased to take to Himself the fruits which He had lent us, and He took first our most beloved, Stagio, our darling and blessed first-born. He died of the plague on the morning of Friday, 30 July 1400, in Florence without my seeing him, for I was in the country. Master Lionardo and Monna Ghita were with him. May God bless him and grant that he pray for us.

On 22 August of the same year, the Divine bounty was pleased to desire a companion for that beloved soul. God called our son Mari to Himself and he died at eleven o'clock on Sunday, of the plague. God grant us the grace to find favor with Him and to bless and thank Him for all things.

On Wednesday, 13 July 1401, after midnight, the Lord lent us a seventh child. Betta had a son whom we called Stagio Benedetto. The sponsors were Nardo di Lippo and Demenico Benini. Divine providence was pleased to take him back and for this too may He be thanked and praised. The child suffered from a cough for a fortnight, and at midday on 29 September, St. Michael's Day and the Eve of St. Jerome's Day, passed away to Paradise. God grant that we, when we leave this mortal life, may follow him there.

On 5 July 1402, before the hour of terce, Betta gave birth to our eighth child. We had him baptized straight after terce in the love of God. His godparents were Nardo and blind Margherita, and we called him Piero Antonio because of Betta's special devotion to S. Antonio. God bless him and grant that he become a good man.

After that my wife Isabetta passed on to Paradise as is recorded on the opposite page, and I shall have no more children by her to list here. God be praised.

Our creator was pleased to call to Himself the soul of our gentle and good son Antonio. He left this life, I think, on 2 August. For I was in great trouble and did not know it at the time. It was in Pisa where he is buried at St. Caterina's.

Betta and I had eight children, five boys and three girls.[38]

11

Margaret Paston: A Fifteenth-Century Gentlewoman

"And as for the first acquaintance between John Paston and the said gentlewoman, she made him gentle cheer in gentle wise and said he was verily your son. And so I hope there shall need no great treaty [discussion] between them. The parson of Stockton told me that if you would buy her a gown her mother would give thereto a goodly fur."[1]

The announcement of the betrothal of Margaret Mauteby to John Paston was written by the bridegroom's mother, Agnes Paston, from the family place in Norwich, in eastern England, to her husband William in London in 1440. As in the case of the Datinis a half century before, the act of letter writing marked the Pastons as affluent, but by now the affluent were more numerous and paper cheaper.

The Pastons had only recently emerged from the upper level of the English peasantry. William Paston's ancestors were well known in the seacoast village of Paston, where they had tilled the soil for hundreds of years, probably without benefit of the Norman progenitor that the family in its time of prosperity claimed. A laconic fifteenth-century account that is the only

near-contemporary source of information on the family's rise calls William's father Clement Paston

> a good plain husband [husbandman, i.e., farmer] [who] lived upon his land that he had in Paston and kept thereon a plow at all times in the year, and sometimes in barleysell two plows. The said Clement worked at one plow both winter and summer, and he rode to mill on the bare horseback with his corn [grain] under him. . . . And also drove his cart with divers corns to Winterton to sell, as a good husband ought to do.[2]

Not content with being a good husbandman Clement conceived the upwardly mobile notion of sending his son William first to school and then to London to study law, an expensive education financed partly by borrowing and partly by help from Clement's father-in-law, of whom nothing more is known.

Clement's investment in his son paid off for the family. Gifted with ability and character, William won appointment as steward to the Bishop of Norwich, became trustee and executor for many families of the Norfolk gentry, gained appointment as serjeant of the Court of Common Pleas in 1421, and in 1429 was appointed Judge of the Common Pleas at the splendid salary of 110 marks per annum.

Did his salary suffice to permit Justice William to purchase a succession of properties around the family holdings in the village of Paston? Perhaps, but dispensation of justice in the fifteenth century very often, even normally, provided financial gain apart from salary. In any case Justice Paston became the chief landowner in the Paston district of Norfolk. Acquisition sharpening appetite, he looked about for a suitable, that is, profitable, match, and found one in Agnes Berry, heiress of Sir Edmund Berry of Harlingbury Hall, Hertfordshire. By the marriage settlement he gained the manor of East Tuddenham in Norfolk, while Agnes in due course inherited three more manors and additional properties.

Justice Paston continued to expand his estates throughout his lifetime, making enemies as he went. ("I pray the Holy Trinity... deliver me... of this cursed bishop of Bromholm, [Walter] Aslak of Sprouston, and Julian Herberd," he wrote cordially of three adversaries, a prelate who claimed kinship with him, a man who threatened him, and a widow who claimed he had robbed her.[3]) He took the precaution of getting his son John educated in the law, saw him married to Margaret, whose charm lay in the fact that she was sole heiress of John Mauteby of Mauteby, Norfolk, and died (1444).

Despite the union's material basis, scarcely masked by Agnes Paston's description of the first meeting of the young couple, the marriage of Margaret and John Paston proved highly successful. From the trove of the Paston letters, one of the richest of medieval personal archives, Margaret emerges as a remarkable woman—intelligent, courageous, steadfast, capable of affection and tenderness toward husband and children, but above all the equal of any man in dedication to the game of getting, holding, and getting more.

With all her qualities, however, she may not have been able to write. Her 104 surviving letters are inscribed in more than two dozen different hands. It is possible that she wrote with difficulty and read with ease, and simply preferred the convenience of an amanuensis. The very multiplicity of hands in her letters indicates that many of those about her were literate. Outside of the clergy, literacy was most common among those who needed to use it—businessmen, public officials, and lawyers. The Paston men all wrote, with varying fluency. Most received formal education at Eton and at Oxford or Cambridge, which had lost their exclusively clerical character. Even literate people commonly used secretaries. Margherita Datini occasionally did even after learning to write, and Margaret Paston's son, Sir John, a Cambridge graduate, regularly paid a London copyist twopence a leaf, a cost that throws light on the economics of the contemporary invention of printing. Neither Margaret

nor her male correspondents used the newly introduced
Hindu-Arabic numerals, sticking to clumsy Roman figures that
required an abacus or calculating board for computation.

The language of the Paston letters is post-Chaucerian, and is
quoted here in modern "translation," which consists mainly of
correcting the spelling. The epistolary form is punctilious, Mar-
garet usually commencing with the formula, "My right wor-
shipful husband, I recommend me to you," and concluding,
"Your servant and bedewoman [meaning woman who prays for
another]." When they are dated, the year is given in medieval
fashion, by king's reign (the Christian calendar was an ecclesias-
tical convention). The style is labored, as if writing a letter, or
dictating it, was a strain. The content sticks doggedly to
business—legal problems, household matters, family affairs.
Yet Margaret expresses sincere concern and affection for John,
writing, "By my troth, I had never so heavy a season as I had
from the time that I knew of your sickness till I knew of your
mending, and still my heart is in no great ease, nor shall be till I
know that you be entirely well. . . ."[4] And again, "It is not my
will either to do or say that which would cause you to be dis-
pleased, and if I have done I am sorry thereof and will amend it,
wherefore I beseech you to forgive me, and that you bear no
heaviness in your heart against me, for your displeasure should
be heavy for me to endure with."[5] And, "Be not strange of
writing letters to me betwixt this and that you come home. If I
might, I would have one every day from you."[6]

All the vexing problems of defending their property were
shared between them, Margaret showing a grasp of her hus-
band's affairs that was admirable but by no means unique.
Fifteenth-century middle-class women were typically as en-
grossed as their husbands in the cares of the propertied class, an
attitude elegantly exemplified in a letter of Lady Isabel Berkeley,
who wrote her husband with airy self-assurance, "Keep well all
about you till I come home, and treat not without me, and then
all things shall be well."[7]

The difficulty of resisting aggressive rivals amid the tangle of complex law, unreliable documents, and corrupt officials was heightened for the Pastons by added circumstances of time and place. Margaret's marriage probably occurred in 1440 (Agnes Paston's letter is undated). The 1440s and 1450s witnessed the English military defeats of the closing stage of the Hundred Years' War and Jack Cade's rebellion at home, while the government suffered first from the incompetence and later the imbecility of Henry VI. The widespread breakdown of authority brought to the fore a new class of nobles enriched by war, enclosures, and sheep farming, who kept private armies with which they backed their sometimes legal, usually dubious, and often spurious claims to neighbors' lands. In the atmosphere of feudal gangsterism that presently turned into the Wars of the Roses, an upstart family like the Pastons found its freshly acquired manors, houses, fields, and forests—to many of which the Paston title was evidently not all that clear—an invitation to aggression.

Rival claimants sued at law while assiduously bribing sheriffs and other authorities. The Pastons fought them off with legal weapons and counterbribes. One prolonged struggle took place when a wealthy baron named Lord Moleyns suddenly took possession (1448) of the manor of Gresham, which Justice Paston had purchased from Thomas Chaucer, son of the poet. Behind Moleyns stood an enemy of John's father named John Heydon, known to be close to the Duke of Suffolk, one of the most powerful lords of the realm. John Paston prudently solicited the help of the Bishop of Winchester, who persuaded Lord Moleyns to let the lawyers for both sides negotiate, though Margaret bitterly observed to John that Moleyns's agent "is collecting the rent [from the peasants] at Gresham at a great pace."[8]

As Moleyns's lawyers took evasive action for their client, John Paston collected a party of followers (October 1449) and seized the mansion, a square, solid blockhouse surrounded by a moat. When John was summoned to London shortly after, he left the

mansion and its little garrison in Margaret's charge. Lord Moleyns suddenly appeared with an overpowering force of armed followers, who intimidated Margaret's men and carried Margaret herself bodily out of the house, after which they looted and half wrecked the place (January 1450).

A few months later several ruffians belonging to a notorious local band set upon John outside Norwich Cathedral. The attack may or may not have been related to the Gresham quarrel, assault being commonplace enough. "At the reverence of God, beware how you ride or go, for naughty and evil-disposed fellowships," Margaret wrote her husband. "God for his mercy send us a good world."[9]

In 1451 John recovered his Gresham property, though he was never able to get Lord Moleyns to pay the two hundred pounds' damage suffered (the sheriff of Norfolk refused to be bribed to act against so highly placed a personage, though he agreed to be John's friend against anybody else he cared to sue).

Following the Gresham affair, the 1450s proved a relatively stable and peaceful decade for the Pastons. John continued to spend several months of each year in London for the law-court term, while Margaret raised eight children (six boys, followed by two girls—others may have failed to survive; we do not know) and ran her household. She supervised the breadmaking, ale brewing, winemaking, dairy, poultry, and pigs, and oversaw the spinning, weaving, sewing, and needlework. In preparation for winter she organized the smoking of ham and bacon, drying of fruit, and storage of grain. Richard Calle, the Pastons' bailiff, notified her, "I have got me a friend in Lowestoft to help to buy me seven or eight barrel [of herring], and . . . shall not cost me above 6/8 a barrel. . . . You shall do more now [autumn] with 40 shillings, than you shall at Christmas with 5 marks."[10] For Lent she purchased extra fish for drying and salting, writing John, "As for herring, I have bought an horse-load for 4/6. I can get no eels yet."[11]

Most basic supplies came from the nearby countryside and

from Norwich and Yarmouth, but Margaret obtained fine cloth, laces, hats, hose, and shoes, as well as oranges, dates, spices, and other luxuries from London. "I pray you heartily that you will send me a pot with treacle [molasses, imported from Genoa] in haste for I have been right evil at ease,"[12] she wrote her husband at one point. She was not, however, given to consumption of luxuries, and certainly not to ostentation. Once late in her life the queen (Margaret of Anjou, wife of Henry VI) visited Norwich, and though by that time Margaret was a very wealthy woman she had to borrow jewelry to make herself presentable.

Domestic convenience had improved measurably since the days of Eleanor de Montfort two hundred years earlier. Soap was now cheap—Margaret could buy a bar of ordinary soap for a penny, Castile for five farthings (a farthing was a quarter-penny). Mattresses and featherbeds lent comfort in the bedroom, where canopies and side curtains were now part of middle-class decor—the Pastons' were of blue buckram and worsted. Tapestries or cheaper "painted cloths" covered walls. Every decent home had a fireplace at least in the kitchen, with andirons, spits, tongs, and bellows, and like the Datinis' house, the Pastons' various dwellings were warmed by several.

But rushes still covered the floors, and tallow still cost more than meat, so that feeble rushlights survived along with candles. Window glass remained so expensive that window frames were made removable, to be stored when the owner was absent or taken from one house to another. For many years Margaret moved between her old house at Elm Hill in Norwich and another at Gresham. Otherwise she traveled little, going on an occasional pilgrimage to the shrine at Walsingham forty kilometers away, and only once in her life venturing all the way to London. In her travels she probably rode astride, as women had always done, rather than sidesaddle, a style just coming into vogue in the fifteenth century.

The tasks of mothering a large family were alleviated by the English middle-class custom of farming children of both sexes out at an early age to households of higher social status. Thus Margaret sought to get her daughter placed in the household of the Countess of Oxford or the Duchess of Bedford or "in some other worshipful place."[13] The Venetian ambassador thought the custom showed "the want of affection in the English . . . strongly manifested towards their children; for after having kept them at home till they arrive at the age of seven or nine years at the utmost, they put them out . . . to hard service in the houses of other people. . . . And on inquiring the reason for this severity, they answered that they did it in order that their children might learn better manners."[14]

Such children, dispatched to the houses of strangers, were often homesick. One girl, Dorothy Plumpton, wrote her father begging him "to send for me to come home to you," but got no answer. "I beseech you to . . . show now by your fatherly kindness that I am your child," she wrote, "for I have sent you divers messages and writings, and I had never answered again . . . wherefore it is thought in these parts, by those persons that list better to say ill than good, that ye have little favor unto me; which error ye may now quench, if it will like you to be so good and kind father unto me."[15]

Discipline was matter-of-factly corporal, and sometimes cruel. At one time, during a dispute with her daughter over her marriage prospects, Agnes Paston beat John's grown sister Elizabeth weekly, once leaving her with "her head broken in two or three places."[16] Margaret was kinder and felt affection for her children, though they often disappointed her. Her favorite was Walter, her fifth son, of whom she wrote when he went off to Oxford, "I were loth to lose him, for I trust to have more joy of him than I have of them that be older."[17] She was doomed to tragic disappointment; Walter died shortly after taking his degree, the youngest mortality in the family that we know of.

Caister Castle, east of Norwich, inherited by John Paston from Sir John Fastolf in 1459. *Hallam Ashley*.

Amid her unending domestic activities, Margaret never took her eye off the Paston properties, negotiating with tenant farmers, receiving applications for leases, interviewing judges, and fighting lawsuits, all the while transmitting to her husband a stream not only of information but advice on everything from dealing with threats to selling wool.

In the early 1450s John Paston became legal and financial counselor to one of the richest landowners in the east of England, Sir John Fastolf, at the moment building an elegant residence, Caister Castle, east of Norwich. Fastolf was a veteran captain of the Hundred Years' War who had founded his fortune partly on loot, and who despite a bright military record was destined to have his courage impugned and his name memorialized in mangled form as Shakespeare's Falstaff. In retirement Sir John was quirky, grasping, suspicious, and litigious, and found John Paston, who himself possessed some of these qualities and was expert in the law, to be a reliable aide and comforter. It also appears that Fastolf was distantly related to Margaret Paston (Caister is three miles from Mauteby). In any case, in 1457 the old soldier made John a trustee of his immense properties scattered through Norfolk and Suffolk, and two days before his death in 1459 wrote a new will in which John was named principal heir, subject only to his founding a college (for training clergy) at Caister Castle. The Pastons thus acquired dozens more manors and estates, John Paston became a Knight of the Shire, i.e., Member of Parliament, and the mayor and mayoress of Norwich paid Margaret the compliment of sending a dinner out to her country place and arriving to share it with her.

Given the state of England, such a windfall as the Fastolf bequest could hardly go unchallenged. Besides direct claimants to various properties, there were parties who sought rewards by helping the king to lay claims. Two former executors of Sir John's estate, Judge William Yelverton and William Jenney,

seized some of the manors and evidently got the capricious royal power on their side, because when John Paston delayed obeying a summons from the king to come to London he ended up in Fleet prison.

John succeeded in obtaining his release, but had to remain in London much of the time during the embattled years that followed, throwing the burden of immediate defense of the properties on Margaret. Yelverton sued in Ecclesiastical Court to overturn Fastolf's deathbed will, which he claimed was a forgery. A focal point of conflict developed at the manor of Cotton, which Yelverton and Jenney had sold. Margaret doughtily took possession in person and began collecting the rents. The Yelverton purchaser arrived on the scene, but a combat was averted by the Duke of Norfolk, who arranged a truce while the disputed deeds to the property were scrutinized.

In 1465 the Duke of Suffolk, who coveted the Fastolf manor at Drayton, sent a force of three hundred men to attack Margaret and her eldest son in nearby Hellesdon, but the Pastons, forewarned, assembled a garrison sixty strong, armed with guns and crossbows, and the duke's force did not attack. Instead they launched a campaign of terror against the Pastons and their friends in and around Norwich, whose mayor the duke had bribed. Within a year, however, Hellesdon was seized and plundered, the assailants razing the manor house, robbing the peasants, and even raiding the church.

The Pastons at least got some sympathy as a result, Margaret writing John in London that "There cometh much people daily to wonder thereupon... and they speak shamefully thereof. The duke had better than a thousand pound that it had never been done; and ye have the more good will of the people that it is so foully done."[18]

Before John died in 1466, reputedly worn out by his troubles (one of his three brief terms in Fleet prison, the result of machinations of his enemies and royal whim, was the occasion of

Fortified gate of Drayton Lodge, one of the manor houses inherited by the Pastons from Sir John Fastolf and defended by Margaret against the Duke of Suffolk. *Hallam Ashley*.

Margaret's solitary visit to London), Margaret wrote him that
the Bishop of Norwich had told her that he "would not have
abiden the sorrow and trouble that ye have abiden, to win all Sir
John Fastolf's goods."[19] Margaret later wrote one of her sons
about Fastolf's land, "Remember it was the destruction of your
father."[20]

John was succeeded by his son, also named John, but distin-
guished by the fact that he had been knighted. Like many
third-generation heirs, Sir John proved a less stern character
than father and grandfather, and soon came to a settlement with
Bishop Wayneflete, the Lord Chancellor, who was also a Fas-
tolf executor. A famous detail of the settlement substituted for the
college Fastolf had desired to found at Caister a subsidy for
seven priests and seven poor scholars at Magdalen College,
Oxford. Consequently Sir John was able to assume title to Cais-
ter Castle, a splendid residence for a sybaritic bachelor.

The settlement did not satisfy some of the other claimants.
Yelverton succeeded in inducing Sir Thomas Howes, who was
co-executor with John Paston of Fastolf's last will, to declare the
will false (more bribery?) and the pair sold Caister Castle to the
Duke of Norfolk.

Sir John Paston, in London, directed his younger brother,
confusingly also named John, to take command of the Caister
garrison, and sought protection from the king, youthful Yorkist
Edward IV. But the intermittent Wars of the Roses were on
again, Edward was suddenly captured by his enemy the Earl of
Warwick (summer 1469), and the Duke of Norfolk seized the
opportunity presented by the general breakdown of authority to
lay siege to Caister. Margaret wrote Sir John in London that if
the garrison "be not holpen it shall be to you a great diswor-
ship,"[21] but the younger John was forced to surrender, being
allowed to march his men out of the castle leaving guns and
crossbows behind, for all the world like real war.

The loss of Caister, with its considerable rents from the de-
pendent peasants, put a sudden crimp in the recently expanded

Paston budget. Letters between provident Margaret and profligate son Sir John took on a new tone, Margaret nagging about "the great cost and charge" of this and that, John proposing advance collection of rents, sale of manors, and recourse to the pawnbroker with the silver plate.

The same year (1469) that saw the loss of Caister Castle witnessed another calamity. Margaret's daughters did not go down to Oxford or Cambridge or off to London's law courts. They married, either well or badly. Daughter Margery fell in love with an unsuitable man and before the affair could be stopped the two had taken secret but binding vows. What is interesting (apart from the demonstration that people *did* fall in love in the fifteenth century) is the identity of the man. He was Richard Calle, the Pastons' bailiff, an able and unswervingly loyal overseer of the family's properties. But he owned no property himself, or almost none—in addition to his duties as bailiff he apparently found time to run a little shop, because John Paston III declared that "he should never have my good will for to make my sister to sell candle and mustard in Framlingham."[22]

This attitude represented more than parvenu snobbishness. Marriage was a basic economic device of medieval society. Not only kings but barons, gentry, merchants, and peasants maneuvered on the matrimonial field, where a few strokes of skill or luck lifted families from obscurity to greatness: Woodvilles, Howards, Tudors.

In the case of marrying a son, the best course was to shop for an heiress; failing that, a handsome dowry. In marrying off a daughter, the aim was an optimum tradeoff of dowry and dower, with any debit made up by social gain, that is, a merchant's daughter with a good dowry wedding a son of the landed gentry.

Among the Pastons and their circle every matrimonial project invariably started and ended with money. "I heard while I was in London where was a goodly young woman to marry, which was daughter to one Seff, a mercer; and she shall have £200 in

money to her marriage," typically wrote John III to Margaret, "and ten marks by the year of land after the decease of a stepmother of hers, which is upon fifty year of age."[23] And Edmund Paston to his brother William: "Here is lately fallen a widow in Worsted, which was wife to one Bolt, a worsted merchant, and worth £1,000, and gave to his wife 100 marks in money, stuff of household, and plate to the value of 100 marks, and £10 by year in land. She is called a fair gentlewoman," he added incidentally.[24] And Margaret: "I was at my mother's, and while I was there, there came in one Wrothe, a kinsman of Elizabeth Clere's, and he saw your daughter, and praised her to my mother. . . . And my mother prayed him for to get for her one good marriage if he knew any; and he said he knew one should be of a 300 marks by year, the which is Sir John Cley's son . . . my mother thinketh that it should be got for less money now in this world than it should be hereafter, either that one, or some other good marriage."[25]

Amid all the money, plate, rents, and calculations, the letter Richard Calle wrote Margery Paston in 1469 rings with honest emotion:

My own lady and mistress, and before God very true wife, I with heart full sorrowful recommend me unto you, as he that cannot be merry, nor nought shall be till it be otherwise with us than it is yet; for this life that we lead now is neither pleasure to God nor to the world, considering the great bond of matrimony that is made betwixt us, and also the great love that hath been, and as I trust yet is, betwixt us, and as on my part never greater.

Wherefore I beseech Almighty God comfort us as soon as it pleaseth Him, for we that ought of very right to be most together are most asunder; meseemeth it is a thousand year ago since that I spake with you. I had liever than all the good in the world I might be with you. . . .

I understand, lady, ye have had as much sorrow for me as any gentlewoman hath had in the world, as would God all that

sorrow that ye have had had rested upon me, so that ye had been discharged of it. . . . [26]

Evidently it was Calle who broke the news to the Pastons of the engagement he and Margery had made, in medieval custom a valid marriage vow—in his letter to Margery, Calle speaks of "the great bond of matrimony that is made betwixt us." The Pastons at first refused to believe him, and when Margery affirmed the truth the storm broke. Margaret and old Agnes enlisted the Bishop of Norwich to interrogate the couple with the object of finding a technical defect in the form of their vow. The honest Bishop found none, but even if he had it would not have helped because, as her mother wrote Sir John, "She rehearsed what she had said, and said if those words made it not sure, she said boldly that she would make it surer ere than she went thence."[27]

Her daughter's steadfastness in love failed to soften the mother's heart. Margaret Paston wrote that Margery's "lewd words grieveth me and her grandam as much as all the remnant,"[28] and "I charged my servants that she should not be received in my house. . . . I pray you and require you that ye take it not pensily [pensively] for I wot well it goeth right near your heart, and so doth it to mine and to other. But remember you, and so do I, that we have lost of her but a brethel [worthless person] and set it the less to heart . . . an he were dead at this hour, she should never be at mine heart as she was."[29]

Margery was literally turned away from the Paston door by Sir James Gloys, Margaret's chaplain, and the Bishop of Norwich had to find a place for her to stay. Yet a curious sequel: Richard Calle remained the Pastons' bailiff, trusted with the properties that were more precious to Margaret than her daughter. In her will Margaret bequeathed twenty pounds to Margery's eldest child.

Margaret's severity toward Margery remains somewhat puzzling, even after due allowance for the attitude of the times.

Margery was certainly a spirited girl, and parents did not shirk from coercion in matrimonial projects. The brutal treatment old Agnes Paston accorded Margery's aunt Elizabeth on one occasion was meant to induce her to accept a middle-aged suitor disfigured by disease. That project fell through and Elizabeth eventually married Robert Poynings, who had been "sword bearer and carver" to the celebrated rebel Jack Cade.

Margaret's other children had varying matrimonial adventures. Both Sir John and John III were involved in interminable negotiations, and when for some reason Sir John decided to renege on his betrothal vows, he wound up paying the pope for a dispensation and went to his grave unwed, though not celibate, leaving behind an illegitimate daughter. John III, after persistent but vain attempts to marry for money, unexpectedly married for love. His bride, Margery Brews, gained the support of a sentimental mother in overcoming her father's opposition, which was also undermined by Margaret Paston's timely concession of the manor of Sparham. "My right well-beloved Valentine," Margery addressed her future husband shortly before their marriage,[30] and four years later, in a postscript, "Sir, I pray you if you tarry long at London that it will please [you] to send for me, for I think [it] long since I lay in your arms."[31]

Anne Paston, after first alarming the family by falling in love with a servant named John Pampyng, wrote a postscript to the bitter legal battle over the Fastolf bequest by marrying William Yelverton, grandson of the Judge Yelverton who had led the fight against her father. The negotiations were, as usual, protracted, and Sir John twice besought his brother to take heed "lest the old love between her and Pampyng renew."[32]

In 1471 the Paston men were directly involved in one of the chief military events of the Wars of the Roses, the battle of Barnet, by which Edward IV defeated the Lancastrian army of the Earl of Warwick. Unfortunately, Sir John Paston and John Paston III fought on the side of the losers, John III taking "an

arrow in his right arm beneath the elbow," as Sir John wrote Margaret, reassuring her that "I have sent him a surgeon, which hath dressed him, and he shall be all whole within right short time."[33]

Both Pastons succeeded in winning pardons from the king, and before long Sir John was busy once more with plans to recover Caister Castle. On the occasion of the Duchess of Norfolk's first confinement he and Margaret redoubled efforts but without success, Sir John apparently ruining the opportunity by a tactless reference to the Duchess's condition. As he explained to his brother, he had meant to say "that my lady was of stature good and had sides long and large, so that I was in good hope she should bear a fair child; he was not laced nor braced in to his pain, but that she left him room to play him in." What gossip reported him as saying was that "my lady was large and great, and that it should have room enough to go out at. . . . I meant well, by my troth, to her. . . . If you can by any means find out whether my lady taketh it to displeasure or not, or whether she think I mocked her . . . I pray you send me word."[34]

Rebuffed on Caister, Sir John turned to pawning family plate and selling manors until Margaret threatened him: if he sold any more properties she would reduce his share in her own estate (her Mauteby inheritance) by double the amount.

At last, following the death of the Duke of Norfolk in 1475, and favored by an unusually apathetic attitude by the widowed Duchess, Sir John peacefully and legally repossessed Caister, where he caroused comfortably until his own death in 1479.

His brother John, a man more in the character of his father and grandfather, became a pillar of the Tudor monarchy, was knighted for service at the battle of Stoke, and appointed sheriff of Norfolk. John's descendants rose to become Earls of Yarmouth.

Margaret Paston died in 1484, her last days in contrast to the turbulence of her earlier life, serenely peaceful. Her will be-

stowed numerous gifts on hospitals, churches, and monasteries. The arms of John and Margaret are carved on the great south door of St. Andrew's in Norwich, and long adorned the windows of St. Peter Hungate, which John and Margaret partly rebuilt.

A sterner figure than Margherita Datini, and forced to deal with more violent realities, Margaret Paston resembles the merchant's wife of Prato in being a model of what the fifteenth century thought a middle-class woman should be: expert household manager, intelligently supportive wife, and, a role Margherita did not share, competent and shrewd mother. Political circumstance demanded more of Margaret Paston than of Margherita Datini, who never became involved in her husband's business.

Despite Margaret's intensive participation in the masculine game of getting and keeping, her life, like Margherita's, illustrates the limits of medieval woman's role as well as its potential. At home, on the peasant holding or on the estate, woman was the partner of man, often his equal, sometimes more than his equal. But when opportunity opened outside the home—the opportunity of war, politics, the law—the man went, the woman stayed home.

12

The Middle Ages and After

Not all women stayed home, and the most famous woman of the entire Middle Ages actually went to war, with brilliant success. Unlike Margherita Datini and Margaret Paston, however, Joan of Arc is no prototype, and whatever her male comrades-in-arms and male enemies thought of her, her image remained unique. Women nearly always, if not always, stayed "inside," and men went "outside." The sense of the division was stated in uncompromising terms in the *Libri della Famiglia*. Writing in the 1430s, in the very aftermath of Joan's exploits, Leon Battista Alberti blandly observes that women are occupied with "little feminine trifles," men with "high achievements." "You are entirely right," declares one of the protagonists, "to leave the care of minor matters to your wife and to take upon yourself . . . all manly and honorable concerns." His friend replies, "I believe that a man . . . not only should do all that is proper to a man, but that he must abstain from such activities as properly pertain to women. The details of housekeeping he should commit entirely into their hands."[1]

During the thousand years of the Middle Ages, Western society made historic strides, technological, commercial, political. Medieval innovations revolutionized industry, architecture, ag-

riculture, and intellectual life, while alleviating and enhancing daily living with the spinning wheel, water mill, windmill, wheelbarrow, crank, cam, flywheel, lateen sail, rudder, compass, stirrup, gunpowder, padded horse collar, nailed horseshoe, three-field system, Gothic engineering, distillation, universities, rhymed verse, Hindu-Arabic numbers, the modern theater, movable type, and the printing press. The Commercial Revolution of the high Middle Ages, led by merchants like Francesco Datini, opened the new age of capitalism, as feudal political fragmentation gave way to new national states.

The technological, economic, and political surge could not fail to have its impact on women—on the work they did, the clothes they wore, the food they ate, the houses they lived in; the health, security, stability, and intellectual enrichment of their lives.

Margherita Datini and Margaret Paston were beyond question better fed, dressed, housed, and educated than their earlier class counterparts, and probably than earlier queens and countesses. Even the chance of survival had improved. Life expectancy for women, lower than for men in the early Middle Ages, seems to have increased by the fourteenth century to the point where women outnumbered men.

In status, on the other hand, the record of women through the medieval millennium is more equivocal, and in fact can be charted as a series of advances and retreats: relatively high in Romanized Europe at the end of the Empire; relatively low in the early centuries of the barbarian kingdoms; advancing with the civilizing influence of Christianity and of contact with Roman culture; cresting at the end of the Dark Ages when women assumed economic and legal responsibilities to free men for military action; leveling off or possibly declining under the new restrictions of feudalism, which yet permitted women to act as regents, command castles, work side by side with men in the fields and city shops, and form the main audience for the new romantic poetry, basis for the future salon; finally, at the end of the Middle Ages, turning downward as bureaucratized govern-

ment and commercial capitalism eroded woman's role in politics and the economy.

Even the gain in life expectancy produced some negative effects by creating economically superfluous women who were a burden to their families. Dante, in *Paradiso* (1315–1321), lamented the good old days of his great-great-grandfather when "the birth of a daughter did not yet appall/The father, for the marrying age and dowry/Were not immoderate on either side."[2] Giovanni Villani (d. 1348) wrote with a similar nostalgia for earlier times when "a hundred pounds was the usual dowry of a woman, and two or three hundred were considered excessive in those times."[3] In the 1420s Saint Bernardine of Siena claimed (with considerable hyperbole) that there were twenty thousand girls unable to find husbands in the city of Milan. Some of the unmarriageable women swelled irregular or heretical religious movements, while others created the pressure on monasticism which alarmed the Cistercians and Cluniacs.

Throughout the Middle Ages, the concentration of literacy in the ranks of the clergy, the professions, and the business community ensured that far more men than women could read and write. Among the women in this book, only Hildegarde of Bingen can confidently be described as highly educated. Although Blanche of Castile, Eleanor de Montfort, and Margaret Paston were almost certainly literate, only in the case of Margherita Datini do we have hard evidence that she could both read and write with competence, and then only as an adult.

A curious footnote to the political role of medieval women, disenfranchised and excluded from political councils and public office, as women had been from ancient times and would be for another half-millennium, was the unique case of a referendum in the Italian Piedmont village of Cravenna in 1304 decided by majority vote of all the inhabitants, including the women.[4]

Two general observations are appropriate to the picture of medieval women throughout the period. One is the significance of widow power. Unmarried girls and wives had little control over their destinies. But queens like Blanche of Castile, peasant

women who took over their dead husbands' fields, craftsmen's wives who inherited shops, tools, and apprentices, were able to discover the opportunities, as well as the problems, of management responsibility. At least in the late Middle Ages, widows often profited from marriage contracts that, in place of the traditional widow's third, gave them far more of their husbands' land, even, on occasion, all of it. Some widows used their wealth to attract youthful suitors. Others, more materialistic or less romantic, used remarriage to increase their wealth. Still others remained widows, often keeping the property from the ultimate heirs, male or female, for decades. Margaret, Countess Marshal, heiress to the Earl of Norfolk, was married to Lord Seagrave by a contract which made her joint tenant of his lands. When he died in 1353, Margaret was left in possession and furthermore survived their heir (a daughter) and her own second husband. She died in 1399, and after some delays her great-grandson finally inherited.

A second important generalization is that status with respect to men varied roughly in inverse ratio to wealth and social standing. At the pinnacle of the hierarchy, men married to produce heirs and to conclude political and economic alliances. With the significant exception of the surrogate function performed when their husbands were absent, royal and baronial wives had little to do, since even the management of their households and care of their children were confided to stewards and nurses. Ruling-class male attitudes reflected this lack of female purpose. On the next level down, middle-class women like Margherita Datini and Margaret Paston earned respect as trusted managers of the difficult medieval household, and even as its doughty defenders against enemies. But only within the peasant and artisan classes, where toil was demanded of all, did the numerous Alice Benyts and Agnes li Patinieres share work and responsibility with husbands and brothers on a nearly equal basis.

NOTES

PART ONE: THE BACKGROUND

Chapter 1. Women in History

1. Trotula of Salerno, *The Diseases of Women; a Translation of Passionibus Mulierum Curandorum*, by Elizabeth Mason-Hohl. Los Angeles, 1940, p. 23.
2. Friedrich Engels, *The Origin of the Family, Private Property, and the State*. New York, 1942, p. 9.
3. Pliny, *Natural History*, with an English Translation, Vol. VIII, trans. W. H. S. Jones. Cambridge, Mass., 1948, p. 55.
4. Pliny, *Natural History*, with an English Translation, Vol. II, trans. H. Rackham. Cambridge, Mass., 1951, pp. 547–549.
5. Leviticus 16: 19–24.
6. Leviticus 12:2–4.
7. Galatians 3: 28.
8. Jill Tweedie, reviewing *Of Women Born, Motherhood as Experience and Institution*, in *Saturday Review*, November 13, 1976, p. 28.
9. Christine de Pisan, *Cyte of Ladyes*, trans. B. Anslay, London, 1521, Bk. 2, Ch. 36, cited in *Not in God's Image*, ed. Julia O'Faolain and Lauro Martines. New York, 1973, p. 181.
10. Christine de Pisan, *Oeuvres Poétiques*, 3 vols., ed. Maurice Roy. Paris, 1965 (reprint of 1891 edition), Vol. II, p. 21, lines 645–651, 664.
11. Christine de Pisan, *Oeuvres*, Vol. II, p. 23–24, lines 722–723, 733–734.

Chapter 2. Women in the Early Middle Ages

1. Vern Bullough, *The Subordinate Sex, a History of Attitudes Toward Women*. Urbana, Ill., 1976, p. 50.

2. Pliny, *Letters and Panegyrics*, trans. Betty Radice. Cambridge, Mass., 1969, Vol. I, pp. 297–298.

3. Juvenal, *Satires*, VI, in *Juvenal and Persius*, trans. G. G. Ramsay. Cambridge, Mass., 1961, p. 121, lines 438–439.

4. St. Jerome, *Select Letters*, trans. F. A. Wright. Cambridge, Mass., 1963, pp. 346–347.

5. Tacitus, *Germania*, in *Tacitus in Five Volumes*, trans. M. Hutton. Cambridge, Mass., 1970, Vol. I, p. 163.

6. Ibid., p. 159.

7. Ibid., p. 159.

8. Ibid., p. 143.

9. Gregory of Tours, *History of the Franks*, trans. O. M. Dalton. Oxford, 1927, Vol. II, pp. 117–118.

10 *The Burgundian Code*, trans. Katherine Fischer Drew. Philadelphia, 1972, p. 78.

11. Ibid., p. 32.

12 Einhard, *Life of Charlemagne*, trans. Evelyn S. Firchow. Coral Gables, Fla., 1972, p. 80.

13. "Laws of Ethelbert," *English Historical Documents*, Vol. I, c. 500–1042, ed. Dorothy Whitelock. New York, 1968, pp. 358–359, articles 14, 16, 73.

14. Ibid., p. 359, articles 79, 80, 81.

15. "The Will of King Alfred," *English Historical Documents*, Vol. I, pp. 492–495.

16. "The Will of Wynflaed," *Anglo-Saxon Wills*, trans. Dorothy Whitelock. Cambridge, Eng., 1930, pp. 11–15.

17. "Will of Wulfwaru," *Anglo-Saxon Wills*, p. 62.

18. "Laws of Cnut," *English Historical Documents*, Vol. I, p. 429, article 74.

19. Ibid., p. 430, articles 76, 76 1a, 76 1b.

20. "Family Lawsuit," *English Historical Documents*, Vol. I, p. 556.

21. Procopius, *History of the Wars*, in *Procopius with an English Translation*, trans. H. B. Dewing. Cambridge, Mass., 1961, V, ii, p. 15.

22. *The Alexiad of Anna Comnena*, trans. E. R. A. Sewter. Baltimore, 1969, p. 66.

23. Ibid., p. 147.

24. David Herlihy, "Land, Family, and Women in Continental Europe, 701–1200," in *Women in Medieval Society*, ed. Susan Mosher Stuard. Philadelphia, 1976, p. 34.

Chapter 3. Women and Feudalism

1. Glanville, Ranulf de, *De legibus et consuetudinibus regni Angliae*, trans. John Beames as *A Treatise on the Laws and Customs of England*. London, 1812, pp. 175–176.
2. Marc Bloch, *Feudal Society*, trans. L. A. Manyon. Chicago, 1964, Vol. I, p. 227.
3. *The Great Roll of the Pipe for the Ninth Year of King John*, ed. A. M. Kirkus. London, 1946, cited in Joseph R. Strayer, *Feudalism*. Princeton, 1965, p. 143.
4. Ibid., p. 144.
5. William Blackstone, *Commentaries*, ed. William Carey Jones. San Francisco, 1916, Vol. I, pp. 625–634.
6. Saint Bernardine of Siena, *Sermons*, ed. Don Nazarene Orlandi, trans. Helen Josephine Robins. Siena, 1920, pp. 77, 79–80.
7. Thomas Aquinas, *Summa contra Gentiles*, trans. by the English Dominican Fathers. London, 1923, p. 112.
8. Thomas Aquinas, *Summa Theologica*, trans. by the English Dominican Fathers. London, 1964, Vol. 34, p. 151.
9. Thomas Aquinas, *Summa contra Gentiles*, p. 116.
10 Thomas Aquinas, *Commentary on the Nichomachean Ethics*, trans. C. I. Litzinger. Chicago, 1964, pp. 767–768.
11. Saint Bonaventure, *On the Sentences*, in John T. Noonan, Jr., *Contraception, a History of Its Treatment by the Catholic Theologians and Canonists*. Cambridge, Mass., 1965, p. 256.

Chapter 4. Eve and Mary

1. I Corinthians 7:29.
2. Tertullian, *De anima*, in J. P. Migne, ed., *Patrologia Latina*, Vol. II. Paris, 1844, Col. 700.
3. Tertullian, *Ad uxorem*, in *Patrologia Latina*, Vol. I. Paris, 1879, Col. 1394.
4. I Corinthians 7:7.

5. I Corinthians 7:1.

6. Ephesians 5:22.

7. Tertullian, *De cultu feminarum*, in *Patrologia Latina*, Vol. I, Col. 1418–1419.

8. Tertullian, *Ad uxorem*, in *Patrologia Latina*, Vol. I, Col. 1385.

9. Marbodi Episcopi Redonensis, *Liber decem capitulorum*. Heidelberg, 1947, pp. 12–13.

10. G. G. Coulton, *From St. Francis to Dante, Translations from the Chronicle of the Franciscan Salimbene, 1221–1288*. Philadelphia, 1972 (reprint of 1907 edition), p. 97.

11. A. Lecoy de la Marche, *La chaire française au moyen âge*. Paris, 1886, pp. 438–439.

12. Humbert de Romans, "Ad omnes mulieres," cited in Bede Jarrett, *Social Theories of the Middle Ages, 1200–1500*. New York, 1966, pp. 70–72.

13. Tertullian, *De Cultu feminarum*, in *Patrologia Latina*, I, Col. 1429.

14. Thomas Aquinas, *Summa Theologica*, Vol. 13, p. 37.

15. Ibid., pp. 59–61.

16. Conon de Bethune, "Chanson d'Amour," *Penguin Book of French Verse*, Vol. I, ed. Brian Woledge. Baltimore, 1966, p. 96.

17. Le Chatelain de Coucy, "Chanson d'Amour," *Penguin Book of French Verse*, p. 98.

18. Le Chatelain de Coucy, "Chanson d'Amour," *Penguin Book of French Verse*, p. 99.

19. Le Chatelain de Coucy, "Chanson d'Amour," *Penguin Book of French Verse*, p. 96.

20. Jean de Meung, *Roman de la Rose*, trans. David and Patricia Herlihy, in *Medieval Culture and Society*, ed. David Herlihy. New York, 1968, p. 237.

21. *Les quinze joyes de mariage*, ed. Joan Crow. Oxford, 1969.

22. "Anonymous Aube," *Penguin Book of French Verse*, p. 90.

23. *Anthology of the Provençal Troubadours*, ed. Raymond T. Hill and Thomas G. Bergin. New Haven, 1941, p. 96.

24. Andreas Capellanus, *The Art of Courtly Love*, trans. J. J. Parry. New York, 1941, pp. 106, 107.

25. *Fuero Jusgo*, II, iv, 4, Madrid, 1815, cited in *Not in God's Image*, p. 178.

26. *Statuti di Perugia*, ed. G. degli Azzi. Rome, 1913, cited in *Not in God's Image*, p. 178.

27. Edgcumbe Staley, *The Guilds of Florence*. New York, 1967, p. 91.

28. *Coutumes de Beauvaisis*, ed. A. Salmon. Paris, 1899, p. 335.

29. *The Lawes Resolution of Womens Rights*, London, 1632, cited in Not in God's Image, p. 176.

30. Cherubino de Siena, *Regole della vita matrimoniale*. Bologna, 1888, pp. 12–14, cited in Not in God's Image, p. 177.

31. *Ancient Popular Poetry*, ed. J. Ritson. London, 1884, Vol. II, p. 20, lines 131–132.

32. Jean de Joinville, *The Life of St. Louis*, in Chronicles of the Crusades, trans. M. R. B. Shaw. Baltimore, 1963, p. 225.

33. Aristotle, *Generation of Animals*, trans. A. L. Peck. Cambridge, Mass., 1943, Bk. 1, pp. 101, 103, 109, 113.

34. Ibid., Bk. IV, vi, pp. 459 ff.

35. Thomas Aquinas, *Summa Theologica*, Vol. 13, p. 37.

36. Albertus Magnus, *De Secretis Mulierum*. Lyons, 1615, cited in Not in God's Image, pp. 124–125.

37. Galen, *De Uteri Dissectione*. Basel, 1536, cited in Not in God's Image, p. 120.

38. P. Borgarucci, *Della contemplatione anatomica sopra tutte le parti del corpo humano*. Venice, 1564, cited in Not in God's Image, pp. 121–122.

39. I. de Valverde, *Historia de la composicion del cuerpo humano*. Rome, 1556, cited in Not in God's Image, p. 122.

40. Hostiensis, *Lectura*, X, 4.13.11, cited in James A. Brundage, "Prostitution in the Medieval Canon Law," Signs, Summer 1976, Vol. 1, No. 4, p. 832.

41. I Corinthians 7.

42. Geoffrey Chaucer, *The Canterbury Tales*, trans. into modern English by Nevill Coghill. Baltimore, 1960, p. 278.

43. John F. Benton, ed., *Self and Society in Medieval France, the Memoirs of Abbot Guibert of Nogent*. New York, 1970, p. 149.

44. Ibid., pp. 63–64, 67.

45. Augustine, *The Good of Marriage*, in Corpus scriptorum ecclesiasticorum latinorum. Vienna, 1866, Vol. 41, p. 208.

46. Augustine, *Against Julian*, in Patrologia Latina, Vol. 44, Turnhout, Belgium, n.d., Col. 687.

47. Huguccio, *Summa*, 2.32.2.1, cited in Noonan, Contraception, p. 197.

48. Robert of Courçon, *Summa Theologica*, cited in Noonan, Contraception, p. 198.

49. William of Auxerre, *Summa aurea in quattuor libros sententiarum*, IV, f. 288. Frankfurt, 1964 (facsimile of edition of Paris, 1500).

50. Bartholomew of Exeter, *Penitential*, ed. Adrian Morey. Cambridge, Eng., 1937, p. 204.

51. Hostiensis, *Summa aurea*. Lyons, 1542, cited in Noonan, *Contraception*, p. 272.

52. Bernardine of Siena, *Seraphic Sermons*, 19, cited in Noonan, *Contraception*, p. 273.

53. Jean Gerson, "Sermon Against Lechery for the Second Sunday in Advent," *Opera*, III, Antwerp, 1706, cited in Noonan, *Contraception*, p. 269.

54. Bernardine of Siena, *Le prediche volgari*. Florence, 1958, cited in Noonan, *Contraception*, p. 433.

55. Guillaume de St.-Pathus, *Vie de Saint-Louis*. Paris, 1899, pp. 129–130.

56. Lina Eckenstein, *Woman Under Monasticism*. New York, 1963 (reprint of 1896 edition), p. 293.

57. Jacques de Vitry, *Historia occidentalis*. Westmead, Eng., 1971 (facsimile of 1597 edition), p. 278.

58. Michael Psellus, *Chronographia*, trans. E. R. A. Sewter. New Haven, 1953, pp. 73–74.

59. Chaucer, *Canterbury Tales*, pp. 292–296.

PART TWO: THE WOMEN

Chapter 5. An Abbess: Hildegarde of Bingen

1. Eckenstein, *Woman under Monasticism*, pp. 135–137.

2. Anne L. Haight, *Hroswitha of Gandersheim*. New York, 1965, p. 21.

3. Eckenstein, *Woman under Monasticism*, pp. 172–174.

4. F. A. Gasquet, *English Monastic Life*. Freeport, New York, 1971 (reprint of 1904 edition), pp. 155–156.

5. Johann Busch, *Liber de Reformatione Monasteriorum*, ed. Karl Grube. Halle, 1886, pp. 644–645.

6. *The Rule of St. Benedict*, ed. and trans. Justin McCann. Westminster, Md., 1963, Chapter 48, p. 111.

7. *Regestrum Visitationum Archiepiscopi Rothomagensis*, cited in Eileen Power, *Medieval English Nunneries*. Cambridge, Eng., 1922, p. 652.

8. Ibid., p. 654.

9. Ibid., p. 654.

10. Jacques de Vitry, cited in Power, *Medieval English Nunneries*, p. 372.

11. Power, *Medieval English Nunneries*, p. 657.

12. Ibid., p. 45.

13. *Patrologia Latina*, Vol. 197, Turnhout (Belgium), n.d., Col. 384.

14. Ibid., Col. 109–110.
15. Boethius, *The Consolation of Philosophy*, Bk. 1, trans. Richard Green. Indianapolis, Ind., 1962, pp. 5–6.
16. Charles Singer, "The Scientific Views and Visions of Saint Hildegarde (1098–1180)," *Studies in the History and Method of Science*. Oxford, 1917, p. 32 (also in *From Magic to Science*, New York, 1958, pp. 215–216).
17. *Patrologia Latina*, Vol. 197, Col. 742–743.
18. Ibid., Col. 743.
19. Ibid., Col. 744.
20. Ibid., Col. 425.
21. Ibid., Col. 415.
22. Ibid., Col. 145.
23. Ibid., Col. 186–187.
24. J. B. Pitra, ed., *Analecta Sacra*, Vol. VIII. Paris, 1882, p. 556, cited in Albert Battandier, "Sainte Hildegarde, sa vie et ses oeuvres," *Revue des Questions Historiques*, XXXIII (1883), p. 415.
25. Ibid., p. 415.
26. *Patrologia Latina*, Vol. 197, Col. 17–18.
27. *Revelations of Mechtild of Magdeburg, 1210–1297*, trans. Lucy Menzies. London, 1953, p. 67.
28. Ibid., p. 21.
29. Ibid., p. 11.
30. Ibid., p. 11.
31. Ibid., p. 9.
32. St. Bernard, *Sermones in Cantica*, in *Patrologia Latina*, Vol. 183, Col. 1091.
33. R. W. Southern, *Western Society and the Church in the Middle Ages*. Harmondsworth, Eng., 1970, p. 314.
34. J. Moorman, *A History of the Franciscan Order from Its Origins to the Year 1517*. Oxford, 1965, p. 35.
35. H. Gundmann, *Religiöse Bewegungen im Mittelalter*. Darmstadt, 1970, p. 263.
36. Thomas of Eccleston, *The Coming of the Friars Minor to England (De adventu fratrum minorum in Angliam)*, in *Thirteenth Century Chronicles*, trans. Placid Hermann. Chicago, 1961, pp. 185–186.
37. Southern, *Western Society and the Church*, p. 329.
38. Ibid., p. 330.
39. *The Book of Margery Kempe*, A.D. 1436, ed. W. Butler-Bowdon. London, 1944, pp. 23–25.

40. Ibid., pp. 68–69.
41. Ibid., p. 105.
42. Ibid., p. 125.
43. Ibid., pp. 131, 134.
44. Ibid., pp. 88, 90.
45. Ibid., p. 181.
46. J. Vaissète, *Histoire générale du Languedoc*. Toulouse, 1872–92, Vol. VIII, p. 224.

Chapter 6. A Reigning Queen: Blanche of Castile

1. Louis Sebastien Le Nain de Tillemont, *Vie de Saint-Louis*, ed. J. de Gaulle. Paris, 1847, Vol. I, p. 6.
2. Philippe Mousket, *Chronique*, in *Recueil des historiens des Gaules et de la France*, Vol. XXII, Paris, 1855, p. 38, lines 27145–27148.
3. *Chronicon Turonense*, in *Recueil des historiens des Gaules et de la France*, Vol. XVIII, Paris, 1879, p. 317.
4. Adam of Eynsham, *Life of St. Hugh of Lincoln* (*Magna Vita Hugonis Episcopi Linconensis*), ed. and trans. Decima L. Dowie and Dom Hugh Farmer. London, 1962, Vol. II, p. 48.
5. Ibid., p. 156.
6. Guillaume de St.-Pathus, *Vie de Saint-Louis*, in *Recueil des historiens des Gaules et de la France*, Vol. XX. Paris, 1890, p. 65.
7. Joinville, *Life of St. Louis*, pp. 181–182.
8. *Récits d'un ménéstrel de Reims au XIIIe siècle*, ed. J. N. de Wailly. Paris 1876, pp. 301–302.
9. Hincmar of Reims, *De ordine palatii*, *Monumenta Germaniae Historica*, *Capitularia regum Francorum*, 2, ed. A. Boretius. Hanover, 1897, p. 525.
10. Thibaut IV, "Chanson," *Le Livre d'Amour*. New York, 1887, p. 134.
11. *Extraits des chroniques de St. Denis*, in *Recueil des historiens des Gaules et de la France*, Vol. XXI, Paris, 1865, pp. 111–112.
12. Matthew Paris, *Chronica majora*, ed. H. R. Luard. London, 1872, Vol. III, p. 169.
13. Guillaume de Nangis, *Vie de Saint-Louis*, in *Recueil des historiens des Gaules et de la France*, Vol. XX. Paris, 1890, p. 322.
14. Joinville, *Life of St. Louis*, p. 316.
15. Ibid., p. 316.
16. Ibid., pp. 187–188.
17. Matthew Paris, *Chronica majora*, Vol. IV, p. 253.

18. Joinville, *Life of St. Louis*, p. 190.
19. Matthew Paris, *Chronica majora*, Vol. VI, p. 154.
20. Matthew Paris, *Chronica majora*, Vol. V, pp. 260–261.
21. *Les grandes chroniques de France*, ed. Jules Viard, Vol. VII. Paris, 1932, p. 169.
22. Matthew Paris, *Chronica majora*, Vol. V, p. 354.
23. *Grandes chroniques*, Vol. VII, pp. 167–168.
24. "La deposition de Charles d'Anjou pour le procès de canonisation de Saint Louis," *Notices et documents publiés pour la Société de l'Histoire de France*. Paris, 1884, p. 169.
25. Matthew Paris, *Chronica majora*, Vol. V, p. 354.
26. Robert Fawtier, *The Capetian Kings of France*, trans. Lionel Butler. London, 1965, p. 28.

Chapter 7. A Great Lady: Eleanor de Montfort

1. "Jehan et Blonde," *Oeuvres Poetiques de Philippe de Rémi, Sire de Beaumanoir*, Vol. II. New York, 1966 (reprint of 1885 edition).
2. Bibliothèque Nationale MS Clairembault 1188, f. 80, cited in Charles Bémont, *Simon de Montfort, Comte de Leicester*. Paris, 1884, pp. 333–335.
3. Matthew Paris, *Chronica Majora*, Vol. III, p. 475.
4. Ibid., pp. 479–480.
5. *Close Rolls, Henry III, 1237–42*, cited in Margaret Wade Labarge, *Simon de Montfort*. London, 1962, p. 51.
6. Matthew Paris, *Chronica Majora*, Vol. III, p. 487.
7. Ibid., pp. 566–567.
8. Ibid., p. 335.
9. Mary Ann Everett Green, *Lives of the Princesses of England*, Vol. II. London, 1849, p. 82.
10. *Adae de Marisco Epistolae*, in *Monumenta Franciscana*, Vol. I, ed. J. S. Brewer. London, 1858, p. 264.
11. Ibid., pp. 294–296.
12. Ibid., p. 299.
13. *Royal Letters, Henry III*, ed. W. W. Shirley. London, 1862–1866, Vol. II, Letter No. 644, pp. 294–295.
14. Green, *Lives of the Princesses*, Vol. II, Appendix VIII, p. 456.
15. T. Rymer, *Foedera Conventiones, Litterae et cujuscunque generis Acta Publica*, ed. T. D. Hardy and D. Sandeman, Vol. I, 1066–1307. London, 1816, Pt. I, 576.

Chapter 8. Piers Plowman's Wife

1. Adalbero, Bishop of Laon, cited in R. H. Hilton, *Bond Men Made Free*. New York, 1973, pp. 53–54.
2. Matthew Paris, *Chronica majora*, Vol. IV, p. 262.
3. J. A. Raftis, *Tenure and Mobility*. Toronto, 1964, pp. 44–45.
4. Ibid., p. 44.
5. P. D. A. Harvey, *A Medieval Oxfordshire Village: Cuxham, 1240 to 1400*. Oxford, 1965, p. 123.
6. George C. Homans, *English Villagers of the Thirteenth Century*. New York, 1975, p. 181.
7. Raftis, *Tenure and Mobility*, pp. 72–73.
8. Mathilde l'Aigle, *Le livre des trois vertus de Christine de Pisan*. Paris, 1912, p. 299.
9. Chaucer, *Canterbury Tales*, pp. 230–231.
10. William Langland, *Piers Plowman's Crede*, ed. W. W. Skeat. London, 1867, pp. 16–17.

Chapter 9. A City Working Woman: Agnes li Patiniere of Douai: Women and the Guilds

1. Chaucer, *Canterbury Tales*, p. 29.
2. Georges Espinas, *Les origines du capitalisme*, Vol. I, *Sire Jehan Boine-broke, patricien et drapier douaisien*. Lille, 1933, pp. 18–20.
3. Ibid., p. 21.
4. Ibid., pp. 29–30.
5. Ibid., pp. 21–24.
6. Ibid., p. 29.
7. Powers, *Medieval Women*, p. 59.
8. Ibid., p. 59.
9. *English Guilds: The Original Ordinances of More Than One Hundred Early English Guilds*, ed. J. Toulmin Smith. London, 1870, p. 382.
10. *Book of Margery Kempe*, p. 9.
11. William Langland, *The Vision of William Concerning Piers Plowman*, ed. W. W. Skeat. Oxford, 1906, p. 51, lines 226–227.
12. M. de la Fontanelle de Vaudoré, *Les arts et métiers à Poitiers pendant les XIIIe, XIVe et XVe siècles*. Poitiers, 1837, p. 13.
13. Auguste Parenty, *Les anciennes corporations d'arts et métiers de la ville d'Arras*. Paris, 1868, p. 42.
14. Vaudoré, *Arts et métiers à Poitiers*, p. 18.

15. *Proceedings, Minutes and Enrolments of the Company of Soapmakers of Bristol, 1562–1642*, ed. H. E. Matthews. Bristol, 1940, pp. 47, 52.
16. *English Guilds*, p. 182.
17. Ibid., p. 180.
18. Sylvia Thrupp, *The Merchant Class of Medieval London*. Ann Arbor, Mich., 1962, p. 152.
19. H. T. Riley, *Memorials of London and London Life, 1276–1419*. London, 1868, p. 52.

Chapter 10. Margherita Datini: An Italian Merchant's Wife

1. Iris Origo, *The Merchant of Prato, Francesco di Marco Datini*. New York, 1957, p. 160.
2. Ibid., p. 161.
3. Ibid., p. 66.
4. Ibid., p. 264.
5. *Le Ménagier de Paris*, trans. Eileen Power. London, 1928, pp. 50–51.
6. Origo, *Merchant of Prato*, p. 250.
7. Ibid., p. 250.
8. Leon Battista Alberti, *I Libri della Famiglia*, trans. Renee Neu Watkins as *The Family in Renaissance Florence*. Columbia, S.C., 1969, pp. 222–224.
9. Origo, *Merchant of Prato*, p. 192.
10. Ibid., p. 193.
11. Ibid., p. 193.
12. "Le lettere di Margherita Datini a Francesco di Marco," ed. Valeria Rosati, *Archivio di Stato Pratese*, 1975, p. 33.
13. Alberti, *I Libri della Famiglia*, pp. 220–221.
14. Ibid., p. 224.
15. Origo, *Merchant of Prato*, p. 162.
16. "Lettere di Margherita Datini," p. 12.
17. Origo, *Merchant of Prato*, p. 210.
18. Ibid., pp. 210–211.
19. Christine de Pisan, *Citye of Ladyes*, I, 11, cited in *Not in God's Image*, p. 181.
20. "Lettere di Margherita Datini," p. 19.
21. Ibid., p. 25.
22. Ibid., p. 27.
23. Ibid., p. 9.
24. Ibid., pp. 35–36.

25. Ibid., p. 18.
26. Ibid., pp. 57, 58.
27. Ibid., p. 47.
28. Origo, *Merchant of Prato*, p. 186.
29. Ibid., p. 186.
30. Ibid., p. 187.
31. Ibid., p. 188.
32. Ibid., pp. 200–201.
33. Saint Bernardine of Siena, *Sermons*, p. 89.
34. Origo, *Merchant of Prato*, p. 330.
35. *Ménagier de Paris*, pp. 171–172.
36. Origo, *Merchant of Prato*, p. 338.
37. Ibid., p. 299.
38. *Two Memoirs of Renaissance Florence, the Diaries of Buonaccorso Pitti and Gregorio Dati*, trans. Julia Martines. New York, 1967, pp. 115–117.

Chapter 11. Margaret Paston: A Fifteenth-Century Gentlewoman

1. *The Paston Letters and Papers of the Fifteenth Century*, ed. Norman Davis. Oxford, 1971, Vol. I, p. 26.
2. Ibid., pp. xli–xlii.
3. Ibid., p. 7.
4. Ibid., p. 218.
5. Ibid., p. 251.
6. Ibid., p. 254.
7. T. D. Fosbroke, *Abstracts and Extracts of Smyth's Lives of the Berkeleys*, London, 1821, pp. 152–153.
8. *Paston Letters*, Vol. I, p. 225.
9. Ibid., Vol. I. p. 268.
10. Ibid., Vol. II, p. 358.
11. Ibid., Vol. I, p. 251.
12. Ibid., Vol. I, p. 243.
13. Ibid., Vol. I, p. 339.
14. *The Italian Relation of England*, ed. C. A. Sneyd, London, 1847, p. 24, cited in H. S. Bennett, *The Pastons and Their England*. Cambridge, Eng., 1970 (reprint of 1922 edition), p. 82.
15. *The Plumpton Correspondence*, ed. T. Stapleton. London, 1839, pp. 190–191.
16. *Paston Letters*, Vol. II, p. 32.

17. Ibid., Vol. I, p. 370.
18. Ibid., Vol. I, p. 330.
19. Ibid., Vol. I, p. 300.
20. Ibid., Vol. I, p. 361.
21. Ibid., Vol. I, p. 340.
22. Ibid., Vol. I, p. 541.
23. Ibid., Vol. I, p. 613.
24. Ibid., Vol. I, p. 639.
25. Ibid., Vol. I, p. 287.
26. Ibid., Vol. II, p. 498.
27. Ibid., Vol. I, p. 342.
28. Ibid., Vol. I, p. 342.
29. Ibid., Vol. I, p. 343.
30. Ibid., Vol. I, p. 662.
31. Ibid., Vol. I, p. 665.
32. Ibid., Vol. I, p. 472.
33. Ibid., Vol. I, p. 437.
34. Ibid., Vol. I, p. 450.

Chapter 12. The Middle Ages and After

1. Alberti, I Libri della Famiglia, p. 208.
2. Dante, Divine Comedy, III, Paradiso, trans. Louis Biancolli. New York, 1966, p. 59.
3. Giovanni Villani, Chronica, 2:96, Florence, 1823, cited in David Herlihy, "Life Expectancies for Women in Medieval Society," The Role of Woman in the Middle Ages, Albany, 1975, p. 19.
4. Guido Rossi, "Statut juridique de la femme dans l'histoire du droit italien, époque mediévale et moderne," Société Jean Bodin, Recueils: La Femme II. Brussels, 1962, p. 120.

BIBLIOGRAPHY

Asterisk denotes that complete information appears in General listing.

GENERAL

Bardèche, Maurice, *Histoire des femmes*, 2 vols. Paris, 1968.

Beard, Mary, *Women as a Force in History*. New York, 1946.

Beauvoir, Simone de, *The Second Sex*, trans. H. M. Parshley. New York, 1957.

Bullough, Vern L., *The Subordinate Sex, a History of Attitudes toward Women*. Urbana, Ill., 1973.

Jarrett, Bede, *Social Theories of the Middle Ages, 1200–1500*. New York, 1966.

Langdon-Davies, John, *A Short History of Women*. New York, 1927.

Lehmann, Andrée, *Le rôle de la femme dans l'histoire de France au moyen âge*. Paris, 1952.

————, *Le rôle de la femme dans l'histoire de la Gaule*. Paris, 1944.

Liberating Women's History, ed. Berenice A. Carroll. Urbana, Ill., 1976.

Not in God's Image: Women in History from Greeks to Victorians, ed. Julia O'Faolain and Lauro Martines. New York, 1973.

Power, Eileen, *Medieval Women*, ed. M. M. Postan. Cambridge, Eng., 1975.

Putnam, Emily, *The Lady*. Chicago, 1970.

Rogers, Katherine M., *The Troublesome Helpmate, a History of Misogyny in Literature*. Seattle, 1966.

The Role of Woman in the Middle Ages, Papers of the Sixth Annual Conference of the Center for Medieval and Early Renaissance Studies, State University of New York at Binghamton, 6–7 May, 1972, ed. Rosemarie Thee Morewedge. Albany, 1975.

Société Jean Bodin, *Recueils: La Femme*. Brussels, 1962.

Stenton, Doris, *The Englishwoman in History*. London, 1957.

Sullerot, Evelyn, *Woman, Society, and Change*. New York, 1971.

Tavard, George H., *Woman in Christian Tradition*. Notre Dame, Ind., 1973.

Women from the Greeks to the French Revolution, ed. Susan G. Bell. Belmont, Calif., 1973.

Women in Medieval Society, ed. Susan Mosher Stuard. Philadelphia, 1976.

PART ONE: THE BACKGROUND

Chapter 1. Women in History

*Beard, *Women as a Force in History*.

*Bullough, *The Subordinate Sex*.

Not in God's Image, ed. O'Faolain.

Pinet, Marie-Josephe, *Christine de Pisan, 1364–1430*. Paris, 1927.

Pisan, Christine de, *Oeuvres Poétiques*, 3 vols., ed. Maurice Roy. Paris, 1965 (reprint of 1891 edition).

Pliny, *Natural History*, Vol. II, trans. H. Rackham, Cambridge, Mass., 1951; Vol. VIII, trans. W. H. S. Jones, Cambridge, Mass., 1948.

*Power, *Medieval Women*.

*Rogers, *The Troublesome Helpmate*.

Trotula of Salerno, *The Diseases of Women* (*Passionibus Mulierum Curandorum*), trans. Elizabeth Mason-Hohl. Los Angeles, 1940.

*See General listing.

Chapter 2. Women in the Early Middle Ages

The Alexiad of Anna Comnena, trans. E. R. A. Sewter. Baltimore, 1969.

Anglo-Saxon Wills, trans. Dorothy Whitelock. Cambridge, Eng., 1930.

Baldsdon, J. P. V. D., *Roman Women, Their History and Habits*. London, 1963.

*Bardèche, *Histoire des femmes*.

*Beard, *Women as a Force in History*.

Blair, Peter Hunter, *An Introduction to Anglo-Saxon England*. Cambridge, Eng., 1966.

Buckler, Georgina, "Women in Byzantine Law about 1100 A.D.," *Byzantion*, Vol. XI (1936).

*Bullough, *The Subordinate Sex*.

The Burgundian Code, trans. Katherine Fischer Drew. Philadelphia, 1972.

Carcopino, Jerome, *Daily Life in Ancient Rome*. New York, 1971.

Diehl, Charles, *Byzantine Empresses*, trans. Harold Bell and Theresa de Kerpely. New York, 1963.

————, *Theodora, Empress of Byzantium*, trans. Samuel R. Rosenbaum. New York, 1972.

Duckett, Eleanor Shipley, *Death and Life in the Tenth Century*. Ann Arbor, Mich., 1968.

————, *The Gateway to the Middle Ages, France and Britain*. Ann Arbor, Mich., 1964.

————, *The Gateway to the Middle Ages, Italy*. Ann Arbor, Mich., 1965.

Einhard, *Life of Charlemagne*, trans. Evelyn S. Firchow. Coral Gables, Fla., 1972.

English Historical Documents, ed. Dorothy Whitelock, Vol. I, c. 500–1042. New York, 1968.

Ganshof, François-L., "Le statut de la femme dans la monarchie franque," Société Jean Bodin, *Recueils: La Femme II*. Brussels, 1962.

Gregory of Tours, *History of the Franks*, 2 vols., trans. O. M. Dalton. Oxford, 1927.

Herlihy, David, "Land, Family, and Women in Continental Europe, 701–1200," in *Women in Medieval Society*, ed. Stuard.

Juvenal and Persius, trans. G. G. Ramsay. Cambridge, Mass., 1961.

Lacey, W. K., *The Family in Classical Greece*. Ithaca, N.Y., 1968.

Latouche, Robert, *Caesar to Charlemagne, the Beginnings of France*, trans. Jennifer Nicholson. London, 1973.

*Lehmann, *Le rôle de la femme dans l'histoire de France au moyen âge*.

*————, *Le rôle de la femme dans l'histoire de la Gaule*.

McNamara, Jo-Ann, and Suzanne F. Wemple, "Marriage and Divorce in the Frankish Kingdom," in *Women in Medieval Society*, ed. Stuard.

Not in God's Image, ed. O'Faolain.

Pliny, *Letters and Panegyrics*, 2 vols., trans. Betty Radice. Cambridge, Mass., 1969.

Procopius, *History of the Wars*, Vols. 1–5 of *Procopius with an English Translation*, 7 vols., trans. H. B. Dewing. Cambridge, Mass., 1961.

Riché, Pierre, *Education and Culture in the Barbarian West, Sixth Through Eighth Centuries*. Columbia, S.C., 1976.

Runciman, Steven, *Byzantine Civilization*. New York, 1956.

St. Jerome, *Select Letters*, trans. F. A. Wright. Cambridge, Mass., 1963.

Seltman, Charles, *Women in Antiquity*. London, 1956.

*Stenton, *The Englishwoman in History*.

Tacitus, *Germania*, in *Tacitus in Five Volumes*, trans. Sir W. Peterson. Cambridge, Mass., 1970, Vol. I.

Chapter 3. Women and Feudalism

*Beard, *Women as a Force in History*.

Blackstone, William, *Commentaries*, Vol. I, ed. William Carey Jones. San Francisco, 1916.

Bloch, Marc, *Feudal Society*, 2 vols., trans. L. A. Manyon, Chicago, 1964.

*Bullough, *The Subordinate Sex*.

Glanville, Ranulf de, *De legibus et consuetudinibus regni Angliae*, trans. John Beames as *A Treatise on the Laws and Customs of England*. London, 1812.

Jouon de Longrais, F., "Le statut de la femme en Angleterre dans le

droit commun médiéval," Société Jean Bodin, *Recueils: La Femme II*.

*Lehmann, *Le rôle de la femme dans l'histoire de France au moyen âge*.

Lloyd, Alan, *The Maligned Monarch*. New York, 1972.

Metz, René, "Le statut de la femme en droit canonique médiéval," Société Jean Bodin, *Recueils: La Femme II*.

Noonan, John T., Jr., *Contraception, a History of Its Treatment by the Catholic Theologians and Canonists*. Cambridge, Mass., 1965.

———, "Power to Choose," in "Marriage in the Middle Ages," ed. John Leyerle, *Viator*, 4 (1973).

Not in God's Image, ed. O'Faolain.

*Power, *Medieval Women*.

*Stenton, *The Englishwoman in History*.

Strayer, Joseph, *Feudalism*. Princeton, 1965.

Thomas Aquinas, *Commentary on the Nichomachean Ethics*, trans. C. I. Litzenger. Chicago, 1964.

———, *Summa contra Gentiles*, trans. by the English Dominican Fathers. London, 1923.

———, *Summa Theologica*, trans. the English Dominican Fathers. London, 1964.

Chapter 4. Eve and Mary

Ancient Popular Poetry, ed. J. Ritson. London, 1884.

Andreas Capellanus, *The Art of Courtly Love*, trans. J. J. Parry. New York, 1941.

Anthology of the Provençal Troubadours, ed. Raymond T. Hill and Thomas G. Bergin. New Haven, 1941.

Aristotle, *Generation of Animals*, trans. A. L. Peck. Cambridge, Mass., 1943.

Augustine, *Against Julian*, in *Patrologia Latina*, ed. J. P. Migne, Vol. 44, Turnhout, Belgium, n.d.

———, *The Good of Marriage*, in *Corpus scriptorum ecclesiasticorum latinorum*, Vol. 41. Vienna, 1866.

Bartholomew of Exeter, *Penitential*, ed. Adrian Morey. Cambridge, Eng., 1937.

Benton, John F., "Clio and Venus: An Historical View of Medieval

Love," in *The Meaning of Courtly Love*, ed. F. X. Newman. Albany, N.Y., 1968.

Bogin, Meg, *The Women Troubadours*. New York, 1976.

Brundage, James A., "Prostitution in the Medieval Canon Law," *Signs*, Summer 1976, Vol. 1, No. 4.

Bullough, Vern L., *The History of Prostitution*. New Hyde Park, N.Y., 1964.

————, "Medieval Medical and Scientific Views of Women," in "Marriage in the Middle Ages," ed. John Leyerle, *Viator*, 4 (1973).

*————, *The Subordinate Sex*.

Chaucer, Geoffrey, *The Canterbury Tales*, trans. into modern English by Nevill Coghill. Baltimore, 1960.

Cherubino da Siena, *Regole della vita matrimoniale*. Bologna, 1888.

Coulton, G. G., *From St. Francis to Dante, Translations from the Chronicle of the Franciscan Salimbene, 1221–1288*. Philadelphia, 1972 (reprint of 1907 edition).

Coutumes de Beauvaisis, ed. A. Salmon. Paris, 1899.

Eckenstein, Lina, *Woman under Monasticism*. New York, 1963 (reprint of 1896 edition).

Guillaume de St.-Pathus, *Vie de Saint-Louis*. Paris, 1899.

Jacques de Vitry, *Historia occidentalis*. Westmead, Eng., 1971 (facsimile reprint of 1597 edition).

*Jarrett, *Social Theories of the Middle Ages*.

Joinville, Jean de, *The Life of St. Louis*, in *Chronicles of the Crusades*, trans. M. R. B. Shaw. Baltimore, 1963.

*Langdon-Davies, *A Short History of Women*.

Lecoy de la Marche, A., *La chaire française au moyen âge*. Paris, 1886.

*Lehmann, *Le rôle de la femme dans l'histoire de France au moyen âge*.

Marbodi Episcopi Redonensis, *Liber decem capitulorum*. Heidelberg, 1947.

Medieval Culture and Society, ed. David Herlihy. New York, 1968.

*Noonan, *Contraception*.

Not in God's Image, ed. O'Faolain.

Penguin Book of French Verse, Vol. I, ed. Brian Woledge. Baltimore, 1966.

*Power, *Medieval Women*.

Psellus, Michael, *Chronographia*, trans. E. R. A. Sewter. New Haven, 1953.

Les quinze joyes de mariage, ed. Joan Crow. Oxford, 1969.

*Rogers, *The Troublesome Helpmate*.

Self and Society in Medieval France, the Memoirs of Abbot Guibert of Nogent, ed. John F. Benton. New York, 1970.

*Tavard, *Woman in Christian Tradition*.

Tertullian, *Ad uxorem*, in J. P. Migne, ed., *Patrologia Latina*, Vol. I. Paris, 1879.

———, *De anima*, in ibid., Vol. I.

———, *De cultu feminarum*, in ibid., Vol. I.

Thomas Aquinas, *Summa Theologica*.

William of Auxerre, *Summa aurea in quattuor libros sententiarum*. Frankfurt, 1964 (facsimile of edition of 1500).

PART TWO: THE WOMEN

Chapter 5. An Abbess: Hildegarde of Bingen

Battandier, A., "Sainte Hildegarde, sa vie et ses oeuvres," *Revue des questions historiques*, Vol. 33 (1883).

Boethius, *The Consolation of Philosophy*, trans. Richard Green. Indianapolis, Ind., 1962.

Bolton, Brenda M., "Mulieres Sanctae," in *Women in Medieval Society*, ed. Stuard.

Book of Margery Kempe, The, ed. W. Butler-Bowdon. London, 1944.

Boutiot, T., *Histoire de la ville de Troyes et de la Champagne méridionale*. Troyes, 1870.

Busch, Johann, *Liber de Reformatione Monasteriorum*, ed. Karl Grube. Halle, 1886.

Dickinson, J. C., *Monastic Life in Medieval England*. London, 1951.

*Eckenstein, *Woman under Monasticism*.

Fontette, Micheline de, "Les religieuses à l'âge classique du droit canon," *Bibliothèque de la Société d'Histoire Ecclésiastique de la France*. Paris, 1967.

Gasquet, F. A., *English Monastic Life*. London, 1904.

Grundmann, H., *Religiöse Bewegungen im Mittelalter*. Darmstadt, 1970.

Haight, Anne L., *Hroswitha of Gandersheim*. New York, 1965.

Hildegarde of Bingen, *Liber divinorum operum*, in *Patrologia Latina*, Vol. 197. Turnhout, Belgium, n.d.

——, *Scivias*, in *Patrologia Latina*, Vol. 197. Turnhout, Belgium, n.d.

Jeremy, Sister Mary, *Scholars and Mystics*. Chicago, 1962.

McDonnell, Ernest W., *The Beguines and Beghards in Medieval Culture*. New York, 1969.

Moorman, J., *A History of the Franciscan Order from Its Origins to the Year 1517*, Oxford, 1968.

Oldenbourg, Zoe, *Massacre at Montségur*. London, 1961.

Pisan, Christine de, "Le dit de Poissy," *Oeuvres Poétiques*, Vol. II.

The Plays of Hroswitha, trans. Christopher St. John. London, 1923.

Power, Eileen, *Medieval English Nunneries*. Cambridge, Eng., 1922.

*——, *Medieval Women*.

Revelations of Mechthild of Magdeburg, 1210–1297, trans. Lucy Menzies. London, 1953.

Robinson, A. Mary F., "Beguines and the Weaving Brothers," in *The End of the Middle Ages, Essays and Questions in History*. London, 1889.

Roth, I. W. E., "Beiträge zur Biographie der Hildegarde von Bingen, O.S.B., sowie zur Beurtheilung ihrer Visionen," *Zeitschrift für kirchliche Wissenschaft und kirchliches Leben*, Vol. IX. Leipzig, 1888.

The Rule of Saint Benedict, ed. and trans. Abbot Justin McCann. Westminster, Md., 1963.

St. Bernard, *Sermones in Cantica*, in *Patrologia Latina*, Vol. 183. Turnhout, Belgium, n.d.

Singer, Charles, "The Scientific Views and Visions of Saint Hildegarde," in *Studies in the History and Method of Science*. Oxford, 1917.

Southern, R. W., *Western Society and the Church in the Middle Ages*. Harmondsworth, Eng., 1970.

Thomas of Eccleston, *De adventu fratrum minorum in Angliam*, trans. Placid Hermann as *The Coming of the Friars Minor to England, Thirteenth Century Chronicles*. Chicago, 1961.

Thompson, Alexander Hamilton, "Double Monasteries and the Male Element in Nunneries," in *The Ministry of Women, a Report Appointed by His Grace the Archbishop of Canterbury*. London, 1919.

Thorndike, Lynn, *History of Magic and Experimental Science*, Vol. II. New York, 1947.

Vaissète, Joseph, *Histoire générale de Languedoc*, Vol. VIII. Toulouse, 1872-1892.

Vita Sanctae Hildegardis auctoribus Godfrido et Theodorico monachis, in *Patrologia Latina*, Vol. 197. Turnhout, Belgium, n.d.

Warner, H. J., *The Albigensian Heresy*. London, 1922.

Workman, Herbert B., *The Evolution of the Monastic Ideal*. London, 1927.

Chapter 6. A Reigning Queen: Blanche of Castile

Adam of Eynsham, *Life of St. Hugh of Lincoln (Magna Vita Hugonis Episcopi Linconensis)*, ed. and trans. Decima L. Dowie and Dom Hugh Farmer, Vol. II. London, 1962.

Berger, Elie, *Histoire de Blanche de Castille*. Paris, 1895.

Boutaric, Edgard, "Marguerite de Provence, son caractère, son rôle politique," *Revue des questions historiques*, Vol. III (1867).

Chronicon Turonense, in *Recueil des historiens des Gaules et de la France*, Vol. XVIII, Paris, 1879.

Extraits des chroniques de St. Denis, in *Recueil des historiens des Gaules et de la France*, Vol. XXI. Paris, 1855.

Facinger, Marion F., "A Study of Medieval Queenship: Capetian France, 987-1237," in *Studies in Medieval and Renaissance History*, Vol. V (1968).

Fawtier, Robert, *The Capetian Kings of France*, trans. Lionel Butler. London, 1965.

Guillaume de Nangis, *Vie de Saint-Louis*, in *Recueil des historiens des Gaules et de la France*, Vol. VII. Paris, 1890.

Guillaume de St.-Pathus, *Vie de Saint-Louis*, in *Recueil des historiens des Gaules et de la France*, Vol. VII.

Les grandes chroniques de France, Vol. 7, ed. Jules Viard. Paris, 1932.

*Herlihy, "Land, Family, and Women in Continental Europe."

Hincmar of Rheims, *De ordine palatii*, in *Monumenta Germaniae*

Historica, *Legum sectio II*, *cap. reg. Francorum 2*, ed. A. Boretius. Hanover, 1897.

*Joinville, Life of St. Louis.

Labarge, Margaret Wade, *Saint Louis, the Life of Louis IX of France*. London, 1968.

Matthew Paris, *Chronica majora*, ed. H. R. Luard, Vols. III–VI. London, 1872–1883.

Mousket, Philippe, *Chronique*, in *Recueil des historiens des Gaules et de la France*, Vol. XXII, Paris, 1855.

Le Nain de Tillemont, Louis Sebastien, *Vie de Saint-Louis, roi de France*, ed. J. de Gaulle, Vols. I–III, Paris, 1847.

Notices et documents publiés pour la Société de l'Histoire de France. Paris, 1884.

Petitot, Claude-Bernard, *Collection complète des mémoires relatifs à l'histoire de France depuis le règne de Philippe-Auguste, jusqu'au commencement du dix-septième siècle*, Vols. II, III. Paris, 1824.

Récits d'un ménéstrel de Reims du XIIIe siècle, ed. J. N. de Wailly. Paris, 1876.

Vincent of Beauvais, *De Eruditione Filiorum*. Cambridge, Mass., 1938.

Chapter 7. A Great Lady: Eleanor de Montfort

Adae de Marisco Epistolae, Monumenta Franciscana, Vol. I, ed. J. S. Brewer. London, 1858.

Bémont, Charles, *Simon de Montfort, Comte de Leicester*. Paris, 1884.

Green, Mary Anne Everett, *Lives of the Princesses of England*, Vol. II. London, 1849.

Labarge, Margaret Wade, *A Baronial Household of the Thirteenth Century*. New York, 1966.

———, *Simon de Montfort*. London, 1962.

Manners and Household Expenses of England in the Thirteenth and Fifteenth Centuries, ed. H. T. Turner. London, 1841.

*Matthew Paris, *Chronica majora*, Vol. III.

Oeuvres Poétiques de Philippe de Rémi, Sire de Beaumanoir, 2 vols. New York, 1966 (reprint of 1885 edition).

Royal Letters, Henry III, Vols. I–II, ed. W. W. Shirley. London, 1862–1866.

Rymer, T., *Foedera, Conventiones, Litterae et cujuscunque generis Acta Publica*, ed. T. D. Hardy and D. Sandeman, Vol. I, 1066–1307. London, 1816.

Chapter 8. Piers Plowman's Wife

L'Aigle, Mathilde, *Le livre des trois vertus de Christine de Pisan*. Paris, 1912.

Ault, W. O., *Open-Field Husbandry and the Village Community*. Philadelphia, 1965.

Bennett, H. S., *Life on the English Manor*. Cambridge, Eng., 1960.

———, *Tenure and Mobility*. Toronto, 1964.

*Chaucer, *Canterbury Tales*.

Du Boulay, F. R. H., *The Lordship of Canterbury*. London, 1966.

Duby, Georges, *Rural Economy and Country Life in the Medieval West*, trans. Cynthia Postan. Columbia, S.C., 1968.

DeWindt, Edwin B., *Land and People in Holywell-cum-Needingworth, Structures of Tenure and Patterns of Social Organization in an East Midlands Village, 1252–1457*. Toronto, 1972.

Hallam, H. E., "Some Thirteenth-Century Censuses," *Economic History Review*, 2nd Ser., Vol. X (1958).

Harvey, P. D. A., *A Medieval Oxfordshire Village: Cuxham, 1240 to 1400*. Oxford, 1965.

Hilton, Rodney H., *Bond Men Made Free: English Peasant Movements and the English Rising of 1381*. New York, 1973.

———. *The English Peasantry in the Later Middle Ages*. Oxford, 1975.

———, *A Medieval Society, the West Midlands at the End of the Thirteenth Century*. New York, 1966.

Homans, George C., *English Villagers of the Thirteenth Century*. New York, 1975.

Hoskins, W. G., *The Midland Peasant, the Economic and Social History of a Leicestershire Village*. London, 1957.

Krause, J., "The Medieval Household, Large or Small?" *Economic History Review*, 2nd Ser., Vol. IX (1956/57).

Langland, William, *Piers Plowman's Crede*, ed. W. W. Skeat. London, 1867.

*Matthew Paris, *Chronica majora*, Vol. IV.

*Power, *Medieval Women*.

Raftis, J. A., "Social Structures in Five East Midland Villages," *Economic History Review*, 2nd Ser., Vol. XVIII, no. 1 (1965).

Scammell, Jean, "Freedom and Marriage in England," *Economic History Review*, 2nd Ser., Vol. XXVII, no. 4 (November 1974).

Stuckert, Howard M., *Corrodies in the English Monasteries, a Study in English Social History of the Middle Ages*. Philadelphia, 1923.

Thrupp, Sylvia L., "The Problem of Replacement Rates in Late Medieval English Population," *Economic History Review*, Vol. XVIII, no. 1 (1965).

Chapter 9. A City Working Woman: Agnes li Patiniere of Douai: Women and the Guilds

Abram, A., "Women Traders in Medieval London," *Economic Journal*, Vol. 26 (June 1916).

Book of Margery Kempe.

* Chaucer, *Canterbury Tales*.

Coornaert, Emile, *Les corporations en France avant 1789*. Paris, 1968.

Early Gild Records of Toulouse, ed. Sister Mary Ambrose Mulholland. New York, 1941.

English Guilds: the Original Ordinances of More than One Hundred Early English Guilds, ed. J. Toulmin Smith. London, 1870.

Espinas, G., *Les origines du capitalisme*, Vol. I, *Sire Jehan Boinebroke, patricien et drapier douaisien*. Lille, 1933.

———, *La vie urbaine à Douai au moyen âge*. Paris, 1913.

Fontenelle de Vaudoré, M. de la, *Les arts et métiers à Poitiers pendant les XIIIe, XIVe, et XVe siècles*. Poitiers, 1837.

Gies, Joseph and Frances, "A Flemish Merchant Prince: Sire Jehan Boinebroke," in *Merchants and Moneymen, The Commercial Revolution, 1000–1500*. New York, 1972.

———, "Jacob Fugger, the First Modern Capitalist," in *Merchants and Moneymen*.

Hibbert, Francis A., *Influence and Development of English Guilds*. New York, 1970 (reprint of 1891 edition).

Langland, William, *The Vision of William Concerning Piers Plowman*, ed. W. W. Skeat. Oxford, 1906.

Martin Saint-Leon, Etienne, *Histoire des corporations de métiers depuis leurs origines jusqu'à leur suppression en 1791*. New York, 1975 (reprint of 1922 edition).

Nicholas, David, *Town and Countryside, Social, Economic, and Political Tensions in Fourteenth-Century Flanders*. Bruges, 1971.

Parenty, Auguste, *Les anciennes corporations d'arts et métiers de la ville d'Arras*. Arras, 1868.

Plummer, Alfred, *The London Weavers' Company, 1600–1970*. London, 1972.

Poerck, G. de, *La draperie médiévale en Flandre et en Artois*, 3 vols. Bruges, 1951.

*Power, *Medieval Women*.

Proceedings, Minutes and Enrolments of the Company of Soapmakers of Bristol, 1562–1642, ed. H. E. Matthews. Bristol, 1940.

Renard, Georges, *Guilds in the Middle Ages*, trans. Dorothy Terry. New York, 1968 (reprint of 1918 edition).

Riley, H. T., *Memorials of London and London Life, 1276–1419*. London, 1868.

Staley, Edgcumbe, *Guilds of Florence*. New York, 1967.

Thrupp, Sylvia, *The Merchant Class of Medieval London*. Ann Arbor, Mich., 1962.

Chapter 10. Margherita Datini: An Italian Merchant's Wife

Alberti, Leon Battista, *I Libri della Famiglia*, trans. Renee Neu Watkins as *The Family in Renaissance Florence*. Columbia, S.C., 1969.

Bensa, Enrico, *Francesco di Marco da Prato: notizie e documenti sulla mercatura italiana del secolo XIV*. Milan, 1928.

Gies, Joseph and Frances, "Francesco Datini of Prato, the Man Who Survived," in *Merchants and Moneymen*.

Guasti, C., *Lettere di un notaro ad un mercante del secolo XIV*. Florence, 1880.

"Le lettere di Margherita Datini a Francesco di Marco," ed. Valeria Rosati, *Archivio di Stato Pratese*, 1975.

Le Ménagier de Paris, trans. Eileen Power. London, 1928.

*Not in God's Image, ed. O'Faolain.

Origo, Iris, The Merchant of Prato, Francesco di Marco Datini, 1335–1410. New York, 1957.

Saint Bernardine of Siena, Sermons, ed. Don Nazarene Orlandi, trans. Helen Josephine Robins. Siena, 1920.

Two Memoirs of Renaissance Florence, the Diaries of Buonaccorso Pitti and Gregorio Dati, trans. Julia Martines. New York, 1967.

Chapter 11. Margaret Paston: A Fifteenth-Century Gentlewoman

Bennett, H. S., The Pastons and Their England. Cambridge, Eng., 1970 (reprint of 1932 edition).

———, Six Medieval Men and Women. Cambridge, Eng., 1955.

Fosbroke, T. D., Abstracts and Extracts of Smyth's Lives of the Berkeleys. London, 1821.

McFarlane, K. B., The Nobility of Later Medieval England. Oxford, 1973.

The Paston Letters and Papers of the Fifteenth Century, ed. Norman Davis. Oxford, 1971.

The Paston Letters, A.D. 1422–1509, ed. James Gairdner. New York, 1965.

The Plumpton Correspondence, ed. T. Stapleton. London, 1839.

*Power, Medieval Women.

Chapter 12. The Middle Ages and After

*Alberti, I Libri della Famiglia.

Dante, Divine Comedy, III, Paradiso, trans. Louis Biancolli. New York, 1966.

Herlihy, David, "Life Expectancies for Women in Medieval Society," The Role of Woman in the Middle Ages. Albany, 1975.

*McFarlane, The Nobility of Later Medieval England.

Rossi, Guido, "Statut juridique de la femme dans l'histoire du droit italien," Société Jean Bodin, Recueils: La Femme II. Brussels, 1962.

Thompson, James Westfall, The Literacy of the Laity in the Middle Ages. New York, 1963.

INDEX

abortion, 6, 15, 157
Adelaide, empress, wife of Otto I, 23
Adelaide, queen, wife of Louis VI, 103
adultery, attitudes toward, 6, 13, 15, 18, 19, 42–46
Aethelbert of Kent, king, code of, 19
Aethelflaed, daughter of King Alfred, 23
Alberti, Leon Battista, 193, 197, 229
Albertus Magnus, 50–51, 52
Albigensian heresy. *See* Cathar heresy
ale-tasters, 161, 177
Alfred, King, 20, 23
Alphonse of Poitiers, 100, 109, 111, 113–114, 116, 118
Amalasuntha, queen, 22
anchoresses, 92
Andreas Capellanus, 46
Anna Comnena, 24, 25
annulment. *See* divorce
Aregund, queen, 17
Aristotle, 49–50, 51, 80
Arte di Calimala, 179, 198
Augustine, Saint, 53, 79

Barons' War, 136–140
Beaumanoir, Philippe de, 120–121, 125
beguines, 91–92
Benedictine Rule, 65, 66
Benyt, Alice, 147, 150, 155, 159–160, 161–162, 164

Benyt, Robert, 146, 147, 149, 159
Berkeley, Lady Isabel, 213
Bernard of Clairvaux, Saint, 81, 82, 87
Bernardine of Siena, Saint, 34, 55, 204, 231
betrothal, 31–32, 152, 210
birth control. *See* contraception
Black Death, 157, 181, 194, 201, 205, 206
Blackstone, William, 3–4, 30
Blanche of Castile, 97–119 (*101*, *108*), 188, 231; marriage, 98–100; children, 100–101; coronation, 102; first regency, 104–110; as dowager queen, 110–115; second regency, 115–118, 119; death, 118–119
Boinebroke, Jehan, 166–168, 170–173, 174
Bonaventure, Saint, 36
brewing, 161, 175–177
Brunhild, queen, 22
Bullough, Vern, 13
Busch, Johann, 71
Byzantium, women in, 24–25

Caesaria, abbess, 65
Caesarius, bishop of Arles, rule of, 65
Caister Castle, *218*, 219, 222, 223, 226
Calle, Margery Paston, 223, 224–225
Calle, Richard, 215, 223, 224–225